CLEARLY INSPIRED

Contemporary Glass and Its Origins

KAREN S. CHAMBERS

TINA OLDKNOW

TAMPA MUSEUM OF

Pomegranate

SAN FRANCISCO, CALIFORNIA

Clearly Inspired: Contemporary Glass and Its Origins is published in conjunction with the exhibition of the same name, curated by Karen S. Chambers for the Tampa Museum of Art.

This catalogue was made possible in part by a generous grant from the Art Alliance for Contemporary Glass.

Exhibition Schedule:
Tampa Museum of Art, 28 March–6 June 1999
Fort Wayne Museum of Art, 11 September–9 November 1999

Published by
Pomegranate Communications, Inc.
Box 6099, Rohnert Park, CA 94927
Pomegranate Europe Ltd.
Fullbridge House, Fullbridge
Maldon, Essex CM9 4LE, England

Library of Congress Cataloging-in-Publication Data
Chambers, Karen S.
 Clearly inspired : contemporary glass and its origins / Karen S. Chambers and
Tina Oldknow.
 p. cm.
 Published in conjunction with an exhibition held at the Tampa Museum of Art,
Mar. 28–June 6, 1999 and the Fort Wayne Museum of Art, Sept. 11–Nov. 9, 1999.
 Includes bibliographical references.
 ISBN 0-7649-0932-0 (pbk.)
 1. Glass art—United States—History—20th century—Exhibitions. 2. Glass art—United
States—Foreign influences—Exhibitions.
 I. Oldknow, Tina. II. Tampa Museum of Art. III. Fort Wayne Museum of Art. IV. Title.
NK5112.C45 199998-48061
748.2913'09'40745965—dc21 98-48061
 CIP

Cover and interior design by Monroe Street Studios, Santa Rosa, California

Printed in Hong Kong

08 07 06 05 04 03 02 01 00 99 10 9 8 7 6 5 4 3 2 1

CLEARLY INSPIRED:
Contemporary Glass and Its Origins

FOREWORD

The Tampa Museum of Art has held several past exhibitions devoted to glass from its origins to the present day. The museum's well-known permanent collection of Greek and Roman antiquities contains a number of examples of ancient glass, which have been the catalyst for several exhibitions of early pieces. In 1993 the museum hosted *Chihuly: Form from Fire* and in 1995 *The Lamps of Tiffany: Highlights of the Egon and Hildegarde Neustadt Collection*.

Tiffany and Chihuly, the two most celebrated and prodigious explorers of the glass medium in this country over the past hundred years, are but bellwethers in a long tradition that has been insufficiently shared with the general public. While artists who work in glass are beginning to receive the recognition their accomplishments merit, often this is through exhibitions that isolate them from the rich tradition of which they are a part. It is not surprising that the historical precedents of the contemporary Studio Glass movement are less than well known: as the essays in this book demonstrate, glass itself is a mysterious (some would say magical) substance with a history largely anonymous and at times highly secretive.

The occasion of the Glass Art Society conference in Tampa in 1999 suggested a perfect opportunity to present an exhibition to engage our general public as well as the more specialized audience of artists, educators, students, and collectors attending the conference.

It was our tremendous good fortune that guest curator Karen S. Chambers had already been researching the ideas that would become *Clearly Inspired: Contemporary Glass and Its Origins*. Karen's thesis serendipitously meshed with our institution's desire to explore further the traditions underlying the contemporary glass movement. Her ability to articulate the exhibition ideas clearly and bring together exciting and important examples of work has made this one of our most enjoyable exhibition efforts. The essays by Karen S. Chambers and Tina Oldknow for this book make significant contributions to the literature of the glass movement, and we are grateful to Katie Burke and her staff at Pomegranate Communications, Inc., for recognizing this.

On behalf of the Tampa Museum of Art, I would like to thank the artists, individuals, galleries, and museums who have generously shared works from their collections with us. Without their support, an exhibition of this significance would not be possible. The publication of this book by Pomegranate Communications, Inc., has ensured that, long after the exhibition closes and the loans are returned, the ideas and images presented in the exhibition will have an enduring life.

Emily S. Kass
Director, Tampa Museum of Art

ACKNOWLEDGMENTS

Clearly Inspired: Contemporary Glass and Its Origins was clearly inspired by Suzanne Ramljak, and my first thank-you is to her. In the summer of 1997, when she was curator at the American Federation of Arts, we talked about a traveling glass exhibition for the AFA. The result, *Reflecting the Past: Contemporary Glass in Context*, became the basis of this show.

Thanks also to Michael Monroe, then director of the American Craft Council, who in the fall of 1997 suggested that I contact Emily S. Kass at the Tampa Museum of Art. She was looking for a glass-themed exhibition to coincide with the annual Glass Art Society meetings to be held in Tampa in the spring of 1999. In one of those "small world" coincidences, Kass had been director of the Fort Wayne Museum of Art when it hosted a traveling exhibition I had organized for the Contemporary Arts Center in Cincinnati, *Transparent Motives: Glass on a Large Scale.*

Unlike many exhibitions, *Clearly Inspired* had a gestation of just one year. That would never have been possible without the help of many people, including Sandra Knudsen, coordinator of publications and curatorial consultant for ancient art, Davira Taragin, exhibitions team leader and curator of nineteenth- and twentieth-century glass, Pat Whitesides, registrar, and Lee Mooney, secretary, registrar's office, Toledo Museum of Art; Gary Baker, curator of glass, and Linda M. Cagney, registrar assistant, Chrysler Museum of Art; Jane Adlin, curatorial assistant, twentieth-century art, Jessie McNab, associate curator, European sculpture and decorative arts, and Deanna Cross, photography library, Metropolitan Museum of Art; Ulysses Grant Dietz, decorative arts curator, The Newark Museum; Jim Peele, director, and Ginger Gregg, assistant director, Museum of Contemporary Art, Lake Worth, Florida; and Robyn G. Peterson, curator of collections, Rockwell Museum. All these institutions generously loaned historical objects from their magnificent glass collections. For illustrations of works that could not be included, I want to thank Susan M. Rossi-Wilcox, administrator, The Ware Collection of Blaschka Glass Models of Plants, The Botanical Museum of Harvard University; Jill Thomas-Clark, assistant registrar, Corning Museum of Glass; Wendy Brandow, Margo Leavin Gallery; and Cheryle T. Robertson, rights and reproductions coordinator, Los Angeles County Museum of Art.

In the process of creating an exhibition that includes contemporary art, the curator forms working relationships with galleries and artists. The galleries representing the artists included here were uniformly helpful and supportive. Special thanks must go to Barry Friedman, Carole Hochman, Dara Metz, and Marla Goldwasser of Barry Friedman Ltd., New York; Jacqueline Franks of Grand Central Gallery, Tampa; Linda Boone and Jo Mett of Habatat Galleries, Boca Raton; Lillian Zonars of Habatat Galleries, Pontiac; Kenn Holsten of Holsten Galleries, Stockbridge; Scott Jacobson, Terry Davidson, and Lynn Leff of Leo Kaplan Modern, New York; Suzanne De Bruyne of Naples Art Gallery, Naples; and Rick Snyderman and David Morsa of Snyderman Gallery, Philadelphia. Douglas Heller, Michael Heller, and Bob Roberts of Heller Gallery, New York, provided invaluable support and assistance. And Kate Elliott

of Elliott-Brown Gallery, Seattle, also generously shared her knowledge of the field.

In many cases, I went directly to the artists, who took time from their demanding schedules to help me locate and secure works to illustrate the exhibition's theme. Their studio assistants were extremely helpful, and special thanks must go to Jennifer Lewis, Don Hudgins, and Tom Lind of Dale Chihuly's studio; Catherine Keenan at Dan Dailey's; David Schimmel of Schott Crystal where Christopher Ries is artist-in-residence; and those supportive spouses, Karla Trinkley's husband, Will Dexter, Christopher Ries' wife, Colleen, and William Gudenrath's wife, Amy Schwartz.

I also want to thank the private collectors who played such an important role in the growth of the Studio Glass movement. *Clearly Inspired* could never have been assembled without their awareness of the importance of such an exhibition and their willingness to share their treasures: Dale & Doug Anderson, Dr. and Mrs. Richard Basch, Joan and Milton Baxt, Michael and Annie Belkin, Mr. and Mrs. William Block, Ron and Lisa Brill, Ron and Jackie Carmen, Charles Cowles, Robert and Cheri Discenzo, Barrie Feld, Ian Friedman, R. C. Friedman, Lorraine and Ron Haave, Sara Jane Kasperzak, Sam and Beverly Kostrinksky, Nancy and Philip Kotler, Jeffrey and Cynthia Manocherian, Myrna and Sheldon Palley, Sheldon and Lois Polish, Mr. and Mrs. Thomas Schreiber, and Barbara and Kenneth Tricebock.

The staff of the Tampa Museum of Art is to be commended for taking on this project. First, I thank Emily S. Kass for offering me the opportunity to realize this concept. Then I thank the museum staff for helping me do it. The exhibition could never have been accomplished without the professionalism and patience of Kay T. Morris, registrar; the extraordinary commitment and conscientiousness of Jose R. Gelats, curatorial assistant, who was also the most congenial partner in this project; and the management skills of Curator Elaine D. Gustafson, who had to cope with this fast-track project and Hurricane Georges in her first few weeks on board. Exhibition Designer Bob Hellier met the challenge of creating a coherent visual statement of the theme, showing twenty diverse artists' work in historical context.

It was a pleasure to work with Tina Oldknow as she contributed her insightful essay, providing the historical framework for today's work.

I thank Katie Burke, publisher of Pomegranate Communications, Inc., for having the vision to take on this project, and commend her staff for their excellent work, especially James Donnelly as managing editor and Zipporah Collins as a much-appreciated and sensitive editor.

I owe a debt of gratitude to Paul Hollister, esteemed glass scholar, for freely giving comments and insights as I began this project; Beth Hylen of the Corning Museum of Glass Rakow Library; Doug Navarra; and William Gudenrath, who helped clarify various aspects of my essay. Special thanks go to Jeffrey R. Sipe, who saw me through all the late nights as this inspiration assumed tangible form in the exhibition checklist and catalogue.

Karen S. Chambers
New York, New York
28 September 1998

This book and exhibition are dedicated to the memory of Mary Alice Chambers.

Introduction: Revival and Revolution

"Make it new," exhorted Ezra Pound. In twentieth-century art that seems to be the defining concept. But what about the adage that there is nothing new under the sun? These are not irreconcilable concepts, and nowhere is this more apparent than in the visual arts.

We have traditionally seen the history of art as a succession of styles, marching in a tidy linear progression. A more apt image might be a looping line that swoops back into history to pick up a mode of composition, a motif, a treatment, and then rushes back to the present.

This is clearly illustrated with classical style, a specific style in ancient Greece with recognizable attributes. The Greeks' classical ideals were adopted *and adapted* by the Romans. In altering them, the Romans made them distinctly their own; their contributions, notably in the realm of engineering, created a Roman visual identity and demonstrated their primacy. The Roman principles of design were resurrected in the Romanesque style of the medieval period, when the trappings of Imperial Rome were admired.

Several centuries later, classical precepts were refined to a new level in Renaissance architecture and perhaps perverted in the Mannerism that followed. An exaggeratedly decorative interpretation was made during the Baroque period.

In the revivalist nineteenth century, classicism, as it had been defined and repeatedly redefined for two thousand years, reappeared in the neoclassical and Beaux-Arts styles. In the next century, it might be seen as underpinning Modernism, and it was definitely recycled as Postmodernism. With all these loops, *classical* has now also taken on another meaning: timeless.

Even in the twentieth century, with Pound's advice ringing in our ears, the past exerts a strong pull on artists. There are still schools, such as the New York Studio School of Drawing, Painting, and Sculpture, that practice transcription—copying the great masters—which has been the basis of art academy curricula since the eighteenth century. Dean Graham Nickson believes that "a transcription is an adventure, an entry into the unknown in search of knowing. It is a fount of possibilities never before fully realized that will nourish the transcriber when that person returns to his or her own work."[1] Emulating the past, students absorb its lessons, perhaps viscerally as well as intellectually. Then they can move on to create their own distinctive artistic expression.

This practice might be considered the height of conservatism, but it can also be seen as the intellectual basis of a far more radical strain of artmaking: appropriation. Appropriation is a manifestation of conceptual art, whose roots can be found in the Dada movement and the work of its godfather, Marcel Duchamp, who valued concept over object. For him it was the "discovery" that made the work, not the uniqueness of the object, as H. H. Arnason has pointed out.[2]

[1] Essay by Graham Nickson, "Why Transcribe," in *New York Studio School of Drawing, Painting and Sculpture Catalogue* (New York, 1997), p. 35.

[2] H. H. Arnason, *History of Modern Art* (Englewood Cliffs, NJ: Prentice-Hall; New York: Harry N. Abrams, Inc., Publishers, 1968), p. 305.

Simply put (a stance rarely taken by conceptual artists), the idea is paramount and the physical manifestation of it secondary. In the words of Bernice Rose, "At the heart of conceptual art is the ambition to return to the roots of experience, to recreate the primary experience of symbolization uncontaminated by the attitudes attached to traditional visual modes, whether representational or abstract."[3]

One of the tangible manifestations of this attitude is appropriation, which is a kind of critically approved visual plagiarism. The best examples that I can provide are the photographs by Sherrie Levine (born 1947) of Walker Evans's records of farm life during the Depression. Evans had been commissioned by the Farm Security Administration, a federal program, to make the original photographs. Levine obtained copy prints, as can anyone, from the Library of Congress, rephotographed them, and displayed the resulting prints as her artwork. Without a label—a verbal explanation—there was little way of knowing that the prints were Levine's art and not Evans's except that they were a uniform eight-by-ten-inch size rather than the dimensions of the originals. Levine has also made photographs "after" Elliot Porter, Edward Weston, and Alexander Rodchenko, rephotographing their images from books or posters.

Since these photographic works of the 1980s, Levine has gone on to make paintings after Miró, Malevich, Schiele, and others and objects inspired by other artists' works, sometimes even realizing unexecuted works or, at least, extending the artist's

Sherrie Levine (American, born 1947)
After Alexander Rodchenko: #9 Positive, 1987
Gelatin silver print, 8" H x 10" W
Photograph courtesy of Margo Leavin Gallery, Los Angeles, CA

work in logical if not exactly intended ways. We can't be sure that Marcel Duchamp ever considered using the malic molds represented in *The Bride Stripped Bare by Her Bachelors, Even,* his painting on glass (often referred to as *The Large Glass*), to create actual objects to symbolize the "bachelors." The voluminous literature on this piece indicates that

[3] Bernice Rose, "Sol LeWitt and Drawing," in *Sol LeWitt* (New York: Museum of Modern Art, 1978), p. 35.

While I would gladly claim Duchamp's masterwork for the history of glass art, I suspect he did not see himself as a part of that continuum—any more than he saw himself as a ceramic sculptor because of *The Fountain*, his infamous ready-made sculpture of a urinal. But he would surely have been interested in the question of originality and this conjunction of old and new. The conjunction is perhaps most heightened in craft media, where tradition has been the prevailing aesthetic factor. Forms and techniques are passed down from generation to generation, often carefully guarded for economic reasons. For example, the thin-walled, nearly ethereal glassware of the Renaissance Venetians was widely prized; despite restrictions by the state[4] aimed at maintaining a monopoly, some masters managed to transport the secrets to France, the Lowlands, England, and elsewhere to create the *façon de Venise* (the term given to Venetian-style glass made elsewhere). It was not this dissemination that destroyed Venice's glass industry, however, but rather the market's desire for the new. The style pendulum swung to the heavier lead glass of Britain and northern Europe, and Venice's products were no longer popular.

Within the craft traditions, glass is a particularly fruitful area for examining the relationship of old and new, the artistic strategies that might be described as adoptive and adaptive. Glass has a history dating back five thousand years, yet artists have been using it for purely personal aesthetic

Sherrie Levine (American, born 1947)
Untitled (The Bachelors: "Gardien de la paix"), 1989
Glass, 10½" H x 11" W x 4½" D
Photograph courtesy of Margo Leavin Gallery, Los Angeles, CA

the molds were designed to be filled with seminal fluid for the bride. Levine used these silhouettes to make molds and then had them cast in glass. She appropriated Duchamp's image and extended its power by transposing it from two dimensions into three while remaining faithful to the material Duchamp chose: glass.

4 In 1291 the Grand Council of Venice confined all glasshouses to the island of Murano, ostensibly to contain the fires that were caused by the furnaces.

purposes only since the early 1960s (with a few isolated earlier instances).[5]

Today's glass artists[6] are nearly all art-school trained, not products of the apprenticeship system that dates to the beginning of the craft. They know the history of both the fine arts and the decorative arts. They have mastered their material, learning by experimentation as well as by studying with the great European masters who keep alive the traditions of the craft.

This exhibition aims to examine how contemporary artists working within the glassmaking craft traditions are reinterpreting them, carrying on the time-honored practice of adoption and adaptation that has defined art throughout the millennia.

These glass artists have been inspired and influenced by the past. Sometimes they have been challenged by it, as Barry Sautner was when he set out to duplicate and then surpass the achievements of the Roman cage cup makers. Or they have appropriated the old techniques and appearance, as Dale Chihuly has used the Venetian style for his own personal expression.

Tina Oldknow's thoughtful essay establishes the historical context for this century's developments in the glass arts. My own essay examines how the twenty artists in this exhibition reflect the past. They are just a few of the many artists who have been clearly inspired.

Karen S. Chambers
New York, New York
28 September 1998

[5] At the beginning of the twentieth century, the Art Nouveau designer Émile Gallé (1846–1904) worked closely with his artisans to create unique works of art. Later Maurice Marinot (1882–1960) learned how to blow glass to fashion his own vessels, qualifying him for the title of first Studio Glass artist.

[6] The art versus craft debate may continue, but I agree with furniture maker and MacArthur prizewinner Sam Maloof when he says, "People who talk about the difference between art and craft don't have enough to do."

BABYLON, VENICE, DAMASCUS, PRAGUE: TRAVELS THROUGH THE PAST OF GLASS

by Tina Oldknow

The state of transparency is one of the most effective and beautiful conjunctions of opposites: matter exists but it is as if it did not exist because one can see through it.

—J. E. Cirlot, A Dictionary of Symbols, 1962

Throughout history, people have suspected that glass is magic. How else can a material be explained that imitates other materials but cannot itself be imitated? That is five times stronger than steel, yet can be broken by the human voice? That is invoked by heating sand and ash and then bewitched into an infinite variety of forms and textures in an astonishing array of colors? That is hot liquid and frozen solid, transparent and opaque, common and exalted?

Glass is created from silica, alkali, and lime heated to a high temperature. These simple ingredients then metamorphose into a unique complex substance with a disordered molecular structure similar to that of liquids and a mechanical rigidity characteristic of crystalline materials. Scientists used to call hardened glass a supercooled liquid, a never-quite-solid, amorphous mass. In the last fifty years, however, the concept of a supercooled liquid has given way to that of a solid in which typical crystalline structures have not developed. Why? When molten glass cools, its randomly distributed molecules attempt to form an ordered configuration like those of crystals but instead form an alternative structure because the viscosity of glass is much greater than that of ordinary liquids. This resistance to flow hinders cooling molecules from forming into typical crystalline lattices and gives glass its unique characteristics.

Glass is formed in nature when fire and stone intersect. Long, thin tubes of glass called fulgurites are made when lightning strikes sand. Obsidian, a glass formed by erupting volcanoes, has been collected and chipped into cutting blades since the time of the Neanderthals. The Aztecs collected large chunks of greenish-black obsidian to make "smoking mirrors," the polished disks they used for divination. The Western world learned of these obsidian mirrors from publicity about the "Magic Mirror of Dr. Dee," property of Englishman John Dee, who was astrologer to the court of Queen Elizabeth I.

Equally magical and literally otherworldly is the space glass known as tektites, from the Greek *tektos*, meaning "molten." These small, aerodynamically shaped bodies of primeval, nonvolcanic glass are believed to be formed either extraterrestrially or from the impact of meteorites on earthly rocks. Tektites and fulgurites are much rarer than obsidian and are praised for their mysterious origins, but they have surprisingly little in common with glass made by humans, apart from the impressive methods of their creation.

Antiquity

When you set up a kiln to make glass, first search for a favorable month and a propitious day. . . . As soon as you have completely finished building the kiln, go and place Kubu-images there. . . . On the day you plan to place the [glass] in the kiln, make a sheep sacrifice before the Kubu-images, place juniper incense on the censer, pour out a libation of honey and liquid butter, and only then make a fire in the hearth of the kiln and place the [glass] inside.

—Mesopotamian cuneiform text excavated at the Library of Ashurbanipal, Nineveh

The origins of glass made by people are mysterious and obscure. In general, archaeologists agree that glass was first worked sometime between 4000 and 3000 B.C. somewhere in Egypt or Mesopotamia (now Iraq). Many scholars believe that the manufacture of glass was a natural outgrowth of working with Egyptian faience, a bright blue silica paste that could be hand-modeled and cast, and the use of vitreous glazes to decorate stone and ceramics. Mixing colors for glazes led early glassworkers to experiment with color by adding metal oxides to their glass (which is naturally tinted green). Because glass can acquire a wide range of colors—from transparent colorlessness (achieved by adding manganese) to opaque midnight blue (achieved by adding cobalt)—one of the common applications of glass throughout its history has been to imitate gems and semiprecious stones. Some of the earliest known glass takes the form of stone beads decorated with glass sheaths to imitate turquoise, lapis lazuli, and red jasper.

Glass beads have played a significant role in economic and cultural history. They have served as a medium of exchange for barter and as monetary units in market systems. In America alone, they purchased everything from real estate (Manhattan Island) to human lives (African slaves). Beads have been worn to communicate social status, advertise political alliances, and protect from evil. One of the earliest types of glass beads—the "eye" bead—is still used throughout the Mediterranean. Made in Mesopotamia and Egypt from the third millennium B.C. and adopted by many early cultures, "eye" beads are decorated with concentric circles or spirals around a pupil, creating the impression of a staring eye. They are designed to protect the wearer from harmful influences, especially the evil eye. The Egyptians had their own form, an amulet called *udjat*, the eye of the falcon-headed god, Horus. Glass beads, which are usually cast or

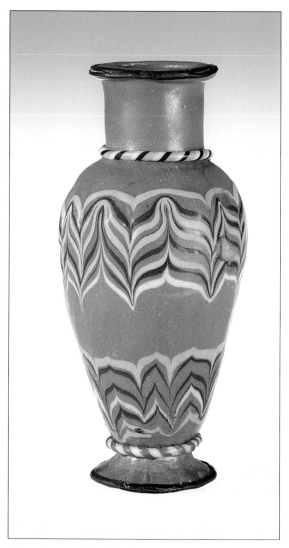

Vase, Egyptian, New Kingdom, about 1400–1300 B.C. Core-formed glass; trail-decorated and tooled, 4¼" H. The Corning Museum of Glass, Corning, NY 66.1.213. © The Corning Museum of Glass. *The bright turquoise glass used to make this small bottle is reminiscent in color of Egyptian blue faience. The "combed" trail decoration is typical of core-formed glass and inspired the American Art Nouveau glass of Louis Comfort Tiffany.*

worked on a rod, were manufactured throughout the ancient Mediterranean world.

Glassworking emerged as a distinct industry in Mesopotamia sometime during the middle of the second millennium B.C. The earliest glass vessels appeared around the same time, in the late 1600s or 1500s B.C. Small, precious, and labor-intensive, these vessels were made of molten glass trailed around a core of clay mixed with sand, dung, or grasses in a process we call core-forming. This technique, which is related to the rod-forming technique of bead-making, appears to have started in northern Syria or Mesopotamia. After 1500 B.C., core-formed vessels appear in increasing numbers and surprisingly colorful hues in both southern Mesopotamia (Babylon) and Egypt. The bright vessels in opaque blues, yellows, and reds may have been preserved as treasured objects for rituals rather than used routinely. Many from Mesopotamia have been found in temples dedicated to Ishtar and in burials, while significantly fewer have been found in the remains of palaces or private houses.

Core-formed vessels were made throughout Mesopotamia, Syria, Egypt, Greece, and Italy until as late as the first century A.D. Casting and cutting, which encompass a variety of glassworking and lapidary techniques, were the other primary production methods for vessels until the invention of glassblowing in the first century B.C. Glass was worked for over three thousand years before being successfully blown, probably because it was usually worked at open hearths and in simple kilns, which did not produce the much higher heat that glassblowing requires. The closed furnace, capable of sustaining higher temperatures, may have been invented by the Romans. Most pre-Roman glassworks did not make their own glass but instead melted chunks of glass ingots imported from the few ancient sources capable of mixing the raw materials.

The earliest physical evidence of blown glass comes from Jerusalem in the beginning of the first century B.C., where glassworking materials and partially inflated glass tubes have been excavated. By the middle of the century, it appears glassworkers had developed a revolutionary new tool—the clay blowpipe—which quickly spread throughout the Roman Empire. The invention of glassblowing initiated a period of unprecedented activity. Overnight, it seems, the labor-intensive crafting of elite luxury vessels expanded into the mass production of inexpensive blown wares that every member of Roman society—and possibly even slaves—could afford to

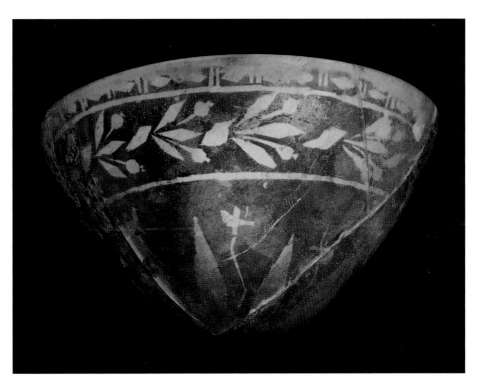

Gold-glass Bowl, Greek, Eastern Mediterranean, late third–second century B.C. Cast, ground, and polished glass and applied gold foil, 3″ H x 6″ Diameter. The Corning Museum of Glass, Corning, NY 71.1.5. © The Corning Museum of Glass. *The casting of nearly colorless bowls enclosing gold-leaf decoration was the ultimate luxury technique invented during the Hellenistic period.*

own. Glass represented an important new technology, and the ceramic domestic wares that had dominated the market for centuries were soon eclipsed.

Thousands of preserved blown-glass flasks, bottles, plates, vials, bowls, cups, and jars testify to the immediate popularity of glassblowing in the Roman world. Easy to clean, dispose of, and replace, versatile, watertight, attractive, and colorful, glass was a highly functional material that literally changed the way people lived. The Julio-Claudian emperors of the first century B.C. and first century A.D. loved glass and brought the best glassmakers to Rome; the Roman emperor Nero (who reigned from A.D. 54 to 68) is said to have been a passionate collector. Sophisticated casting processes, which had been developed during the Hellenistic period (fourth to first centuries B.C.) continued to be used along with blowing and mold-blowing. During the early Imperial period, the Romans created elaborate and vivid mosaic glass (which they called *murrine*) and refined cutting methods, producing remarkable cameo and other relief-cut glass, but the use of these luxury decorations gradually declined in favor of less expensive techniques.

The most important literary source on glassworking in the Roman period is the encyclopedic compendium of ancient knowledge of the natural world, *Natural History*, written by Roman historian Gaius Plinius Secundus, known as Pliny the Elder (A.D. 23–79). While some of the stories in *Natural History* lean more toward legend than fact, Pliny makes some interesting observations about glass—for example, that during the reign of the emperor Tiberius (A.D. 14–37) a "method of blending glass was invented to make it flexible, but the craftsman's workshop was completely destroyed for fear that this might detract from the value of metals such as copper, silver, and gold." This dubious-sounding invention may have been mold-blowing, which became popular and widespread during the first century A.D. The surface modeling and patterning of mold-blown glass could have been confused, by someone who did not understand the process, with the hammered surface of metal objects.

Pliny also notes that, in ancient Rome, the "most highly prized glass is transparent, its appearance as close as possible to that of rock crystal." Like their predecessors, Roman glassmakers were skilled at imitating precious and semiprecious stones. Some of their famed *murrine* and relief-cut bowls verged on the miraculous, changing color in different lights (a characteristic of dichroic

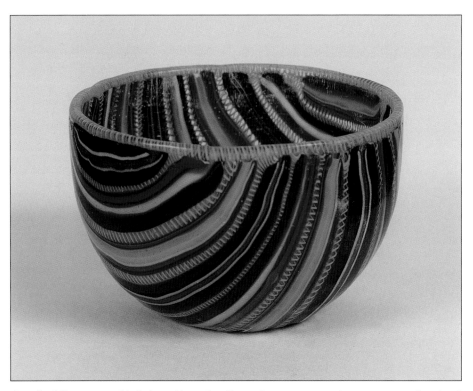

Agate Bowl, Roman, possibly Italy or Alexandria, Egypt, first century B.C.–first century A.D. Fused and slumped glass, 2¼" H x 3¹¹/₁₆" Diameter. The Toledo Museum of Art, Toledo, OH 1968.87. *In a technique invented during the Hellenistic period, the different-colored bands of this small glass bowl were made from lengths of glass cane that were cut, assembled, and fused together in a sheet before being slumped over a hemispherical mold inside a kiln. The rim of the bowl was later finished with a trail of softened glass cane decorated with an internal spiral.*

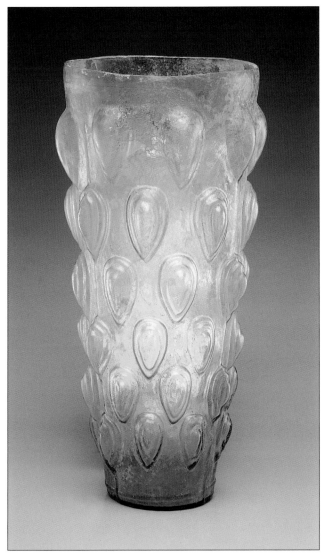

Truncated Conical Beaker with Knot-shaped Knobs, Roman, probably Eastern Mediterranean, about A.D. 50–100. Mold-blown glass, 8″ H. The Toledo Museum of Art, Toledo, OH, Gift of Edward Drummond Libbey 1923.490. *Conceived soon after the invention of glass-blowing, the technique of blowing glass into clay or wood molds for shaping spread quickly throughout the Roman empire. The modeled and patterned surface of mold-blown glass may have been confused at first with the hammered surfaces of metal objects, inspiring the Roman legend of "flexible" or unbreakable glass.*

Egyptian natron (a natural soda) made a stop near Ptolemais, in Phoenicia, where the Belus River empties into the Mediterranean Sea (now the River Naaman in Israel). The sailors built fires on the beach, and having no stones to support their cooking pots, relates Pliny, they "rested them on lumps of soda from their cargo. When these became heated and were completely mingled with the sand on the beach, a strange translucent liquid flowed forth in streams, and this, it is said, was the origin of glass."

The fact that glassmaking was believed to have been invented in Phoenicia is not surprising, since the Syrian region—including Phoenicia and Judaea—had emerged as a leading glassmaking center by Roman times. For many centuries the production of glass depended on the Belus River, Pliny wrote, and Jewish historian Flavius Josephus (A.D. 37–100) noted that its sands were constantly collected for export. Modern studies of Belus River sand do show it to have a high content of lime, an indispensable ingredient for making glass, although that was not recognized at the time.

Ancient glassmakers were highly traditional and secretive about the nature of their craft and enjoyed a social status unavailable to tradespeople in general. In Roman times, Syrian glassmakers were honored with the title *Cives Romani* (Roman citizens). Centuries later, glassmakers in Renaissance Europe were still regarded as "gentlemen" and were the only tradespeople capable of marrying into nobility. Knowledge of glassmaking was traditionally restricted to certain families and communities, who handed down techniques and terminology for centuries. Recent philological research indicates that first- and second-century A.D. Phoenician glassmakers used craft terms similar to those preserved in seventh-century B.C. Mesopotamian texts. Some of the names of the early glassmaking families of Europe may have originated in areas where ancient Aramaic was spoken, that is, ancient Syria, including Phoenicia and Judaea on the eastern Mediterranean coast, and Persia (now Iran).

glass). The ability of glass to imitate stone was perhaps its most remarkable aspect to the ancients, who invented most of the basic glassworking techniques in use today as well as others that only recently have been duplicated successfully, such as the cast and cut *diatreta,* known as "cage cups."

Pliny is best known in glass circles for his largely fictitious account of the discovery of glass. According to *Natural History,* a trading ship carrying

The Middle Ages

*God is the light of the Heavens and the Earth. His light
is as a niche in which is a lamp, the lamp in a glass, the
glass, as it were, a glittering star.*

—The Koran

In spite of the interest in glass and glassmaking in
Rome during the Imperial period, the focus of the
ancient craft was in the eastern Mediterranean,
mainly in Syria and, to a lesser extent, Egypt, par-
ticularly Alexandria. Syrian glassmakers best weath-
ered the centuries of political upheaval in the West.
While western Europe fell prey to marauding tribes
after the fall of Rome in the fifth century A.D., the
eastern Roman Empire, centered at Constantinople
(now Istanbul), flourished under Byzantine Greeks.
Syrian glassmakers came
under the influence of
Sasanian Persians,
Byzantium's rivals to the
east, in the sixth century.
Persia had a long tradition
of casting and cutting
glass, and Sasanian glass-
makers produced distinc-
tive, thick-walled bowls
and bottles with deep
wheel-cut decorations.
These esteemed and ele-
gant vessels were traded as
far away as Japan.

Relatively little
Byzantine glass has sur-
vived, but archaeological
and literary evidence
attests to its manufacture
at Constantinople and on
mainland Greece at
Corinth, where it is said
that the first pane glass,
used in window glazing,
was made. Byzantine

sacred architecture is renowned for its outstanding
glass mosaics, but the culture's glass vessels are
paradoxically rather drab blown or mold-blown
wares, or spectacular deluxe creations, such as the
cast, blown, cut, and enameled objects in the trea-
sury of the Basilica of San Marco in Venice. While
thousands of ancient glass objects are preserved in
tombs, Christian burial customs discouraged inter-
ment of grave gifts with the deceased. As a result,
we lack as complete a picture of the quantity, avail-
able forms, and colors of Byzantine and Western
medieval glass as we have for ancient Greek and
Roman glass.

In the thirteenth and fourteenth centuries in
Syria, under the rule of Muslim Ayyubid and
Mamluk caliphs, medieval glass manufacture

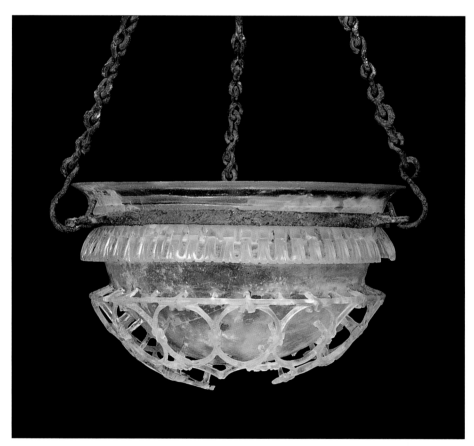

Cage Cup, Roman, about A.D. 300. Glass and copper, 2¾" H x 4¾" Diameter. The Corning
Museum of Glass, Corning, NY, Gift with funds from the Arthur Rubloff Residuary Trust 87.1.1.
© The Corning Museum of Glass. *This bowl with openwork cast and cut "cage" decoration was found with a
bronze chain for hanging. It represents one of the most elusive and sophisticated of the ancient luxury techniques for
glass. Although many attempts (some successful) have been made to reproduce the cage cups during the twentieth cen-
tury, it still is not known precisely how ancient Roman glassmakers or engravers made them.*

reached its pinnacle in the East. In addition to a taste for cut-glass vessels inherited from their Sasanian forebears, Syrian Muslim glassworkers were known for a number of innovative decorative techniques, including luster-painting, first practiced in Egypt around the seventh or eighth centuries, and enameling and gilding on glass, developed sometime between 1170 and 1270 at Raqqa, in Syria. The finest enameled and gilt Islamic glass, however, was produced at Damascus. Although important glassmaking centers of the

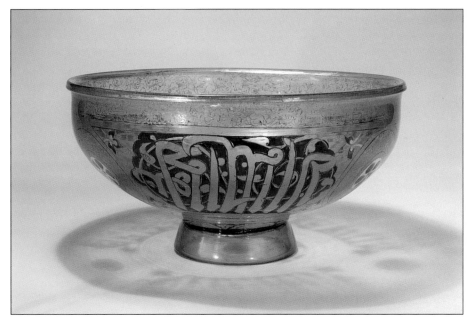

Bowl, Islamic, mid-fourteenth century. Mold-blown and enameled glass, 7″ H. The Toledo Museum of Art, Toledo, OH, Purchased with funds from the Libbey Endowment, Gift of Edward Drummond Libbey 1944.33. *The Arabic inscription on this bowl, enameled in large and decorative calligraphy, records that it was made for the fifth Rasulid sultan of Yemen (south Arabia), al-Mujahid' Ali ibn Da'ud. An elegant vessel such as this, commissioned, perhaps, as part of a set from a Syrian or Egyptian glasshouse, may have been used to pour rosewater over the hands of visitors to the court.*

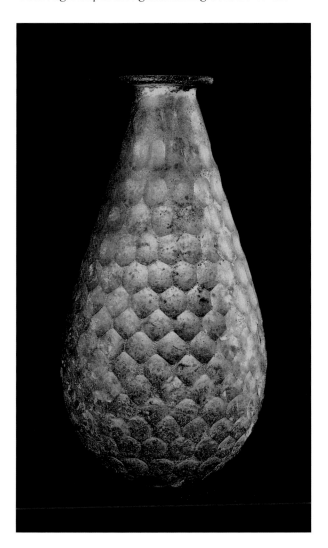

Bottle, Sasanian, Persia, fourth to sixth century. Blown, tooled, cut, ground, and polished glass, 7⅞″ H. The Corning Museum of Glass, Corning, NY 62.1.4. © The Corning Museum of Glass. *The Sasanians sought to revive the ancient Achaemenid Persian empire of Cyrus and Darius and the sophistication of their courts. They reinstated many early Persian traditions, such as the Zoroastrian fire cult and the crafting of thick-walled, cut, ground, and polished luxury glass vessels, like this bottle.*

period included Baghdad (Babylon), in Mesopotamia, and Cairo, in Egypt, the glasswares of Damascus, particularly its elaborately enameled and gilt mosque lamps, were celebrated throughout the Islamic East and the Christian West.

Glassmaking in Europe waned after the fall of the Roman Empire. Distinctive claw beakers (*Rüsselbecher*) and drinking horns made by Frankish glassblowers were traded throughout Northern Europe and Britain by the sixth century; in general,

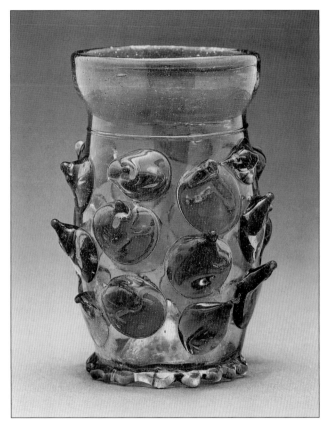

Krautsrunk, German, fifteenth century. Free-blown glass with applied decoration, 4⅝" H. Los Angeles County Museum of Art, Los Angeles, CA, Purchased with funds provided by William Randolph Hearst, Decorative Arts Council Acquisition Fund, Museum Associates General Acquisition Fund, Decorative Arts Curatorial Discretionary Fund, Mrs. Lorna Hammond, the Estate of William A. Dinneen, Mrs. Edwin Greble, Mrs. Walter Barlow, Mr. and Mrs. Allan C. Balch Collection, and Allan Ross Smith 84.2.4. *Named after the wood ash, or potash, used as a primary ingredient, "forest glass" (Waldglas) was popular throughout northern and central Europe into the early sixteenth century. The applied glass knobs, called prunts, helped clumsy or greasy hands grasp the slippery glass.*

glassworks tended to be minimal operations at locales convenient to fuel sources. Like the Byzantine mosaic industry, medieval glassmaking in the West was propelled by the church. It focused on large-scale production of stained-glass windows and smaller-scale manufacture of vessels for use as reliquaries, lamps, or everyday domestic containers. In France and Italy, bottles and drinking glasses have been found walled up in medieval churches, perhaps ceremonially marking the completion of an important stage in building. During Romanesque times (the eleventh and twelfth centuries), drinking glasses, especially chalices or lidded goblets, had added meaning in sacred contexts as symbols of the human heart.

By the fifteenth century, glassmaking in the eastern Mediterranean region was all but extinguished. The sack of Damascus and other Syrian cities by the Turco-Mongol armies of Tamerlane, a central Asian Muslim warlord, ended Islamic glass production in 1400. Soon after, in 1453, Constantinople fell to the Ottoman Turks, signaling the final days of the Byzantine Empire. The vacancy caused by the demise of Islamic and Byzantine glass manufacture was soon filled by the most capable competitor, the rising Italian glass industry centered on the Venetian island of Murano. During the Renaissance and for centuries beyond, Venetian glassblowers became so technically proficient and important to the history of the medium that even today Venice is considered the spiritual center of glassmaking, the historic home of a craft that is nearly six thousand years old.

The Renaissance

[Glass is]. . . a fusible substance, almost turned into a mineral by the art, the power, and the virtue of fire, born from the speculation of the most skilled alchemists, who imitate metals on the one hand and the diaphaneity and resplendence of jewels on the other. [It is] . . . a thing of utmost beauty, not to be left buried in silence.

—Vannoccio Biringuccio, 1540

Physical evidence of glassmaking in the Venetian lagoon dates to the seventh century on the island of Torcello. An important location in the early history of Venice, Torcello is the site of the lagoon's oldest building, a Byzantine cathedral founded in A.D. 639, and Venice's first glasshouse, where remains of glass furnaces, vessel fragments, and numerous mosaic *tesserae* (squares) dating between A.D. 600 and 650 have been excavated. Although ample documentary evidence exists of glassmaking in Venice from the tenth century on, and for the relocation of all the city's glasshouses to the island of Murano in 1291, relatively little Venetian glass made prior to 1450 has survived. Excavated fragments and especially period paintings show the domestic wares popular in Venice during the thirteenth and fourteenth centuries: bottles, window glass, ribbed and plain tumblers, enameled cups and (occasionally) goblets, and imitation gems and beads, always a mainstay of the Venetian glass industry.

It is generally thought that enameling and gilding on glass—the leading Muranese decorative techniques until the sixteenth century—were inherited from Islamic glassworkers. Indeed, Venice maintained close trading contacts with Damascus and was producing glass and textiles for the Islamic market into the fifteenth and sixteenth centuries. But the eastern influences on medieval Venetian glass may have come from Byzantine Constantinople. The Byzantine context of the Torcello glassworks, their proximity in date to the church, and the fact that mosaic *tesserae* were being made there support the idea that it was the traditions of Byzantium, rather than Islam, that early Venetian glassworkers might have adopted.

As glassmaking in the eastern Mediterranean declined during the early fifteenth century, major changes were taking place in Venice. After 1450, Muranese glass production suddenly surged, flooding the northern European and Mediterranean markets with a new glass the Venetians called *cristallo*. A feather-light, malleable, and purely colorless soda-lime glass, the ethereal *cristallo* is said to have been the brainchild of Murano's greatest glassmaker,

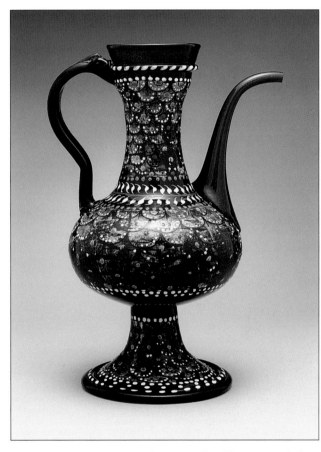

Ewer, Italian, Venice, Murano, about 1500. Free-blown, enameled, and gilt glass, 10" H. Los Angeles County Museum of Art, Los Angeles, CA, Purchased with funds provided by William Randolph Hearst, Decorative Arts Council Acquisition Fund, Museum Associates General Acquisition Fund, Decorative Arts Curatorial Discretionary Fund, Mrs. Lorna Hammond, the Estate of William A. Dinneen, Mrs. Edwin Greble, Mrs. Walter Barlow, Mr. and Mrs. Allan C. Balch Collection, Allan Ross Smith, and Mrs. Wesley Heard 84.2.1. *Sumptuous Renaissance luxury vessels like this ewer are among the earliest known intact glasswares from Venice. Similar ewers made in "chalcedony" glass (calcedonio) have also survived; they imitated costly objects carved of semiprecious stone, just as this version may have imitated lavish gem-encrusted vessels of precious metal. The spout and handle were originally entirely gilt.*

Angelo Barovier (about 1400–1460) and was widely praised for its imitation of rock crystal. Quartz, or rock crystal, was prized at the time for its magical properties. It was often incorporated into religious objects of veneration, and only the very wealthy could afford to have it made into articles for domestic use. *Cristallo* glass proved the perfect middle-class substitute. Period sources lauded its beauty, and it became so popular that trips to glasshouses to observe Muranese glassblowers at work became one of the favorite attractions Venice offered its important visitors.

Drinking Glass from a Collection of Form Glass, Italian, Venice, Murano, about 1550–1650. Free-blown glass, 9" H. Los Angeles County Museum of Art, Los Angeles, CA, Purchased with funds provided by Mr. and Mrs. Eric Scudder, Miss Bella Mabury, Dorothy S. Blankford, Mr. and Mrs. Jerome K. Orbach, and others M.85.150.1. *For the first time in the history of the medium, Venetian glassblowers created forms for* cristallo *glass in addition to those derived from shapes found in metalwork and ceramics.*

Strength, elasticity, and transparency were the most remarkable qualities of *cristallo*. For the first time in history, Muranese glassblowers could create brand new forms not derived from metalwork or ceramics. Embodying the fundamental Renaissance ideals of harmony, proportion, and balance, these dramatic new forms survive today in the silhouette of the common wineglass. Now familiar, even mundane, this new drinking glass made an impact throughout the Renaissance world, increasing the demand for Venetian glass and ensuring prosperity for the glass manufacturers of Murano.

Legendary in his abilities as a glassblower, Angelo Barovier applied even greater genius to the research and development of new glasses, colored as well as colorless. Barovier's experiments led to the creation of other luxury glasses that imitated stones, such as "chalcedony" glass (*calcedonio*), first mentioned in connection with the Baroviers in 1460. The ancient Roman technique of mosaic glass (called *millefiori*, or "thousand flowers," during the Renaissance) was revived in Murano in 1496 by Angelo's son, Marino Barovier. Marino Barovier must have known of ancient examples of *murrine* from the discoveries of classical art that were constantly being made and publicized during the Renaissance.

Perhaps the most brilliant decorative technique inspired by the new *cristallo* was filigree glass, or *vetro a filigrana*, a colorless glass incorporating stripes and twists of white or colored glass cane. The first record of filigree glass is a petition in 1527 by the brothers Filippo and Bernardo Catani of the glasshouse *alla Sirena*, for a twenty-five-year exclusive on their invention. They were granted the production rights for ten years only,

and by 1540 their new technique was being worked all over Murano. By 1600, *vetro a filigrana* was being exported in impressive numbers from Venice and copied in glasshouses all over Europe. It was even sent to the new British colonies in America, as excavations from seventeenth-century Jamestown, Virginia, have proved. Other new decorative techniques of the period included goblets with stems sculpted at the furnace into a variety of shapes, and

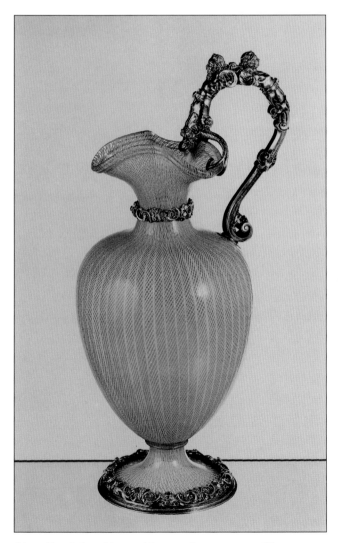

Filigree Vase, Italian, Venice, Murano, about 1608–36. Glass vase mounted as a ewer with silver-gilt mounts, 11^{11}/$_{16}$″ H. The Toledo Museum of Art, Toledo, OH, Gift of Edward Drummond Libbey 1960.36. *Created both in Venice and in* façon de Venise *workshops in the Netherlands, filigree glass (*vetro a filigrana*) showpieces such as this ewer may have been as treasured as their counterparts in gold or silver. The ewer, one of a pair, was furnished with its silver-gilt mounts by Heinrich Straub of Nuremberg (active 1608–36); its mate in the Los Angeles County Museum of Art exhibits a different filigree pattern.*

an unusual glass with a crackled surface called iceglass, made by dipping the molten vessel into cold water during the blowing process.

The explosion of new glasses and techniques in Venice from about 1450 to 1550 caused the republic's leaders to impose controls on all glassworkers and monitor sales of raw materials. The manufacture of *cristallo*, in particular, was restricted to Murano, and the secrecy imposed on Muranese glassworkers by the Venetian government is legendary. In spite of dire threats by Venetian officials, however, a constant outflow of glassmakers from Venice to elsewhere in Italy and Europe brought *façon de Venise* (Venetian-style) wares to the glasshouses of Austria, Germany, England, France, the Netherlands, and Spain. Foreign governments often protected the expatriate Venetian glassmakers. One of the most famous, the Muranese glassblower Giacomo Verzelini, established a Venetian-style glassworks in London after being granted a royal patent to manufacture *cristallo* in 1575.

The secrecy and strict hierarchy of the glasshouse owe more, perhaps, to the craft's roots in medieval guilds than to the Venetian government's protectionist policies; during the Middle Ages, glass and other trades, such as stonemasonry, had a strong esoteric side. Sumptuous vessels carved from rock crystal or colored and veined hardstones, such as chalcedony, agate, jasper, garnet, and amethyst, were widely collected by the Renaissance courts of Europe. The Venetian glassmakers who developed luxury glasses that imitated these stones were keeping up with fashions and changing tastes. But the transmutation of sand and ash (through breath and fire) into facsimiles of crystals, rubies, emeralds, and sapphires also had an arcane aspect, bringing glassworking into the mystical realm of alchemy.

From medieval times, the transformational nature of glass was recognized as alchemical, and important Renaissance glassmakers apparently noted this aspect of their craft. Angelo Barovier attended lectures by the well-known philosopher and alchemist Paolo da Pergola at the School of

Rialto in Venice. In the mid-sixteenth-century writings of the Italian naturalist Ferrante Imperato, the making of the philosopher's stone—the secret and sacred property by which alchemists turned base metals into gold—is discussed along with recipes to make colorless glass. Antonio Neri, the first glassmaker to publish formulas for colored and other experimental glasses in his 1612 handbook, *L'Arte Vetraria* (The Art of Glass), may also have been drawn to alchemical studies. (Neri's colleagues apparently encouraged him to read the controversial works of the German physician and alchemist, Paracelsus.) From an alchemical point of view, the engineer of the activity of glassmaking, namely, the master glassblower who was traditionally in charge of the batch, is the magus, the holder of the secrets of an arcane art. This attribute is acknowledged even today in the craft's most accomplished masters.

The Seventeenth and Eighteenth Centuries

The glasshouse master is to keep a watchful eye on the furnace and . . . take care that [no materials are] . . . missing as great trouble can ensue; he shall see to it that hard-working journeymen are retained, and he shall keep them in order; he also sees that nobody sells or takes home his work of the week, but makes sure that everyone gives what he has done to the glasshouse clerk.

—Instructions to a glassworks manager in
Potsdam, Germany, 1674

By the seventeenth century, glass was being produced on a grand scale throughout Europe and Great Britain, although Venice remained a dominant market force. European glass was exported as far east as Japan, where the remarkable objects were depicted in Momoyama-period painting (1578–1615). Glass was even made in America, at the British settlement of Jamestown, Virginia. Founded in 1608, the first North American glasshouse was built in the forest outside Jamestown by Polish and German glassmakers

who had been specifically recruited; it produced simple glass bottles, windowpanes, and beads, supplemented by imports of British and Venetian-style wares.

Northern and central European countries with long glassmaking histories made traditional wares in addition to fashionable *façon de Venise* glasses. Distinctive German and Dutch green glass *Roemers* (drinking glasses) reflected the past of glassmaking north of the Alps, preserving the bumpy prunts and green tint of the simple and often primitive potash

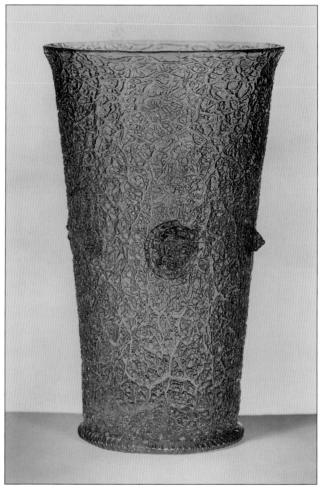

Beaker, Belgian, South Netherlands, about 1550–1600. Crackle glass with applied molded motifs, 8⅜" H. The Toledo Museum of Art, Toledo, OH, Gift of Edward Drummond Libbey 1913.423. *Façon de Venise glasshouses in the Netherlands produced their own versions of favorite Venetian decorative techniques such as filigree glass, so-called "serpent-stem" goblets, and crackle glass or "ice-glass." The rough surface and opacity of this type of glass, named for its resemblance to cracked and fractured ice, contradicts the refined material it is made of—the famed Venetian cristallo.*

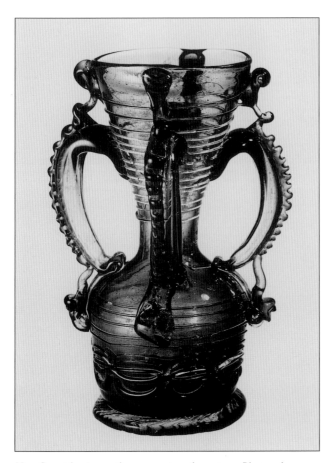

Vase, Spanish, sixteenth or seventeenth century. Blown glass with applied decoration, 5⅞" H. The Corning Museum of Glass, Corning, NY 51.3.279. © The Corning Museum of Glass. *In contrast to the colorless Venetian-style wares produced by* façon de Venise *glasshouses in north and central Spain, the natural green glasses of Andalusia reflect their eastern Mediterranean Islamic and ancient Roman heritage. This type of Spanish glass, and its Roman prototypes, may have inspired twentieth-century designs by Napoleone Martinuzzi in Venice, and later, Dale Chihuly in the United States.*

glasses (*Waldgläser*) from the medieval forest glasshouses of Germany and Bohemia (now the Czech Republic). The techniques of enameling and gilding on glass, which had been taken north by Venetians, remained popular in Germany and Bohemia long after they had passed out of fashion in Venice. Characteristic shapes, such as the lidded *Humpen, Passglas,* and chunky goblets, were enameled with stock images from period engravings or original portraits, which are often fascinating for their depictions of the details of middle-class life.

Unlike Venetian luxury glasses, which were usually reserved for special use or elevated to a nonfunctional role, German and Bohemian enameled glasses were commonly used in the many social rituals that involved drinking. *Willkommen* (welcome glasses) were the beer-filled *Humpen* offered in greeting to guests, while *Passgläser* were customarily passed from one person to the next in communal toasting games. Enameled *Humpen*, like enameled stained-glass windows, were often specially commissioned by guilds or individuals celebrating important dates and anniversaries. An extended family or group might own several of these glasses or windows, which would be prominently displayed in the home or guild house.

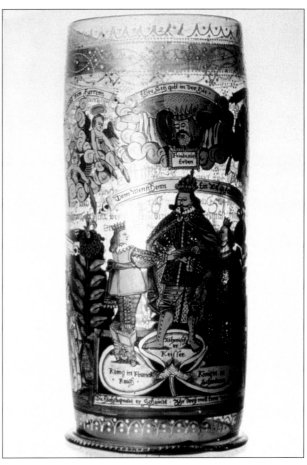

Humpen, German, Franconia, 1651. Enameled glass, 10½" H. The Toledo Museum of Art, Toledo, OH, Gift of Edward Drummond Libbey 1950.29. *Copied after a popular engraving of the period, the image on this* Humpen *(beer glass) celebrates the historic Treaty of Westphalia (1648) that ended the Thirty Years War. This is one of a group of similarly enameled* Humpen *made between 1649 and 1655, most of which are dated 1650 or 1651. The glasses are all inscribed, as is this one, with a long prayer for peace.*

25

The most important development for European glassmakers in the seventeenth century was the formulation of a new colorless glass with a high lead content, first produced in the 1670s by the English glassmaker George Ravenscroft (1618–1681). Ravenscroft was one of a group of glassmakers in Europe, and especially Bohemia, who worked to develop new glasses in the wake of the 1662 English publication of Antonio Neri's *L'Arte Vetraria* and its translation into German in 1679. The brilliant clarity and rock-crystal-like weight and refractivity of the new potash-lime lead glass differentiated it from the Venetian-style soda-lime *cristallo*. While thin, hard *cristallo* could be engraved only with a diamond point, lead "crystal," as it was known, was thicker, softer, and thus perfectly suited for engraving in relief or cameo (called *hochschnitt*) and intaglio (called *tiefschnitt*).

Although cutting and engraving had been practiced with great skill by Roman, Byzantine, and Islamic glassmakers, the Venetians were not as interested in it as in the complex internal decorations they had devised for *cristallo*. Engraving on glass was revived not in Venice but in the Bohemian capital of Prague, where the cutting of semiprecious hardstones was a local specialty that attracted gem cutters from all over Europe. Master engraver Caspar Lehmann (1563–1622), who was brought to Prague by Hapsburg Emperor Rudolf II (who reigned from 1576 to 1612), is credited as the first post-Renaissance craftsman to use gem-cutting wheels on glass. Elaborately engraved colorless glasses quickly became the rage throughout northern and central Europe, especially large, lidded goblets (*Pokal*), whose capacious surfaces showcased the engraver's art. Like the enamelers before them, Bohemian and German engravers used both stock and original images for their decorations.

The new popularity of engraved crystal glass brought about a critical slump in the Venetian glass industry by the beginning of the eighteenth century. People were no longer as taken with the results of manipulating hot glass, a Venetian spe-

Dresden Schiesshaus Beaker, German, Saxony, 1678. Free-blown, enameled, and gilt glass, 12" H. Los Angeles County Museum of Art, Los Angeles, CA, William Randolph Hearst Collection 48.24.137. This enameled and gilt beaker with cover, typically German in form and subject, is nevertheless painted in imitation of Venetian vetro a filigrana, *the most fashionable glass of the day. The opening ceremonies of the Schiesshaus (ducal rifle range) in Dresden featured crossbow and riflery contests and a procession in which guests carried wine in this cup and others like it. The nineteenth-century metal mount is a repair.*

cialty, as with cold-working processes such as engraving. Guiseppe Briati (1686–1722) was the first Muranese glassmaker to experiment with producing a potash glass *ad uso di Bohemia* (in the

Bohemian manner), and he opened a workshop on Murano in 1739 to compete with Bohemian, German, and English products. But the hold Venice had enjoyed over the lucrative European markets would never be wholly regained. By the early nineteenth century, glassmaking had become a diverse and wide-ranging industry on the brink of mechanization, with domestic products being manufactured by nearly every country in the world.

The Nineteenth and Turn of the Twentieth Centuries

My own work consists above all in the execution of personal dreams, to dress crystal in tender and terrible roles, to compose for it the thoughtful faces of pleasure or tragedy. . . . I have sought to make crystal yield forth. . . all the expression it can summon when guided by a hand that delights in it.

—Émile Gallé, 1889

The preference for cut and engraved glasses in Europe and the United States persisted well into the nineteenth century. Bohemian glassmakers reintroduced color, decorating glass by casing (covering one layer with another of a different color), cutting, engraving, enameling, and gilding, often all on the same piece. Americans, following the lead of the English and Irish, preferred colorless, fancy-cut glass.

Looking to create affordable alternatives to the labor-intensive cut glass that was so expensive to produce, American glassmakers in the 1820s patented a process called pressed glass in which hot glass was machine-pressed into metal molds. Not only did the new product imitate cut glass but it was also simple to make and did not require the extensive knowledge that European glassworkers were so unwilling to share. With the increasing mechanization of glassmaking procedures, American factories no longer had to compete for the best foreign craftspeople. Not surprisingly, pressed glass did not catch on in Europe, where

Goblet with Cover, German, early eighteenth century. Glass with copper wheel-engraved decoration of *putti* in Bacchic procession, 14¼" H. The Toledo Museum of Art, Toledo, OH, Gift of Edward Drummond Libbey 1953.107. *While the shape of this goblet belies its English origin, it is stylistically evident that the glass was engraved in Germany, even though it is unsigned. By the eighteenth century, glass blanks were commonly exported from England and elsewhere to Germany and Bohemia for engraving. The* hochschnitt *engraving of a procession celebrating Bacchus, the ancient Roman god of wine, is typical of the period and is particularly appropriate for a wine glass such as this.*

Biedermeier-style Tumbler, Bohemian, about 1840. Glass and gilt, 5¹⁵/₁₆″ H. Chrysler Museum of Art, Norfolk, VA, Gift of Dr. Eugen Grabscheid 58.37.34. © Chrysler Museum of Art, Norfolk, VA. *The elaborate decoration of this tumbler illustrates the renewed interest in color among mid-nineteenth-century Bohemian glassmakers. This style of decoration, with its multiple cased or flashed colors revealed through facet-cutting and embellished with gilding and enameled scenes or portraits, enjoyed wide popularity in Europe and the United States.*

from classical antiquity and the Renaissance. In Germany and especially Bohemia, older styles also found new favor, particularly medieval *Waldgläser* (forest glasses) and seventeenth-century enameled wares. The taste for historicizing glass (called *historismus*) resulted in the reintroduction of a number of techniques thought to have been lost, and the most skillful nineteenth-century imitations were (and still are) often mistaken for originals. While it was never the intention of glassmakers to deceive the public, there were complaints even during the nineteenth century that ancient-style copies were being passed off as genuine antiquities by unscrupulous dealers.

The renewed interest in colored glasses and the variety of techniques rediscovered during the nineteenth century gave turn-of-the-century glassmakers the tools to rebel, to reinvent glass for the next century. Deploring the social and artistic effects of increasing industrialization, which threatened to extinguish the applied arts in particular, British philosopher and art historian John Ruskin (1819–1900) promoted a return to handmade objects and medieval-style craft guilds. Ruskin made lengthy visits to Venice during the 1840s and 1850s and was enchanted by the city, its architecture, and its glass. For Ruskin and his followers—the proponents of the Arts and Crafts movement of the 1880s in Britain—traditional Venetian glass seemed truer to the nature of glass than the "barbarous," ponderous, and heavily worked cut glass that had become the norm. William Morris (1834–1896), who translated many of Ruskin's ideas into design, advocated the simple, unadorned blown shapes of ancient Roman and Renaissance Venetian glasses as the embodiment of the Arts and Crafts style in glass.

In addition to Arts and Crafts philosophies, late nineteenth-century pre-Raphaelite and Symbolist aesthetics exerted a profound influence on the turn-of-the-century Art Nouveau (new art) movement in Europe and the United States. In glass, the Art Nouveau emphasis on organic forms, nature, and

trained glassworkers were widely available and craft traditions strong. English and Irish glassmakers, however, were more open to the process, which they practiced by hand rather than by machine.

After 1860, an interest in older glassmaking techniques and styles took root in Venice as well as Germany and Bohemia. Venetian glasshouses such as Salviati and the Compagnia Venezia e Murano attempted to revive historical styles in glass, primarily

Émile Gallé (French, 1846-1904), *Vase*, about 1890–95. Blown, cased, cut, and acid-etched glass, 6⅛" H. Los Angeles County Museum of Art, Los Angeles, CA, Gift of Hans Cohn M.82.124.55. *Quotations taken from Symbolist writings were often used by Gallé for his well-known "speaking" glasses (verres parlantes), the moods or "impressions" of which were inspired by their inscriptions. The decoration of this vase evokes the poetic phrase, by Maurice Maeterlinck, that is inscribed on the foot: "sous l'eau du songe"—under the "influence" (literally "water") of a dream or recollection. The vase's shining lotus rises out of the dark mud in which it grows, like dreams from the subconscious emerging into the light of conscious thought.*

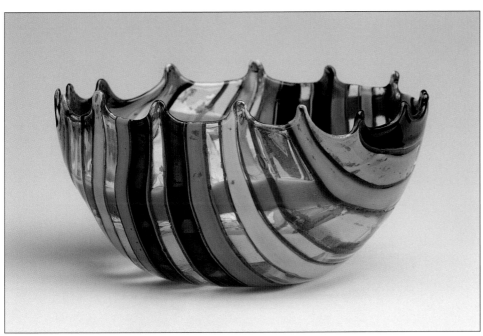

Bowl, Italian, Venice, Murano, about 1875. Fused and slumped glass, 3⅜" H x 6½" Diameter. The Metropolitan Museum of Art, New York, NY, Gift of James Jackson Jarves 1881 (81.8.228). © 1998 The Metropolitan Museum of Art. *Loosely based on ancient Roman prototypes, this blown and tooled mosaic glass bowl reflects the nineteenth-century revival of classical styles in Murano. The look and feel of the bowl is atypical of the period. It is more stylistically akin to the Roman-inspired, experimental glasses produced in Murano from the 1920s to the 1940s rather than the cast reproductions of ancient mosaic glass typically made from the 1860s to 1880s.*

the irrational were defined by Émile Gallé (1846–1904) in Nancy, France, and Louis Comfort Tiffany (1848–1933) in New York. Both men were visionary artists, designers, and factory owners who combined a deep appreciation for the craft of glass-making with recognition of the artistic potential of the material. Drawing on all of the technical resources of glassmaking in the nineteenth century, Gallé and Tiffany initiated fresh approaches to color, form, and decoration for glass.

Art Nouveau laid the foundation for a new century of art glass that celebrated the future while honoring the past. Tiffany's creations—which had a major impact on American Studio Glass in the 1960s and 1970s—paid homage to the ephemeral and iridescent hues of ancient Roman and medieval glass and the opulence of Byzantine and Islamic decorative techniques. The innovative sculptural vessels designed by Émile Gallé, depicting the infinite richness, variety, and magic of the natural world, exploited every decorative technique imaginable, including casing, cutting, inlay, acid-etching, enameling, and cameo- and intaglio-engraving. The love of technique and the open, unorthodox approach to glass as a medium of artistic expression that were embraced by Art Nouveau glassmakers have influenced and inspired all designers and artists working with glass in the twentieth century.

Tina Oldknow is an art historian specializing in historic and contemporary glass. An expert in the field of ancient Greek and Roman art, she began her glass studies with the vessels of classical antiquity. While working as a curator at the Los Angeles County Museum of Art in the 1980s, Oldknow was introduced to contemporary Studio Glass, and her interest in that movement grew after she moved to the Pacific Northwest. Oldknow has served as staff or consultant to several museums, including the J. Paul Getty Museum; the Los Angeles County Museum of Art; the Santa Barbara Museum of Art; the Henry Art Gallery of the University of Washington, Seattle; the Seattle Art Museum; and the Tacoma Art Museum. She is the editor of the *Glass Art Society Journal* and the author of *Pilchuck: A Glass School* (1996), *Chihuly Persians* (1996), and *Richard Marquis Objects* (1997).

CLEARLY INSPIRED:
CONTEMPORARY GLASS AND ITS ORIGINS

by Karen S. Chambers

Glass is a curious material. It is manufactured but it also occurs naturally. The heat of the earth creates igneous rocks such as obsidian, and a lightning strike can fuse the sand on a beach into glassy veins.

Glass is, forgive the pun, a multifaceted material, assuming many forms, presenting many appearances. Unlike any other medium, it can be manipulated by a myriad of techniques. It can be blown into shimmering and ethereal containers or cast into heavy crystalline forms. It can be rough and rugged or polished to pristine perfection. It can appear soft and seductive or jagged and dangerous. It is paradoxical.

We are living in the age of glass, argues sculptor Christopher Ries, not the information age—for fiber optics carry volumes of data. Instead of stone or bronze or iron, lasers are today's tools for cutting.

Human beings have used glass for five thousand years. In what we call "the cradle of civilization," the Mesopotamian region between the Tigris and Euphrates Rivers in present-day Iraq and northern Syria, beads and small cast objects were made in the middle of the third millennium B.C.

Since then people have fashioned glass into vessels to hold everything from the most mundane to the most precious, from water to perfumed oils. Artisans have cast and blown it into forms that not only served but also delighted. And more recently fine artists have turned their hands and minds to this traditionally utilitarian and decorative material, creating works that continue the millennia-long fascination with glass. Inspired and influenced by history, they adopt, adapt, and invent to create expressions distinctly their own.

None of this would have been possible without the efforts of two remarkable men: Harvey Littleton (born 1922) and Dominick Labino (1910–1987). Their knowledge of and passion for glass laid the foundation for what is often called the Studio Glass movement.[1]

Although it lacks a manifesto or coherent aesthetic agenda, the Studio Glass movement *can* be said to have a definite birth date: 23 March 1962, the beginning of a ten-day workshop organized by Littleton at the Toledo Museum of Art.[2] Seven students, all ceramists, and a handful of others experimented with glassblowing and demonstrated that glass could be worked in the small, unsophisticated studio settings available to artists.

[1] Although Tom Buechner, former president of Steuben Glass and director of the Corning Museum of Glass, has pointed out that "movement" is a misnomer, because there is no manifesto, no specific aesthetic, no organization per se, the term continues to be used. The Studio Glass movement (like the Studio Craft movement) recognizes glass as a craft material (along with clay, fiber, metal, and wood) and encompasses small workshops—studios established by artists and artisans skilled in handmade production (limited or open) of functional objects or unique artworks. See Marcia Manhart and Tom Manhart, eds., *The Eloquent Object: The Evolution of American Art in Craft Media since 1945* (Tulsa: Philbrook Museum of Art, 1987).

[2] There are instances of "art glass" made prior to 1962, notably by the Art Nouveau artists and designers Émile Gallé (1846–1904), Louis Comfort Tiffany (1848–1933), and others. Maurice Marinot (1882–1960), a Fauvist painter, learned to blow glass and executed his own works, a defining characteristic of the Studio Glass movement in its earliest years. For a fuller discussion of these and other precursors, see Susanne K. Frantz, *Contemporary Glass: A World Survey from the Corning Museum of Glass* (New York: Harry N. Abrams, Inc., Publishers, 1989), pp. 11–43.

What led to this experiment?[3] Littleton came from a glass family. His father, Jesse, was a physicist and the first person with a Ph.D. to be hired by Corning Glass Works to head its research department. Growing up in the company town in upstate New York, young Littleton saw his mother use Pyrex cookware when it was being developed for the market. At the dinner table his father would study the cracks that occurred when Jello was pulled apart, comparing them to the breakage lines in glass. As a high school student, Littleton took art classes at the Corning Free Academy in a studio designed by Frederick Carder (1863–1963), the glassmaker who shaped Steuben Glass at the beginning of the twentieth century.

At his father's insistence, Littleton studied physics at the University of Michigan in the late 1930s, despite his own desire to pursue art. He took a semester off to study at the Cranbrook Academy in 1941 but returned to Michigan to pursue a degree in industrial design, which combined his artistic interests with a practical career path. The following summer, working in Corning's Vycor Multiform project laboratory, Littleton created his first work in glass: he cast a neoclassical torso in the Multiform material, which is similar to *pâte de verre* (for definitions of this and other unfamiliar terms, see the glossary).

His education interrupted by World War II, Littleton returned to Michigan to complete his degree in industrial design in 1947. He then proposed to Corning that he establish a design department in the factory where designers could work directly with glass rather than merely draw designs to be executed by the master craftsmen, as was the practice. He believed that "there ought to be an ongoing aesthetic experimentation in material at the Corning Glass Works apart from production."[4]

When the proposal was rejected, Littleton resigned himself to not being able to work with the material that so fascinated him. At the time he shared the general belief that "glass was an industrial material and had to be made in a factory with a team of workers rather than in a studio working alone."[5]

Throughout the 1950s, however, he continued to seek ways to fulfill his dream of working with glass. After receiving an M.F.A. in ceramics from Cranbrook in 1951, he taught at the University of Wisconsin. A 1957 grant from the school enabled him to go to Spain to study the Moorish influence on Spanish pottery. After several months in Spain, Littleton visited Murano, the island in Venice, Italy, that had been a glassmaking center for centuries.[6] He became friendly with some of the artisans, who one day allowed him to try working at the small furnaces. "I worked for just one hour, and two men came from the front office. Each on an elbow escorted me out. Literally I didn't touch the ground," he recalled. [7]

This experience convinced him that his dream was possible. He sought funding, sometimes saying that all he needed was a garage to prove that glass could be worked in a simple setting. Otto Wittmann, the director of the Toledo Museum of Art, where Littleton had taught ceramics during his graduate school days, gave him that garage in 1962 for two landmark workshops. Wittmann recalls that "the products [from the first workshop] were pitifully few and inept, but the spark had been kindled."[8]

That fire would never have been lit without Dominick Labino's contribution: a glass that he had developed for the Johns-Manville Fiber Glass Corporation, where he was vice-president and director of research. His #475 marbles required less

[3] One of the best recitals of the events that led to Littleton's workshop can be found in Frantz, *Contemporary Glass*, pp. 45–63.

[4] Joan Falconer Byrd, *Harvey K. Littleton: A Retrospective Exhibition* (Atlanta: High Museum of Art, 1984), p. 7.

[5] Ibid.

[6] Glassware was made in Venice as early as the middle of the fifth century.

[7] Interview with the author, 17 July 1987.

[8] Interview with the author, 26 February 1995.

heat and much less sophisticated equipment to reach the molten state. No longer would glass-working demand sophisticated factories; now artists could set up simply equipped studios. For the first time in history, glass could serve artists, not just the functional or decorative needs of the marketplace.

One of the great accomplishments of the Studio Glass movement was to open communication among glassworkers. American Studio Glass artists experimented to discover the secrets of the material, generously sharing their knowledge with their fellow pioneers. They went to the great glass centers of Europe and studied in the more enlightened factories. European glass artists, who were trained as designers, not glassworkers, frequently comment that Americans brought an infectious enthusiasm and took away technical knowledge that had been passed from generation to generation within a closed circle.

The Venetians were among the world leaders in the glass arts, inspiring later artists, who often had to reinvent the techniques to replicate Venetian accomplishments. With a scholar's intensity and an artist's zeal, William Gudenrath (born 1950) has aspired to duplicate the delicate Venetian glass of its golden age (from the late fifteenth to the early eighteenth century). These exquisite objects had entranced him as a child growing up in Texas. There he mastered scientific glassblowing. Like Littleton, Gudenrath also visited Murano, but, although masters Carlo "Caromea" Toso and Lino Tagliapietra allowed him to watch briefly, he was never invited to the furnace.

Glassblowing is often described as a dance, with each move carefully choreographed. It is also like a musical composition performed note for note multiple times; master performers may have their own interpretations, but the score remains the same. In glassmaking, similarly, production ware must be largely the same each time. A jazz musician's improvisation parallels the work done by Studio Glass artists, who conceive and execute their own "free" work, as it is called in Europe.

A Juilliard-trained harpsichordist and organist, Gudenrath sought to repeat the great performances of the Venetian *maestri*. By studying examples at the Corning Museum of Glass, the British Museum, and the Victoria and Albert Museum, Gudenrath learned the "score"—each telltale mark of a glassblower's tool representing a note or phrase. He has recreated those performances, but as a contemporary artist with his own interpretations. Although he is capable of replicating nearly perfectly a dragon-stemmed goblet in the British Museum (see illustration p. 65), he gives it a playful interpolation by adding a sophisticated—clearly modern—color scheme. Sometimes he takes a single element and elaborates on it; he gives the knots from the dragon stem a new life as heavily gold-leafed serpentine forms above the foot of a large standing bowl.

Like Gudenrath, Dante Marioni (born 1964) was inspired by the achievements of Venice and mastered the techniques by replicating Venetian examples. "When I first began to blow glass as a teenager, I became enamored with the notion of making Venetian wineglasses for two reasons. First, in my opinion, it was the most complete path to becoming a proficient glassblower. Second, the Venetians, even at the expense of function, always seemed most concerned with form."[9]

As Marioni perfected his skills, he began to use them for his own aesthetic purposes. His forms are classic, but the scale is greatly enlarged. This may be one of the hallmarks of the Studio Glass movement. For years the cry has been "big is better." As the artists' technical skills improved, big became attainable. But enlarging the size also changes the viewer's perception of the work, as anyone who has confronted a Claes Oldenburg sculpture can attest: at forty-five feet high, his Cor-Ten and stainless steel *Clothespin* in Centre Square Plaza, Philadelphia, becomes a triumphal arch instead of a utilitarian

9 Artist's statement in *Holding the Past: Historicism in Northwest Glass Sculpture*, 1 July 1995–11 February 1996 (Seattle: Seattle Art Museum, 1995), n.p.

household object. In *Goose Beak Trio* (see illustration p. 68), Marioni increases the size of forms inspired by the past, exaggerates the elements as a Mannerist would, and colors them in vibrant opaque hues. Even as he pays homage to the history of decorative arts, he is clearly concerned with contemporary art issues.

Dale Chihuly (born 1941), who has been most effective in bringing art made of glass to a broader audience, is another artist who aimed to master the Venetian style and then pushed the Venetians' formal concerns to new heights. Chihuly encountered the style firsthand in 1968 as a Fulbright-Hayes Fellow studying in Italy. Letters to approximately a hundred Italian glass factories netted one invitation, from the Venini company, and he became the first American glassblower allowed to work on the island of Murano.

Although Chihuly has frequently said that the most important lesson he learned in Italy was the value of teamwork, two of Chihuly's most important series owe a debt to Venetian glass: "Seaforms," begun in 1980, and "Venetians," which started in 1988 (all of Chihuly's series are ongoing). (See illustrations pp. 56–57.) "Seaforms" develops the tradition known as *façon de Venise.* In it Chihuly pushes to an extreme the delicacy that characterizes this work, with sensuous forms, pale colors, and surface patternings reminiscent of Venetian decorative techniques.

The surface decoration that characterizes the "Seaforms" is achieved by trailing, an ancient technique, which the artist calls a "body wrap." A bit of colored glass is heated nearly to the melting point, then touched to the bubble on the blowpipe as it is rotated, laying a spiraling thread on the surface. Visually this effect alludes to the *filigrana* technique, in which rods of glass with imbedded threads of color are laid out on a hot plate, and the paraison or bubble is rolled over them. When they are reheated, the rods fuse into the surface, giving the piece a lacy look.

What distinguishes Chihuly's "Seaforms" series from most traditional glasswork is its asymmetry. Although examples of asymmetry can be found in the history of glass, blowing lends itself to symmetry. Throughout the process, the bubble must be kept on center in order to control it. The blowpipe is constantly rotated to maintain that symmetry, although in the final moments the fluid glass can be allowed to respond to the heat of the furnace, centrifugal force, and spontaneity. Chihuly calls these his major tools and exploits them in the "Seaforms" series.

The eccentricity of asymmetry has intrigued glassblowers throughout history, even if it remains the exception, not the rule. A fourth-century Roman bowl in the collection of the Metropolitan Museum of Art might fit easily into a Chihuly "set"—

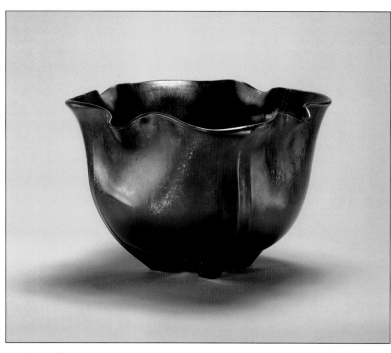

Frederick Carder (American, 1863–1963) for the Steuben Glass Works, Corning, NY

Blue Aurene Grotesque Bowl, about 1928–31

Glass, 5⅛" H x 4⅞" Diameter

Rockwell Museum, Corning, NY 76.478 F

his combinations of individual pieces to constitute a single work. Frederick Carder's "Grotesque" vases and bowls of the late 1920s and 1930s, produced by Steuben, have some of the same free quality seen in Chihuly's wavering forms. And the undulating rim of a Chihuly vessel in which the glass has been pulled out during the final forming shows an affinity with the Venini handkerchief bowls of the late 1940s and 1950s, designed by Fulvio Bianconi (1915–1996) and Paolo Venini (1895–1959). (See illustration p. 118.)

Although the "Seaforms" series clearly continues exploration of the *façon de Venise*, Chihuly's "Venetians" series is a more direct homage to the artist's favorite city and the technical skills of its masters.

In 1987 when Chihuly married Sylvia Peto, the Muranese *maestro* Lino Tagliapietra, who had been teaching at the Pilchuck Glass School north of Seattle, came to Chihuly's Lake Union studio in Seattle to blow a set of dinnerware as a wedding present. Days of blowing with Chihuly's talented team were festive and convivial, as Lino's wife, Lina, cooked the lunches. Tagliapietra suggested that they do a session the following year. Chihuly, who has called Tagliapietra the greatest living glassblower, was apprehensive. Although he had "turned over the stick" to other gaffers a number of years earlier and no longer headed the team himself, he had never worked with a European master. His American gaffers were all art-school trained and open to experimentation. Factory-trained masters, such as Tagliapietra, might possess extraordinary skills but were not necessarily experimental. Still, Chihuly's respect for Tagliapietra made it an offer he couldn't refuse.

What would they make? This question was solved when Chihuly saw a private collection of Art Deco Venetian glasswork in a palazzo in Venice. The works had been inspired by Etruscan ceramics and Roman glass. A passionate collector (of books, carnival whiteware, Northwest Indian baskets, and more), Chihuly longed to acquire examples of this work but found there were essentially none on the market. However, Tagliapietra possessed all the skills necessary to replicate the works. So Chihuly took on the mantle of a Venetian designer from the 1920s and 1930s and drew vessels for Tagliapietra to produce.

As the blowing session in the late summer of 1988 progressed, Chihuly found himself making bolder and more expressive drawings. "Handles changed to knots, prunts became claws, colors went from subtle to bright and forms from symmetrical

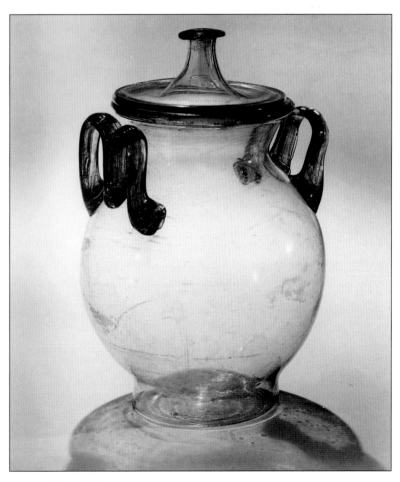

Cinerary Urn with Lid
Romano-German, late first century to early second century
Blown glass, 12⅝" H
The Toledo Museum of Art, Toledo, OH
Gift of Edward Drummond Libbey 77.14

to asymmetrical," Chihuly said.[10] The Art Deco models, clearly made as decorative objects for domestic use, grew to command a sculptural presence. As this series has developed in the last decade, Chihuly has incorporated references to many other European glass styles, from medieval German to French Art Nouveau.

Dan Dailey (born 1947) looked to the French rather than the Venetians. Influenced by the elegant streamlined *moderne* forms of the great glass firm of Daum Frères, he carries on the tradition in his independent work and by designing for the company. *Le Vent* (see illustration p. 58), a limited-edition casting for Daum, bears a close resemblance to an automobile hood ornament designed by one of Daum's competitors, René Lalique (1860–1945). Although Dailey acknowledges the source as Lalique's *Victoire* (about 1926), his is not a slavish interpretation. Enlarging the scale, he takes the elements that define the work as Art Deco—elegance of line, stylization of form, celebration of the machine age—and fits them to his own artistic agenda. Dailey honors the decorative arts tradition by continuing to make functional and decorative objects. His witty lamps *can* be used for illumination but his oversized vessels become metaphors for use.

Glass is undoubtedly a technique-intensive medium—on occasion, even technique-driven. As challenging as the Venetian style is to achieve, it is surpassed by the Roman *diatreta* or cage cups made between the first and fifth centuries A.D.[11] Clearly luxury items (only fifty are known), some

of these vessels may have been used as hanging lamps, according to recent research. Whatever their purpose, their lacy enclosures of a simple vessel form are a *tour de force*, and their virtuosity baffled artists and scholars until this century. Although researchers can never be absolutely

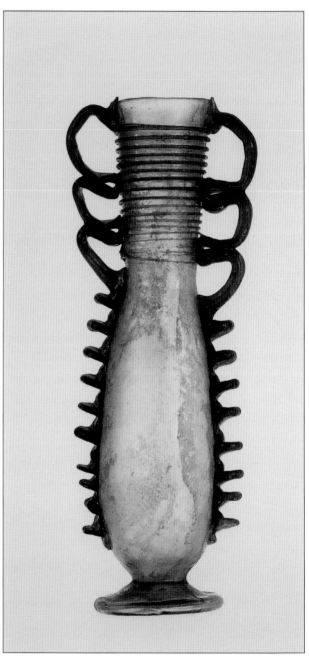

Flask
Roman, Eastern Mediterranean (Syro-Palestinian)
Fourth or fifth century
Blown glass and applied and tooled decoration, 7" H x 2⅜" W
The Toledo Museum of Art, Toledo, OH
Gift of Edward Drummond Libbey 1923.1054

[10] Quoted in Walter Darby Bannard and Henry Geldzahler, *Chihuly: Form from Fire* (Daytona Beach, FL: Museum of Arts and Sciences; Seattle: University of Washington Press, 1993), p. 63.

[11] This is a glass vessel surrounded by a network or openwork pattern of glass that is attached by struts. The German archaeologist J. J. Winckelmann conferred the Latin name in the mistaken belief that the Roman *diatretarii* did only this type of reticulated work. Harold Newman, *An Illustrated Dictionary of Glass* (London: Thames and Hudson, 1977), p. 324.

certain, they now believe that *diatreta* were made using lapidary techniques.

More than one artist has attempted to replicate the effect. Frederick Carder (1863–1963), the creative force behind Steuben Glass during the first third of this century, cast *diatreta* forms (see illustration p. 119) using a lost-wax process and *pâte de verre*. More recently the Japanese-born artist Etsuko Nishi (born 1955), who now lives and works in London, has used a similar technique but allowed herself a looser interpretation. She is also inspired by the fluidity of fabrics such as silk and lace. To create a lacy enclosure attached by struts—the defining feature of a *diatreta*—she casts the interior vessel, then wraps it with fireproof batting, and inserts the glass struts. Using a pastry tube filled with a paste of glass, she "connects the dots," drawing what will be the outer cage. The piece is then heated and the struts are fused to both the inner and the outer forms. The batting, a mold material, withstands the heat of the kiln but dissolves in water after the piece is cooled. Nishi adopts a completely contemporary attitude in which craft is subordinated to effect. She remains true to the concept of the original, not the materials. This is a strategy shared by others using craft media, such as ceramist Ken Price using acrylic paint rather than glaze to achieve his coloristic effects.

While Nishi's exquisite castings look as delicate as spun sugar, Karla Trinkley (born 1956) aims for something entirely different in works that visually reference *diatreta*, although she sees her sources as architectural.[12] Instead of fragile cups to be held with great care and reverence, Trinkley creates large, robust (even beefy) vessels of thick walls, without a true cage but alluding to one. Trinkley's vessels seem to reimagine the Romans as a civilization of giants or worshipers of giants perhaps. Both

fragile and gutsy, these oddly contradictory vessels might have been created for some unknown ritual use. Despite the variations in their immediate and acknowledged sources of inspiration, all three artists have sought to evoke the ancient.

Barry Sautner (born 1952) makes reiterations much closer to the classical models of *diatreta*, but he has raised the technical ante by making double cage cups, a feat not achieved, as far as we know, in antiquity. Using sandblasting techniques adapted from dental technology, Sautner produces astonishing virtuoso results. He now fashions highly charged and expressionistic figurative sculptures. These draw on the figural *diatreta* made during Roman times, such as the *Lycurgus Cage Cup* in the British Museum. Sautner also designs his pieces so that the necessary posts become integral to the aesthetic as well as the structure.

Another tradition that Sautner honors also has its roots in Roman times: cameo glass. The technique of carving into gems to create cameos was transferred by lapidarists to glass as early as the first century B.C. They worked on cased glass blanks made of layers of colored glass to create effects similar to those achieved in stone.

After the fourth century, except for Islamic production in the ninth century, cameo glass carving became nearly a lost art until it was revived in the last part of the nineteenth century. Glass companies such as Stevens and Williams, Thomas Webb & Sons, and the Richardson Company in England produced less labor-intensive and thus more commercial lines by using acid-etching techniques rather than carving.

In France the Art Nouveau glass artists, notably Émile Gallé (1846–1904), contributed the next development and fashion. Nature was the prime inspiration for these artists, just as it is for Sautner, who uses sandblasting techniques to realize his contemporary narratives. As Sautner has matured artistically, he has moved further and further from interpretations of the past to his own distinctive vision.

[12] Martha Drexler Lynn notes Trinkley's "avid interest in all forms of architecture and specifically the architecture of Japan, China, and ancient cultures" in *Masters of Contemporary Glass: Selections from the Glick Collection* (Indianapolis: Indianapolis Museum of Art in cooperation with Indiana University Press, 1997), p. 133.

Mosaic glass was another ancient technique used by the Romans. The earliest instances date as far back as fifteenth-century B.C. Mesopotamia. In this technique, bits or ribbons of colored glass are fused together to form a sheet that can then be shaped around a core or slumped over a form. Because the glass is in a cold state, the glassmaker has great control over the patterning, like the creator of a patchwork quilt.

Although German-born artist Klaus Moje (born 1936) has done work that seems directly related to this technique, he arrived at it more through serendipity than through study. Moje was trained as a glass grinder and etcher; his early pieces were carved blanks of blown glass made by the Hessen Glaswerke. In the early 1970s he saw rods of colored glass manufactured for button and jewelry makers by Hessen. Intrigued by their brilliant hues, he bought some and began experimenting with flattening and fusing them. Moje now bundles and then fuses rods of colored glass into canes that he slices and recombines before cutting them into *tesserae* and fusing them into a sheet. He then places the sheet into a mold and slumps it to his desired form. Finally, hours of grinding produce a matte surface. Geoffrey Edwards, curator of sculpture and glass at the National Gallery of Victoria, explains, "Moje's designs may seem to be spontaneous and the product of a single-sitting, virtuoso performance, but are in fact achieved solely on the basis of masterly deliberation and unfaltering control."[13]

Moje has elaborated his forming techniques over the years to create increasingly complicated compositions, but because he reveres the decorative arts heritage he always stays within it. His forms can be described as bowls or platters even though the compositions might recall contemporary abstract paintings by Bridget Riley, Frank Stella, or Kenneth Noland. However, Moje is never making conscious references to such artists.

Another strain of development within the mosaic tradition involves hot-working. In Venice in the 1940s at the Venini company, architect-designer Carlo Scarpa (1906–1978) designed vessels from patchworks of translucent color blocks. The technique, called *vetro pezzato*, involved creating a design of *tesserae* of colored glass that were "picked up" on the hot bubble of glass. Then the piece was "blown out" and finished. In the 1950s and 1960s Ercole Barovier (1889–1974) of Barovier & Toso, Archimede Seguso (born 1909) of Archimede Seguso, and Fulvio Bianconi (1915–1996) of Venini all used this technique to create modern-looking functional forms intended for the decorative arts market (see illustration p. 120).

In the 1990s Dorothy Hafner (born 1952) has taken that model as her inspiration for a series of large vessels and pitchers that honor both ancient and modern glass. Hafner switched media after many years as a designer of ceramics at her own pottery studio as well as for the German company Rosenthal. (She had produced one of its perennial bestsellers, *Flash*.) Inspired by the experience of diving at the Great Barrier Reef in Australia, Hafner wanted to translate the brilliant colors found in the sea into a less ephemeral medium; glass was the logical choice.

With her interest in design, she also looked to the history of decorative arts for inspiration. *Vetro pezzato* provided the starting point for her explorations, executed by the Muranese master Lino Tagliapietra. Like many Studio Glass artists, Hafner bumped up the scale and made the form more expressive, so that her vessels are clearly of this century and conceived by an artist.

Also inspired by twentieth-century Venetians looking back to their own traditions is Richard Marquis (born 1945). He pays homage to the great Italian designer Carlo Scarpa in his "Marquiscarpa" series. Starting in the mid-1930s, Scarpa designed decorative forms for the Venini company by

[13] Geoffrey Edwards, "Klaus Moje: Three Decades of Glass," in *Klaus Moje: Glass/Glas* (Melbourne, Australia: National Gallery of Victoria, 1995), p. 15.

massing and fusing *murrine* in simple vessel forms (see illustration p. 117). Marquis has appropriated one of Scarpa's modernist designs—a shallow, elongated, canoelike shape—but enlarged the scale and placed it on a pedestal (see illustration p. 71).[14] The forms may be similar but the aesthetic effects are quite different. Marquis has written about the works in this series, "I made them because I pay attention to history. I made them because I wanted to see how I would make them. I made them because to me it was the obvious thing to do."[15]

As a Fulbright-Hayes Fellow working at Venini in 1969, Marquis had seen Scarpa's designs being made, but they did not interest him at the time. The process of making them is long and complex[16] and lacks all the bravura aspects of glassblowing, because each form requires many tedious steps. Marquis himself admits that this "is about the only work I make where I don't enjoy the process, but I like how it looks when it's done."[17]

The *murrine* technique, which forms the basis—conceptually and literally—of the Scarpa works, can be traced to the *murrhine* glassware made in Alexandria from about 200 B.C. to A.D. 100. The same technique was used in sixteenth-century Venice for the *millefiori* cane slices embedded in a clear glass matrix. The most familiar pattern is the namesake "thousand flowers," but the technique was also used for other designs and even portraits.

During Marquis's Fulbright time at Venini, he learned the *murrine* technique. Back in the United States, he designed his own patterns—everything

from hearts to skulls to the Lord's Prayer—and used them to form the bodies of his comically misshapen teapots. Later they appeared as attachments to the surfaces of his "trophies"[18] or his exquisite teapot-goblets with their *filigrana* patterning.

Marquis is a master technician with both a reverence for tradition and a completely irreverent attitude toward it. If Chihuly raised the *façon de Venise* to new heights, Marquis took it into left field.

The works of Toots Zynsky (born 1951) interpreting the ancient techniques of fusing and slumping may be furthest from the mosaic source. Instead of the thick ribbons of glass used in ancient times and revived in the historicizing nineteenth century, Zynsky draws rods of colored glass into tiny threads and then piles literally thousands of them into a form, calling her technique *filet de verre*. The form is heated until the threads melt together. Once this "fabric" is fused, she picks it up with heat-proof gloves and manipulates the form to make it even more active. The resulting "vessels" are like brushstrokes of color frozen forever in space and time. They can be compared to contemporary color field painting or perhaps Clyfford Still's jagged sweeps of color.

Although many glass techniques have remained essentially unchanged for centuries, if not millennia,[19] innovations have been made in the twentieth century. The artists of the Studio Glass movement have enriched the technical arsenal through experimentation that disregarded the time and material cost constraints of the marketplace. This is not to say that factories and their designers have been completely conservative. The Swedish company

[14] Tina Oldknow points out that these forms reference "historic European chalices, ancient Egyptian and traditional African and Asian headrests, and ancient Greek ceramic footed drinking cups (*klylikes*)." Tina Oldknow, *Richard Marquis Objects* (Seattle: Seattle Art Museum, 1997), p. 35.

[15] Artist's statement in *Holding the Past: Historicism in Northwest Glass Sculpture*, 1 July 1995–11 February 1996 (Seattle: Seattle Art Museum, 1995), n.p.

[16] The process is explained and illustrated in Oldknow, *Richard Marquis Objects*, pp. 34–37, 124.

[17] Ibid., p. 116.

[18] A *Two-Handled Cup* from the mid-first century A.D. in the Römanisch-Germanisches Museum has white lozenges of glass applied to its surface and is certainly the spiritual grandfather of Marquis's much later and clearly humorous interpretation. The early piece is illustrated in Donald B. Harden et al., *Glass of the Caesars* (Milan: Olivetti, 1987), p. 109.

[19] Glassblowing was invented around the time of Christ, and, although furnaces are now fired with gas or electricity, the other tools are virtually the same.

Orrefors Glasbruk broke new ground artistically and technically at the beginning of this century.

Founded in 1898, Orrefors originally produced window glass and utilitarian objects such as jam jars and inkwells. Soon after the company changed ownership in 1913, it altered direction to become one of the international leaders in the art glass field. Painter and illustrator Simon Gate (1883–1945) joined the company in 1916, and Edward Hald (1883–1980), a painter who had studied with Matisse, came on board the next year. At the time, a major part of the Orrefors art glass production was derivative of the cameo glass created by the French Art Nouveau artist Émile Gallé (1846–1904), acid-etched with harsh relief. The sharpness dissatisfied Albert Ahlin (1875–1950), manager of the glassworks, and master glassblower Knut Bergqvist (1873–1953), as well as Gate, and a solution was sought. On 28 June 1916, Ahlin wrote to Gate, "If we could but find a completely new and successful technique, the matter would be cleared up. But how to approach finding one? There is so little that is actually new under the sun."[20]

In 1916 Bergqvist did devise a new technique in which the etched, cut, or engraved blank was reheated and cased with a layer of clear glass before being blown out and finished. Ahlin named the new technique Graal, from "the poet Fröding's tale of the glass, which wrapped itself round its contents to make 'the wine as if it were a ruby'; its mysteriousness, both in its effects and in its properties, is what bears up the tale. The name may seem pretentious, but I'll be damned if I'll change it."[21]

The American John Brekke (born 1955) has adopted the Graal technique in his thick vessels, which "trap" stylized representational images within the glass. Having first seen the process demonstrated in 1977 when he was a student at the University of Wisconsin, he uses a fatter blank than is common with Graal. Its thickness is more typical of a related technique developed by Orrefors designers Edvin Öhrström (1906–1994) and Vicke Lindstrand (1904–1983) and called Ariel after the sprite in Shakespeare's *Tempest.* However, Brekke's sandblasting is not deep enough to capture air, which is the defining characteristic of Ariel.

Although Brekke's vessels are larger than Öhrström's Ariel works for Orrefors, the artists appear to be aesthetic cousins. They share a stylized draftsmanship (although Brekke's is directly influenced by Japanese woodcuts) and in many instances a common palette. Brekke often uses a deep brown similar to the "oversweet marmalade"[22] hue used by Orrefors designers. The American gravitated to it because it offered the light and dark contrast he was seeking; perhaps it appealed to Öhrström for the same reason. Brekke has elaborated on the Graal method by sandblasting additional imagery and often stream-of-consciousness text on both the interior and the exterior of his vessels.

Another technique elaborated by contemporary Studio Glass artists is *pâte de verre.* Believed to be an ancient method, it was "rediscovered" in the nineteenth century in France. Artists such as Henri Cros (1840–1907) and Albert Dammouse (1848–1926), working at the Sèvres porcelain factory, and a number of artists working in small studios in Paris, including Amalric[23] Walter (1859–1942), Georges Despret (1862–1952), François-Émile Décorchemont[24] (1880–1971), and Gabriel Argy-Rousseau (1885–1953), made functional and decorative objects with this technique. Often working in Art Nouveau style, they faithfully translated the flora

[20] Dag Widman, "Pioneers, Breakthrough, Triumph," in *Orrefors: A Century of Swedish Glassmaking* (Stockholm: Byggförlaget-Kultur, 1998), p. 242.

[21] Ibid., p. 22.

[22] Ibid., p. 23.

[23] There are various spellings of "Amalric" in the literature, including "Almeric."

[24] An alternative spelling of "Décorchemont" is "Déchorchement."

and fauna of the natural world into the permanence of glass. But these artists essentially invented their own formulas and modes of working, so that the technique was lost when the style fell out of fashion. It would be revived yet again by Studio Glass artists such as Doug Anderson (born 1952).

Doing his own research, based on the limited technical information recorded by Argy-Rousseau and studying photographs in books, Anderson devised his own version of *pâte de verre*. Although his subject matter is drawn from the natural world, like that of the late-nineteenth-century glass artists, he came to it independently, stimulated by the rural Ohio setting in which he was living. Through his research, Anderson found an impression material that could make a "wax duplicate in fingerprint detail," he relates. He was intrigued by the delicacy of the scales of the bluegills in a pond near his home, noticing that details he might miss in real-life observation appeared when cast. Inspired by the technique rather than the subject matter of his predecessors, Anderson's work nonetheless follows their progression naturally. What differs is the humor that marks his pieces.

Likewise Seth Randal (born twentieth century) has researched the methods of his precursors, notably Décorchemont's *pâte de cristal*, which gives a more lucid appearance to the casting and produces intense color with vibrant refractive qualities.[25] Extremely aware of art history, Randal studied jewelry and the lapidary arts. He greatly admired the work of the French designer René Lalique (1860–1945), who was known for his exquisite Art Nouveau jewelry and glasswork, and the creations of his American counterpart Louis Comfort Tiffany (1848–1933). Their influences as

well as those of other French artists working with *pâte de verre* can be seen in Randal's vessels. His pieces have gently nuanced colors but, like much contemporary art, are enlarged in scale. Randal has also been inspired by the grace of the *vasa diatreta* style and has created his own version.

French paperweights of the nineteenth century from Baccarat, Saint-Louis, and Clichy were considered the best in the world in terms of their technical achievements, but the southern New Jersey artist Paul J. Stankard (born 1943), using the lampworking process, has surpassed them. In addition to his technical virtuosity, he underpins his work with an ambitious conceptual program, sometimes even writing poems to accompany the pieces. Heating rods of colored glass over a flame, he and his assistants fashion astonishingly realistic wildflowers, fuzzy honeybees, and even a tiny race of subterranean people, to create compositions that are then encased in pellucid glass. Stankard was trained as a scientific glassblower. When he first applied his prodigious skills to the paperweight form, he essentially replicated nineteenth-century models. Later he followed the path of the Art Nouveau artists, who revered nature and were inspired by it. Stankard, however, has focused on the single bloom rather than the field of flowers.

Unlike the father-and-son team of Leopold (1822–1895) and Rudolph Blaschka (1857–1939), who created glass flowers for study for The Botanical Museum of Harvard University (see illustration p. 42), Stankard takes a romantic approach. Forsaking the familiar globular form of the paperweight, Stankard now showcases his lampworked fancies in rectangular blocks of pellucid glass and calls them "botanicals." This South Jersey lampworker extraordinaire has created a new genre and brought a new vitality to an old glass tradition.

Perhaps it is a stretch to include the lampworked sculptures of Ginny Ruffner (born 1952) in this exhibition, but they show how a technique can be adapted to new aesthetic uses. Instead of the virtuoso miniaturization of Stankard's "botanicals,"

25 In *Seth Randal* (New York: Leo Kaplan Modern, 1993), pp. 5, 7, Martha Drexler Lynn, then assistant curator of the Decorative Arts Department of the Los Angeles County Museum of Art, notes that these effects are "only possible when working with a high quality lead-based optical crystal [which] gives [the pieces] a gem-like quality."

Leopold Blaschka (German, 1822–1895)
Rudolph Blaschka (German, 1857–1939)
Centaurea cyanus L. (Bachelor's Button with Moth), 1913
Colored glass, 1¾" H x 12½" W x 21¼" D
The Ware Collection of Blaschka Glass Models of Plants (Glass Flowers), The Botanical Museum of Harvard University, Cambridge, MA
Photo: Hillel Burger
© Harvard Botanical Museum

Ruffner's sculptures have a muscular, assertive quality. Although the medium retains an inherent delicacy, that is not the predominant characteristic of Ruffner's work. Instead fluidity is paramount. Bending rods of clear glass to her will, Ruffner creates a dimensional support for the painting. Both the forms and the realistic images communicate Ruffner's musings about the nature of beauty, of art, and of life.

Judith Schaechter (born 1961) fills stained-glass panels with her musings about the day's concerns,

using the medium to send a potent message. In the Studio Glass movement, stained glass has been a bit of a stepchild. Traditionally it was part of and often subordinate to architecture, although Gothic stone cathedrals can be seen as merely frames for their luminous stained-glass windows. Autonomous panels designed to be installed in a gallery setting, however, require special handling, and proper lighting is essential unless they incorporate their own, as Schaechter's light boxes do.

The difficulty of presenting Schaechter's intense panels is surpassed by her subject matter. She says bluntly that her "main interests are sex and death, with romance and violence the obvious runners up."[26] She expresses them in a way that combines the jewellike stained glass with a raw drawing style that could be called primitive, barbaric, even grotesque, like the origin of the term *Gothic*. "I stick with stained glass because I think the raw material is pretty. The uncut sheets of glass are really seductive, awesome, and unarguably lovely things. Naturally the temptation to cut and damage all that pristine beauty is too much for me to resist," Schaechter admits.[27] Her medium and visual vocabulary evoke a distant time, but her themes are timeless and timely. Joey Sweeney describes her as "a stained-glass-artist-cum-rocker whose works depict a sort of Gothic pain and melancholy usually reserved for Christ and his cronies. That the subjects of her windows are instead mostly (modern) women in various states of cleaning, drunkenness and undress (not to mention grave-digging or rape) merely serves to reinforce her stature in time, place, medium, and sensibility."[28]

Schaechter's work recalls the medieval not only in her choice of medium but also in her handling of the figures: awkward yet expressive. The rich surfaces of vessels created by Michael Glancy (born

[26] Unpublished artist's statement, 1998.

[27] Ibid.

[28] Joey Sweeney, "Through a Glass Darkly," *Philadelphia Weekly,* 4 June 1997, p. 30.

William Willet (American, 1869–1921)
Beatrice and Dante, about 1910–20
Leaded glass, 46 7/8" H
The Corning Museum of Glass, Corning, NY
Gift of Dr. Thomas H. English 84.4.3

1950) also reference that period, recalling its reliquaries encrusted with jewels (both real and glass paste). Glancy's use of metal and glass has many precedents. A Roman cobalt blue glass-and-silver beaker in the British Museum, made around the second quarter of the first century A.D., bears a striking resemblance to his work. The Roman piece was

blown into the silver casing, but Glancy uses an electroforming technique to create the metal cage for thickly blown and deeply sandblasted glass.[29]

The deep relief that Glancy favors also references French art glass of the early twentieth century, notably a cast glass bowl by Daum Frères, which can be seen in the Chrysler Museum, and the work of Maurice Marinot (1882–1960). Glancy acknowledges all of these precedents and more.

Reverberating Nexus (see illustration p. 61) was directly inspired by a Sasanian vessel with a hemispherical body and neck. But Glancy adds another element—a plate, also in deep relief and electroplated. It "presents" the bottle, elevating it in status as well as physical stature. Thus, the artist makes the decorative arts tradition the conceptual as well as the visual basis of his work. Glancy is more concerned with the *ideas* of use and luxury than with creating a decorative functional object.

The Middle East also provided the point of departure for Chihuly's "Persians" series (see illustration p. 55), a body of work that shares technical and formal affinities with several historical precedents. The series began in 1986 when Chihuly had one of his gaffers experiment with form. The glassblowing process naturally produces a vessel, and the number of variations possible must be considered finite even if enormous. Persian rosewater sprinklers with their elongated necks and teardrop spouts provide a model, conscious or not, for Chihuly's "Persians," just as they did for Tiffany's

[29] Louis Comfort Tiffany might also have been influenced by such Roman works in his *Reticulated Tobacco Jar* (see illustration p. 106) in the Chrysler Museum of Art. He created this piece by blowing the glass into a metal cage, as was undoubtedly done in the Roman example.

"Flower Forms," which, in turn, inspired other Art Nouveau glassmakers such as Quezal Art Glass & Decorating Co. Chihuly's series was titled after the fact, as is usual for this artist. It reflects the exotic nature of the pieces—their eccentric forms and rhythmic surface patterning.

Also looking to the ancient Middle East for inspiration is Robert Carlson (born 1952). His extravagantly patterned enamel-on-blown-glass goblets and sculptures find their ancestors in medieval Islamic glass pieces. The obsessive patterning and techniques are traceable to twelfth-century Syria and were taken up in Venice at the end of the thirteenth century and in Germany and Bohemia in the sixteenth century for decorative and narrative uses. In the nineteenth century, French artist Philippe-Joseph Brocard (died 1896) exhibited pastiches of Islamic enameled glass at the Paris World Exhibition of 1867.[30] Carlson continues this development with his painted glass, sometimes using a potentially functional form, such as *Aeon* (see illustration p. 52), and at other times creating a purely sculptural support for painted designs that exhibit a *horror vacui*. Carlson incorporates as much detail as seems physically possible, all in rich enameled colors, so that viewers are overwhelmed, just as they would be if reading an Islamic or medieval illuminated manuscript. The images Carlson uses have symbolic meanings, often drawn from both Eastern and Western religions. While the painted images never blend, they create a seamless whole intellectually as well as visually.

Painting might seem antithetical to glass, because it obscures its transparency—a quality that has intrigued glassmakers for thousands of years. The dream of replicating the appearance of rock crystal is what spurred glassmakers in Venice to formulate a nearly colorless soda-lime glass called *cristallo*. This soft glass was later eclipsed by lead crystal, a glass with amazing light-refracting qualities. The Englishman George Ravenscroft (1618–1681) in March 1674 patented a "crystalline glass resembling rock-crystal."[31] This development allowed the deep wheel cutting that led, by the end of the eighteenth century, to "cut patterns on blown Anglo-Irish lead-potash glass so highly refractive that they trapped light and turned it back into the

Louis Comfort Tiffany (American, 1848–1933)
Jack-in-the-Pulpit Vase, about 1916
Glass, 19½" H x 10⅞" Diameter
Chrysler Museum of Art, Norfolk, VA
Gift of Walter P. Chrysler, Jr., in honor of Martha Stokes 71.6151
© Chrysler Museum of Art, Norfolk, VA

[30] Ada Polak, *Modern Glass* (London: Faber and Faber, 1962), p. 32.

[31] From Ravenscroft's patent application, quoted by Paul Hollister in "Europe and America 1800–1940," *Glass: 5,000 Years*, ed. Hugh Tait (New York: Harry N. Abrams, Inc., Publishers, 1991), pp. 182, 184.

viewer's eyes," according to Paul Hollister in the British Museum's volume *Glass: 5,000 Years*.[32]

The optical qualities of glass—its ability to refract and reflect light—have fascinated glass-makers for centuries. The faceted glass of Venetian chandeliers that increased candlepower, the sober distortions of reality of English and American blown-glass functional objects of the nineteenth century, and the later brilliantly cut glasses, plates, and vases are a part of the heritage that contemporary sculptors such as Christopher Ries (born 1952) are continuing. He and the earlier artisans share a fascination with glass and light and perception. By cutting and faceting massive chunks of optical glass, Ries creates a composition that confounds the viewer with its mutability. The material is solidly three-dimensional but the impact of the sculpture involves another dimension: time.

It is nearly impossible to describe a Ries sculpture verbally because the organic, eccentric form

functions like a container for the actual aesthetic content of the sculpture. Ries explains, "I control the height, width, and depth to enhance the internal composition in the glass."[33] That composition is an illusion that changes as the viewer circles the piece. Ries calls it an "apparition of light. It doesn't exist in reality. It's magic."[34]

In the five-thousand-year history of glass, millions of objects have been fashioned. Many were multiples, some produced by craftspeople in the simplest of workshops, others conceived by designers and realized in the most sophisticated of factories. As contemporary artists became entranced by glass, they have experimented, pushing it to its physical limits and making it serve their artistic needs rather than more mundane functions. Contemporary glass finds its origins in and is clearly inspired by the lessons and triumphs of the past.

[32] Ibid, p. 188.

[33] Interview with the author, 13 September 1998

[34] Ibid.

ecognized internationally as an authority on Studio Glass, Karen S. Chambers holds a B.F.A. from Wittenberg University, Springfield, OH, and an M.A. in art history from the University of Cincinnati. From 1983 to 1986 she was editor of *New Work*, now *Glass: The UrbanGlass Quarterly*, published by UrbanGlass. She has written over one hundred articles on glass for such magazines as *Neues Glas*, *Art & Antiques*, *The World & I*, and *American Craft*. Chambers is the author of numerous catalogue essays, including one for the *Contemporary Glass Exhibition 95 Taipei*. As a curator, she has organized exhibitions focusing on Studio Glass, including *Transparent Motives: Glass on a Large Scale* for the Contemporary Arts Center, Cincinnati; *Transparenscene: Glass Sculpture* for the Palm Beach Community College Museum of Art, Lake Worth,

FL; and, with Ferdinand Hampson, *Glass from Ancient Craft to Contemporary Art: 1962–1992 and Beyond* for the Morris Museum, Morristown, NJ. In addition, she curated *Tell Me a Story: Narrative Art in Clay and Glass*, an exhibition that toured Asia and Australia for the United States Information Agency.

Augmenting her interest in Studio Glass, Chambers writes about other craft media and the fine and applied arts. Her book *Trompe l'Oeil at Home: Faux Finishes and Fantasy Settings* was published by Rizzoli in 1993, and RC Publications published *Print's Best Letterheads & Business Cards 5* in 1998. She has held curatorial positions at the Dayton Art Institute and the Contemporary Arts Center, Cincinnati, OH, and has worked in a number of commercial galleries in New York.

CLEARLY INSPIRED

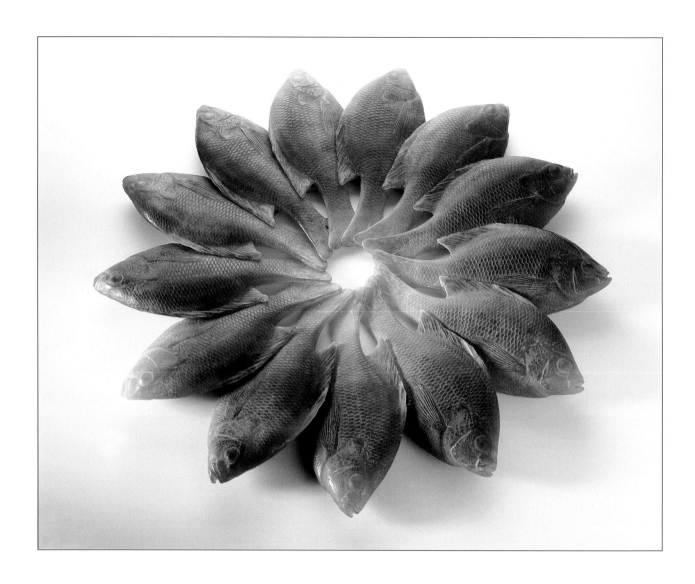

Doug Anderson (American, born 1952)
Fish Plate
1985
Pâte de verre
16″ Diameter
Collection of Jeffrey and Cynthia Manocherian
Photo: Eva Heyd

When I began, I had to do my own research. The only technical information I had came from Argy-Rousseau. I looked at photographs in books, liking the work of Amalric Walter and François-Émile Décorchemont. I discovered everyone had their own interpretation. Through my own research I found a glass and a mold material that were compatible. It was reviving the technique again.

I never thought about the subject matter. I just fell into it. Through trial and error, you just fall into what you're seeking.

Doug Anderson
Warsaw, Ohio
Telephone interview by Karen S. Chambers
12 September 1998

48

Doug Anderson (American, born 1952)

Star Gazer

1989

Pâte de verre

14¼" x 5" x 10½"

Collection of the artist

Doug Anderson (American, born 1952)

Oppressed

1992

Pâte de verre

7½" x 4" Diameter

Collection of the artist

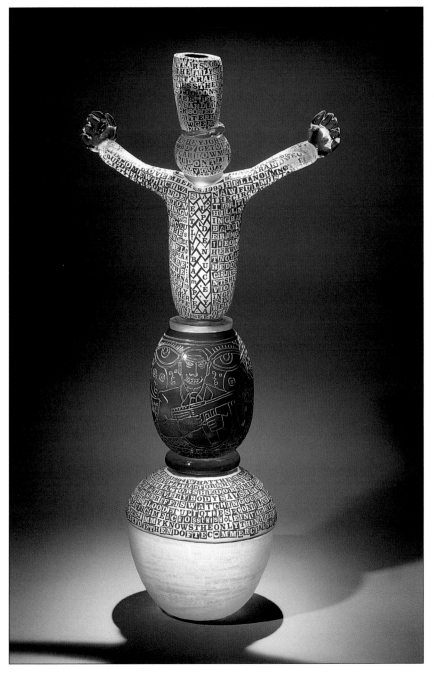

John Brekke (American, born 1955)
Hole in the Levee
1995
Blown and sandblasted glass
28″ x 13″ x 10″
Collection of the artist
Courtesy of Leo Kaplan Modern,
 New York, NY

The other day I was at the Met [Metropolitan Museum of Art, New York]. I came across an enormous black-and-orange classical Greek vase, which had painting and words on it. It was a narrative reaching out to me across a span of two thousand five hundred years. I was struck by the physicality of the thing, and I felt its author was speaking directly to me. That is what I am trying to do with my work: speak to people, telling them stories about the times in which my work is made.

John Brekke
Brooklyn, New York
22 September 1998

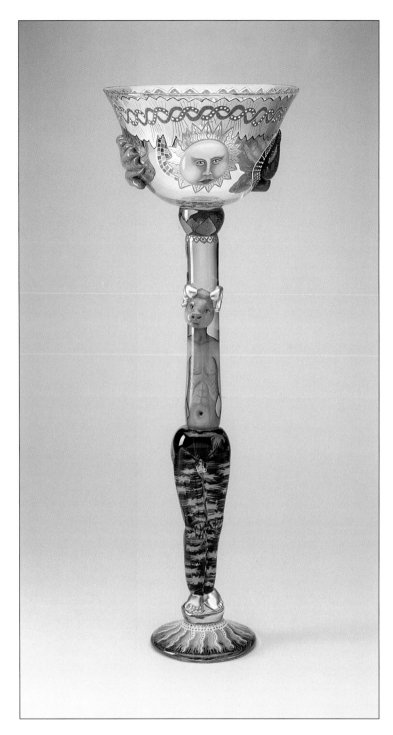

Robert Carlson (American, born 1952)
Aeon
1990–96
Blown glass, pigments, and gold,
 aluminum, and copper leaf
30″ x 10½″ Diameter
The Toledo Museum of Art, Toledo, OH,
 Gift in honor of Ashley and Brennan
 Kasperzak 1996.40
Photo: Tim Thayer
© Robert Carlson

As an artist and a human being, I am concerned with the notion of the soul as a bridge between our conscious self and our larger self, or what the Hindus call Atman, that which includes the totality of our being, unfathomable, mysterious, and ultimately inaccessible to our rational mind.

Visually I am very much influenced by worldwide religious folk art, past and present. What draws me to these images and sculptures, I think, is my belief that art-making is not a cultural "specialization," but rather it is the essence of humanness itself.

To be human is to make art, not "Western" art or "Oriental" art or "Modern" art, but simply art as an expression of the vast mystery of life. It is a human need as much as food or sex is. For me, religious folk art is the clearest expression of this need, a unified expression created across cultural boundaries.

In great religious folk art there is a sense of power and passion, mystery and awe, which is communicated immediately to the viewer. It is at once direct and simple, though often cloaked in intricacy and detail. I've also noticed that color plays a critical role in conveying meaning and emotion. These elements tend to leave the viewer empowered and enlivened, with a sense of hope in life and awe at its majesty. It is with these qualities that I strive to imbue my work. My art does not answer any questions; it does not reveal new knowledge or facts with which to enlighten the intellect. Instead I hope to bring forth in the viewer what is already there.

Robert Carlson
Bainbridge Island, Washington
15 September 1998

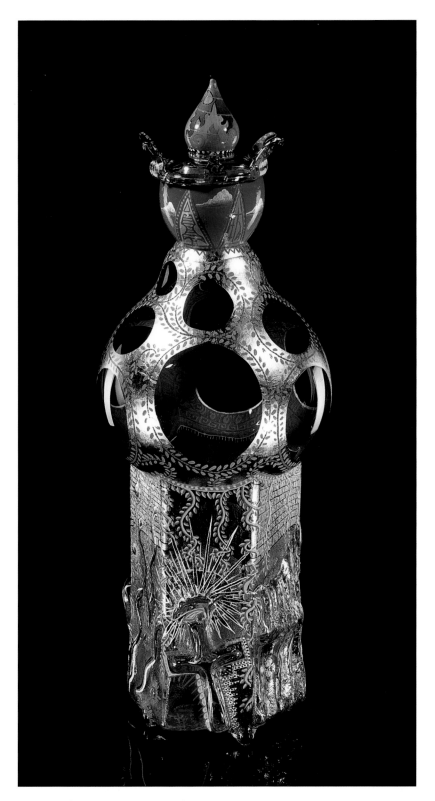

Robert Carlson (American, born 1952)
Temple of Dreams
1993
Blown glass, enamel paint, and gold leaf
31″ x 11″ W
Collection of Nancy and Phillip Kotler
Photo: Roger Schreiber

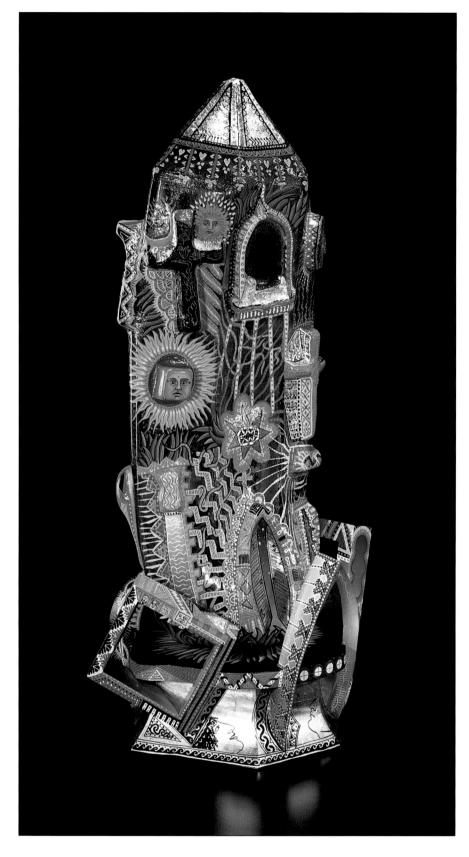

Robert Carlson (American, born 1952)
Axis Mundi
1996
Blown glass, wood, enamel paint, and gold and copper leaf
32″ x 16″ x 13″
Collection of Sara Jane Kasperzak
Photo: Roger Schreiber

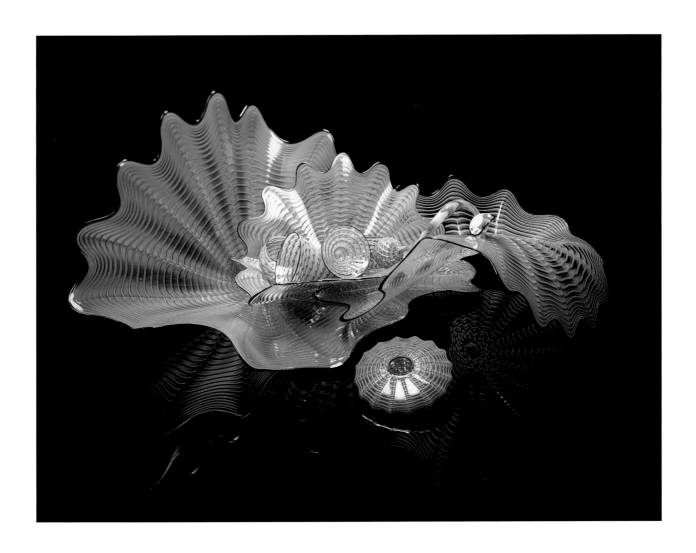

Dale Chihuly (American, born 1941)
Rose and Coral Persian Set with Black Lip Wraps
1998
Blown glass
15″ x 26″ x 31″
Collection of the artist
Photo: Theresa Batty

I don't know where the ideas come from. They come from a lot of different places. One of the most important inspirations for me is the glass itself—the glassblowing process, this wondrous event of blowing human air down a blowpipe and out comes this form.

Dale Chihuly
Seattle, Washington
Unpublished Statement 1994

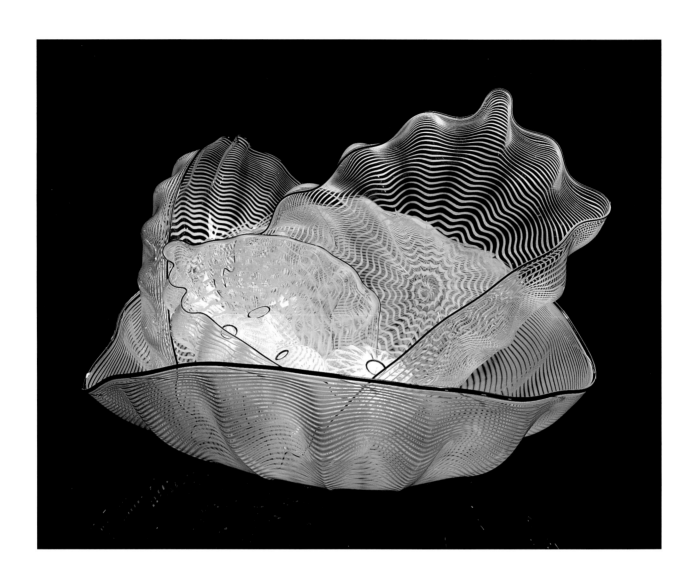

Dale Chihuly (American, born 1941)
Titanium White Seaform Set with Black Lip Wraps
1998
Blown glass
22" x 30" x 22"
Collection of the artist
Photo: Shaun Chappell

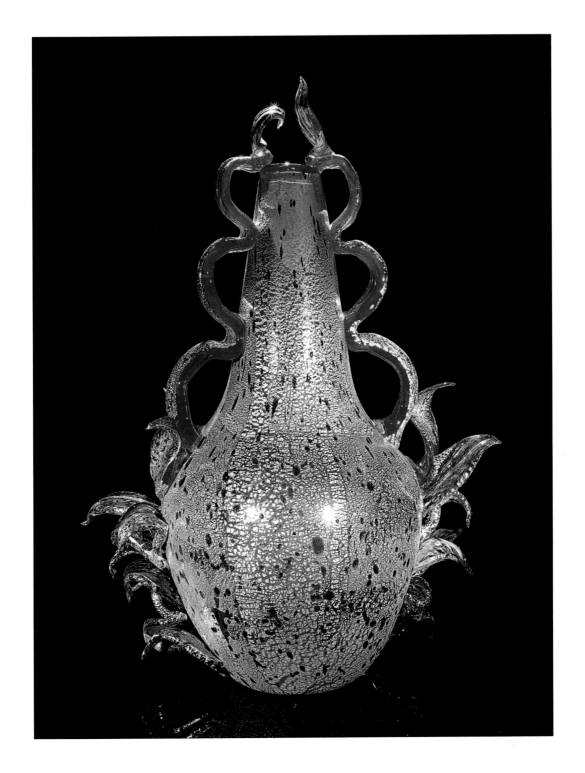

Dale Chihuly (American, born 1941)
Cobalt and Gold Crackle Venetian with Leaves and Coils
1993
Blown glass
24″ x 18″ x 16″
Collection of the artist
Photo: Claire Garoutte

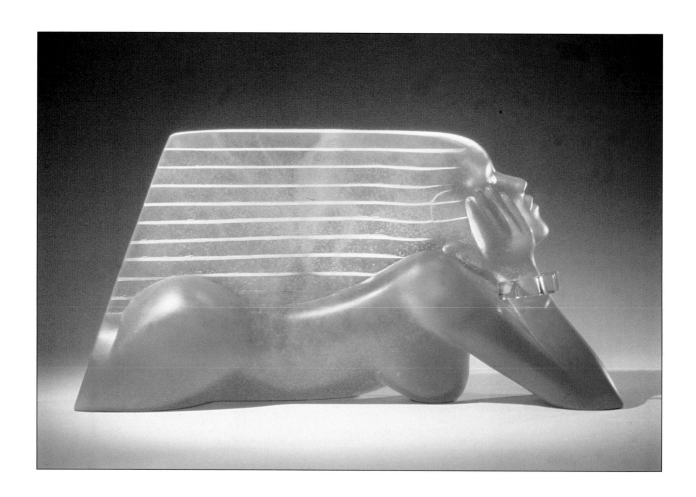

Dan Dailey (American, born 1947)
Le Vent
1984
Pâte de verre
13″ x 23½″ x 4″
Collection of Barbara and Kenneth Tricebock

TINA OLDKNOW: How did you discover Art Deco?

DAN DAILEY: I was in the habit of going to the library and seeking images on purpose. When I go to museums, I take a sketchbook, and anything that I like, I'll take a visual note.

TO: What intrigued you about Art Deco?

DD: Combinations of materials, an attitude of trying to make things that were "deluxe." It's so deliberately geometric, so evocative of the so-called streamline feeling, which suggests motion, suggests the future, suggests speed. A suave, sophisticated style. That whole sense of design somehow caught my fancy.

Dan Dailey
Boston, Massachusetts
Interview by Tina Oldknow
15 May 1997

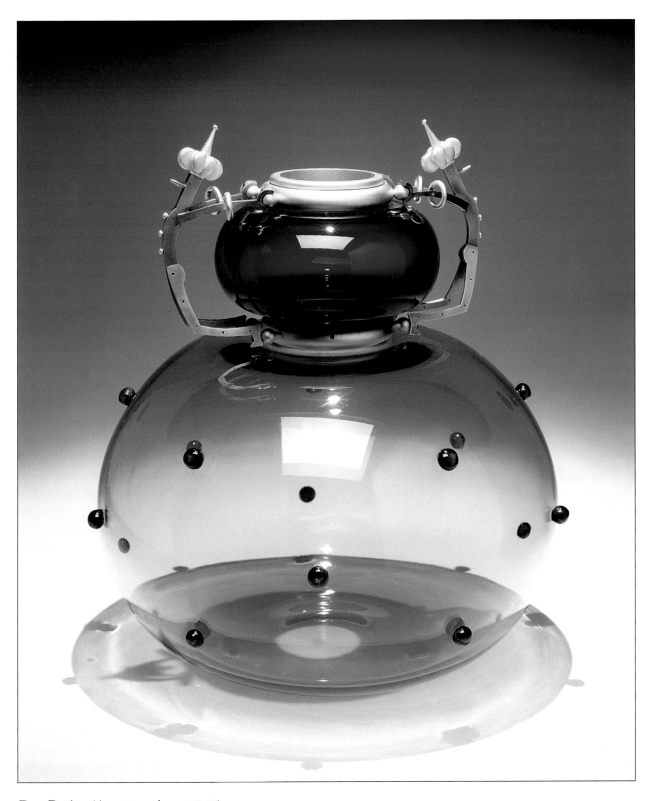

Dan Dailey (American, born 1947)
Antic Circus Vase
1996
Blown glass and gold-plated bronze
18''' x 15" Diameter
Collection of the artist
Courtesy of Riley Hawk Galleries, Columbus and Cleveland, OH

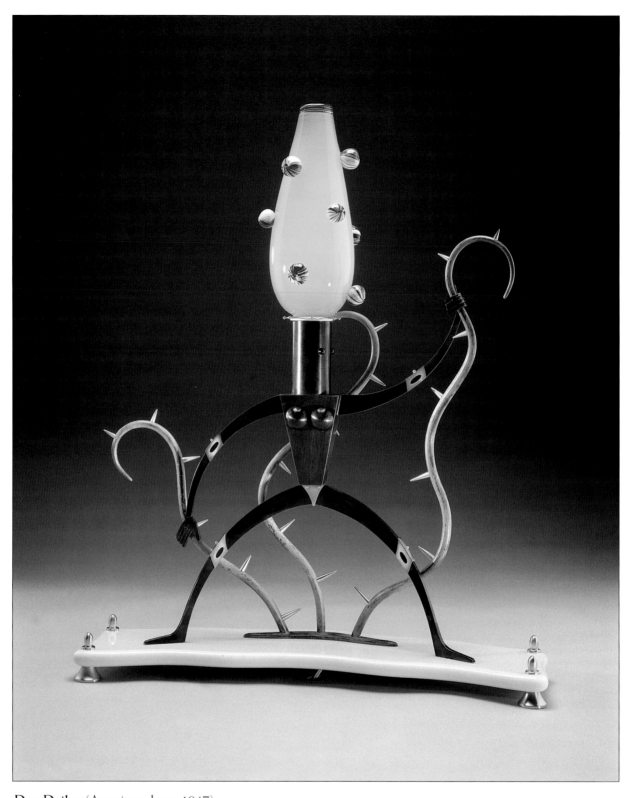

Dan Dailey (American, born 1947)
Nude with Golden Thorns
1995
Blown glass, fabricated and gold-plated bronze, and Vitrolite
31″ x 26″ x 9″
Collection of the artist
Courtesy of Imago Gallery, Palm Desert, CA

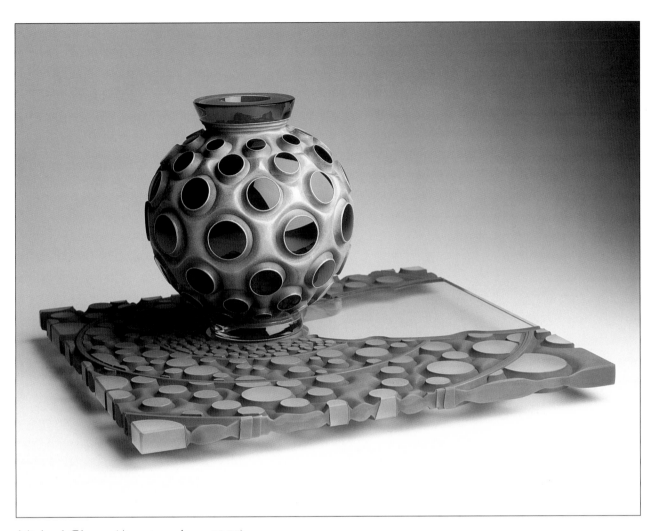

Michael Glancy (American, born 1950)

Reverberating Nexus

1989

Blown glass, industrial plate glass, copper, and silver

11″ x 18″ x 18″

Collection of the artist

Photo: Gene Dwiggins

I firmly believe in the evocative association to man's primitive past through smoke and fire that is the heart of glass. This certainly was as true for me in 1969 (I was a freshman business/marketing major in college) as it was for celebrated glass maestro Lino Tagliapietra. Lino tells the story, in the Corning Museum of Glass's recently released first Master Class video, of the time in his childhood when, playing soccer with a paper ball in Murano, he first saw the fire—he instantly knew the path he must follow. This path is the three-millennium history of glass.

In 1974 I came to Providence, Rhode Island, to study with Dale Chihuly at Rhode Island School of Design. Dale was constantly telling us to go to the library, go to galleries, go to New York City, just go. This is how I "met" Maurice Marinot, the first Studio Glass artist (sorry, Harvey [Littleton]). Through images and through treks to the Lillian Nassau Gallery on 57th Street (Lillian actually allowed me to handle Marinot works!) I found my symbiotic genre. I am not certain I ever attempted to replicate the work of Marinot—I have always attempted to be an original; don't we all?—but I certainly was inspired and highly motivated by his efforts. Some time later, again in New York City, I was introduced by Paul Hollister to Persian glass—specifically the Parthian and Sasanian dynasties (249 B.C.–A.D. 642). This enthusiasm was further reinforced

Continued on p. 62

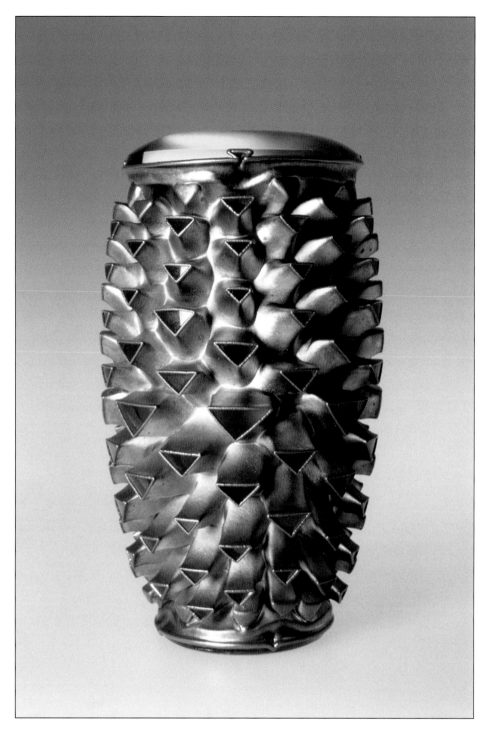

by the great "Glass of the Caesars" exhibition at the Corning Museum of Glass in 1987.

I have always thought of myself as unique as an artist. But, in truth, it is the inspirations of countless artists and originators I owe and am forever indebted to for my strength.

Michael Glancy
Rehoboth, Massachusetts
September 1998

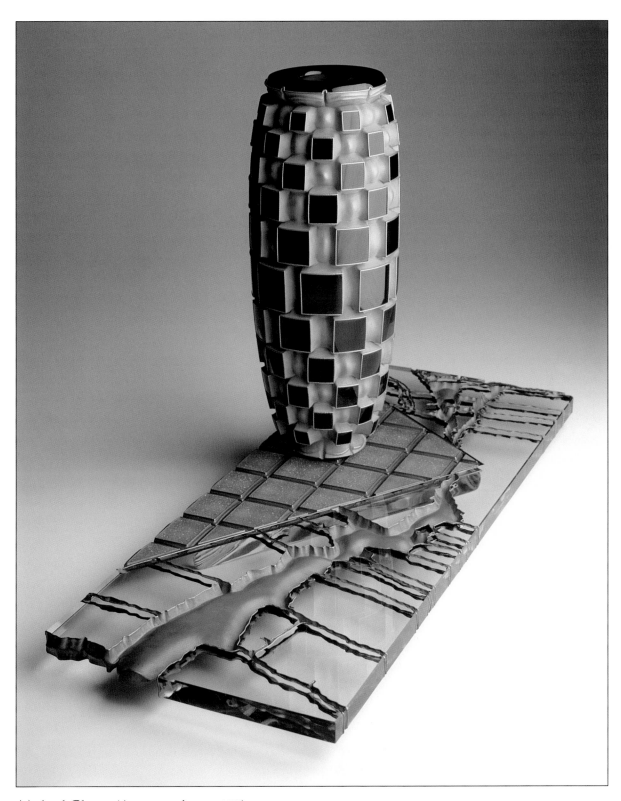

Michael Glancy (American, born 1950)

Boss Codex

1986

Blown glass and copper

15″ x 25″ x 10″

Collection of Myrna and Sheldon Palley

Photo: Gene Dwiggins

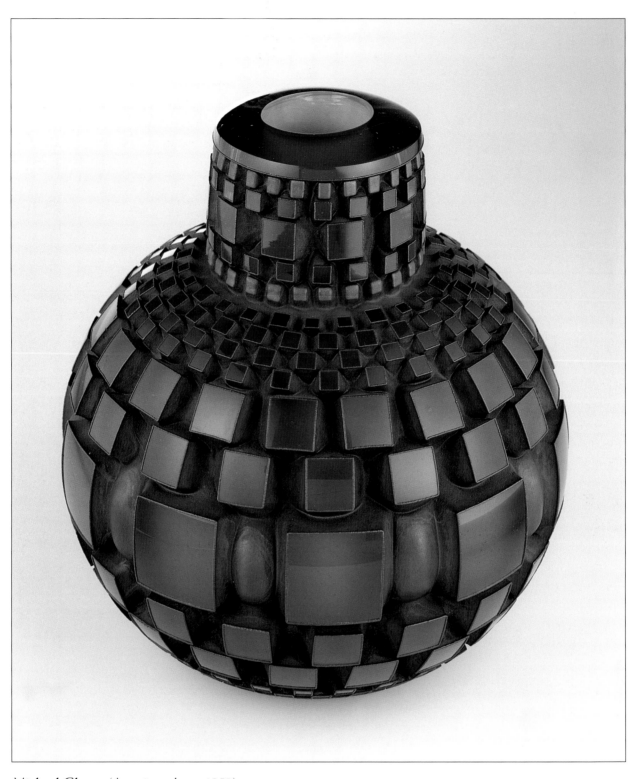

Michael Glancy (American, born 1950)
Euclidean Eruption
1986
Blown glass and copper
7″ x 6″ Diameter
Collection of Jeffrey and Cynthia Manocherian
Photo: Eva Heyd

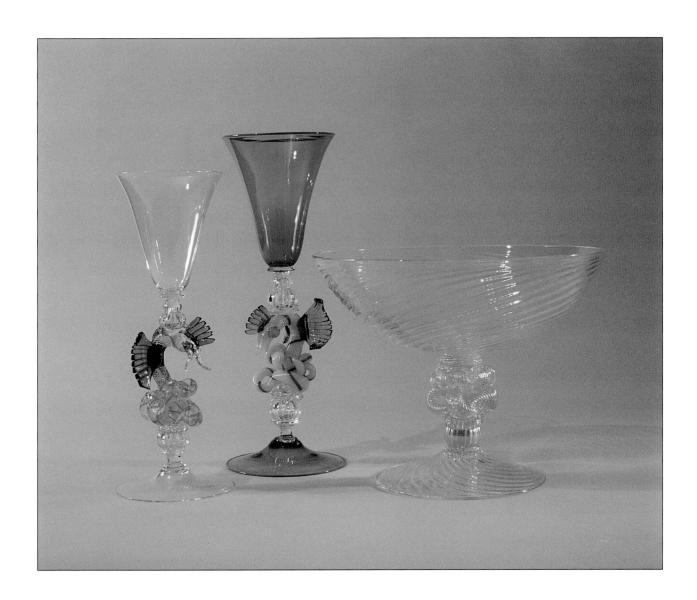

William Gudenrath (American, born 1950)

Left to right (all based on a seventeenth-century Venetian dragon-stemmed goblet in the British
 Museum, London, England):

Dragon-stemmed Goblet
1998
Blown and hot-worked glass
12″ H

Dragon-stemmed Goblet
1998
Blown and hot-worked glass
13″ H

Writhen-stemmed Footed Bowl with Optic Fluting
1998
Blown and hot-worked glass and gold leaf
6″ x 11″ Diameter
All from the collection of the artist

The Venetians were the most highly
skilled glassworkers. I strive to replicate the creativity,
intensity, and techniques of the great masters.

William Gudenrath
Corning, New York
28 September 1998

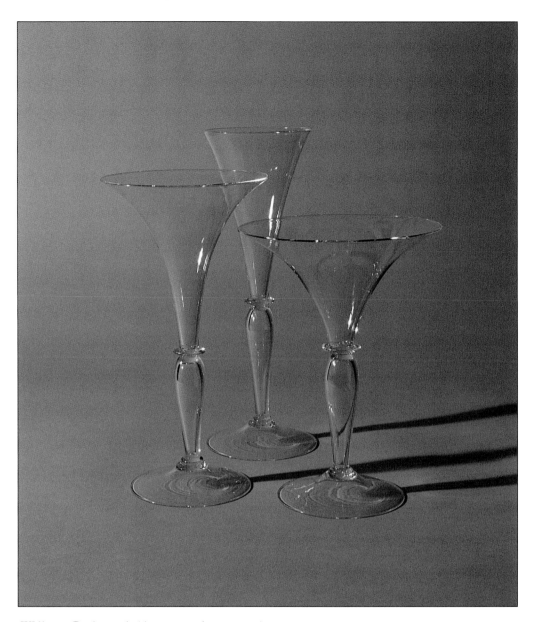

William Gudenrath (American, born 1950)
Left to right (all based on a sixteenth-century Venetian wineglass in
 The Corning Museum of Glass, Corning, NY):
Champagne Glass
1998
Blown glass
9½" H
Champagne Glass
1998
Blown glass
11" H
Wineglass
1998
Blown glass
8" H
All from the collection of the artist

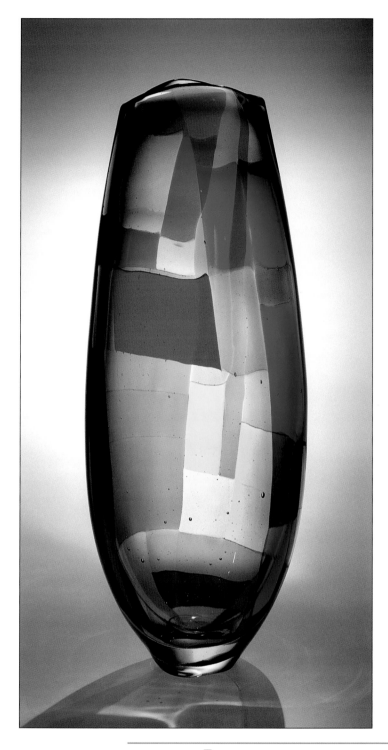

Dorothy Hafner (American, born 1952)
Mozambique
1997
Blown glass
17½" x 6½" x 5½"
Collection of the artist
Courtesy of Heller Gallery, New York, NY
Photo: George Erml
© Dorothy Hafner, 1997

I was first attracted by the *tesserae* work of Bianconi and Barovier because it offered a way to combine two-dimensional (flat color) glass compositions with three-dimensional (blown) glass form.

I try to add my own twist to this method by creating uniquely personal flat glass compositions, which when rolled up and formed, take on references to underwater flora, fauna, and the ever-changing shapes and patterns created when sunlight passes through water.

Dorothy Hafner
New York, New York
28 September 1998

Dante Marioni (American, born 1964)
Goose Beak Trio
1997
Blown glass
18½" x 13¼" W; 34¼" x 8¼" W; 31¾" x 7½" W
Collection of the artist
Courtesy of Grand Central Gallery, Tampa, FL
Photo: Hans Kaczmarek, GMP and Son

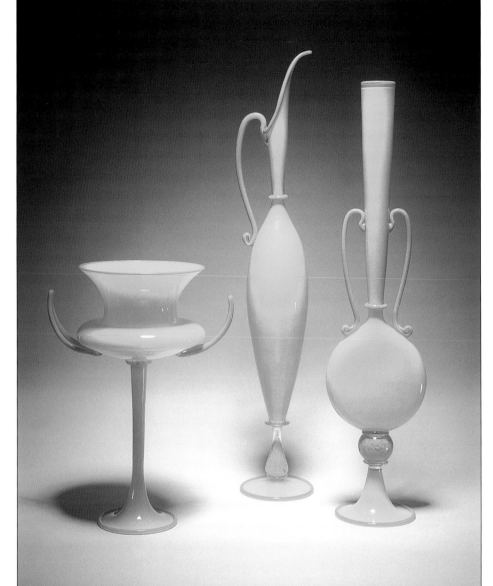

The advent of the Studio Glass movement in 1962 and the founding of the Pilchuck Glass School in 1971, with the access it provides to glass people from around the world, have influenced me directly. I've looked at the works of the Italians Carlo Scarpa, Vittorio Zecchin, and the traditional Venetian stemware as well as the glasswork of Tappio Wirkkala. Classical Venetian off-hand blowing and the *murrine* traditions have been the focus of my work recently.

Dante Marioni
Seattle, Washington
September 1998

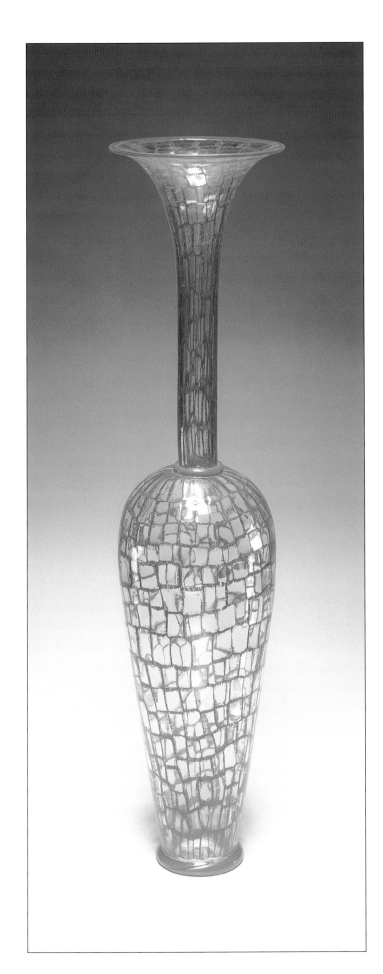

Dante Marioni (American, born 1964)
Red Mosaic Vase
1997
Blown glass
25½″ x 5½″ x 5½″
Collection of Mr. and Mrs. Thomas Schreiber
Photo: Hans Kaczmarek, GMP and Son

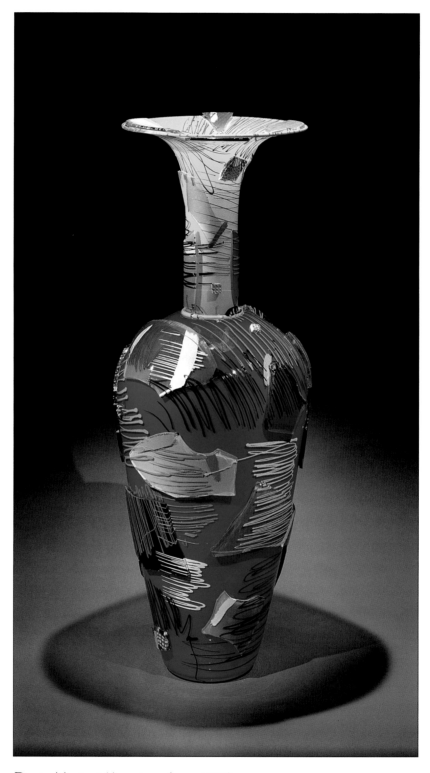

Dante Marioni (American, born 1964)
Richard Marquis (American, born 1945)
Shard Whopper
1992–95 (Blown by Marioni in 1992, decorated by Marquis in 1995)
Blown glass and glass shards
28″ x 10¼″ Diameter
Collection of Dale & Doug Anderson
Photo: Bill Sanders

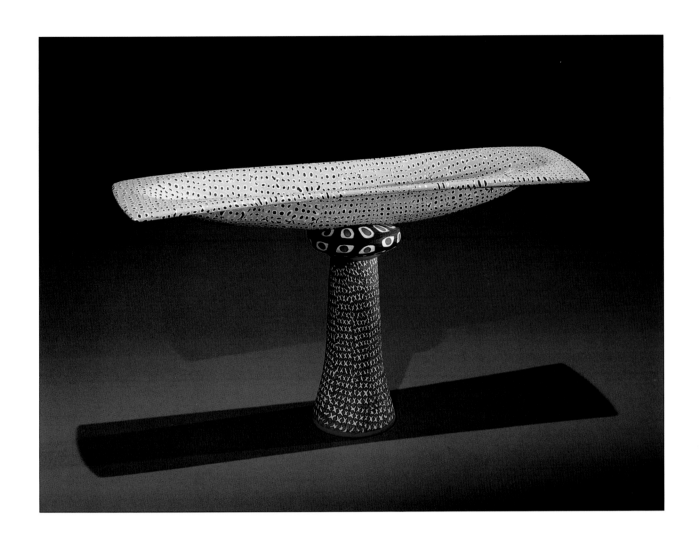

Richard Marquis (American, born 1945)
Marquiscarpa N-1
1991–92
Blown, fused, slumped, and fabricated glass
6½" x 13" x 2½"
Collection of Dale & Doug Anderson
Photo: Bill Sanders

Sometimes I make things because I pay attention to history, sometimes because I want to see how I would make them, and sometimes because it's the obvious thing to do.

Richard Marquis
Whidbey Island, Washington
24 September 1998

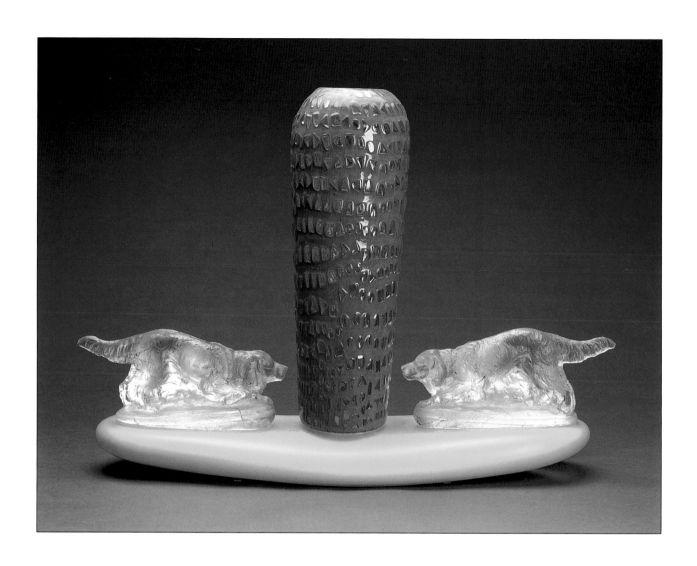

Richard Marquis (American, born 1945)
Hightone Red Rocket
1995
Cast and blown glass
22″ x 29″ x 8½″
Collection of the artist
Photo: Richard Marquis

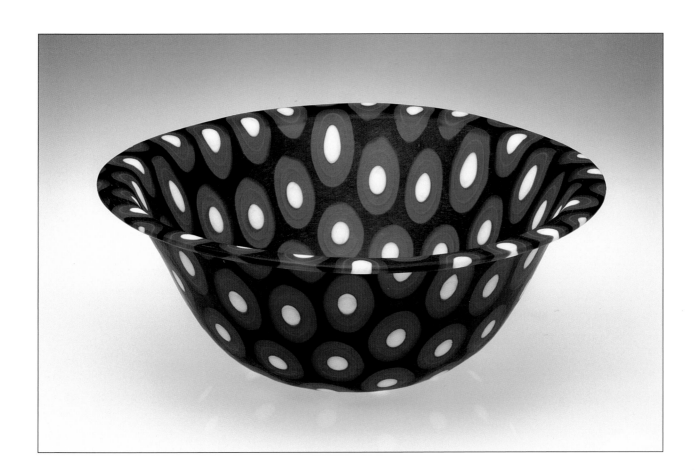

Klaus Moje (German, born 1936)
Untitled (Bowl or Lifesaver)
1979
Fused glass
3⅞" x 10¹⁄₁₆" Diameter
The Toledo Museum of Art, Toledo, OH
 Gift of Dorothy and George Saxe 1993.6
Photo: Tim Thayer

Y ou have to overcome the resistance of the material. Then you are free to express your creative imagination. It is like learning to swim. First you just want to stay afloat and hopefully at one point in the experience of this new medium, you start gliding. This is where you work with the water and not against it.

Tradition is not negative. It's very worthwhile if it leaves you free. But it can also hold you in its claws. It's like a parent and child. If tradition can let you go, it can be a wonderful thing.

Klaus Moje
Corning, New York
Interview by Karen S. Chambers
17 June 1998

Klaus Moje (German, born 1936)

9-1987 #34

1987

Fused glass

1¾″ x 12¼″ x 12″

Collection of the artist

Courtesy of Habatat Galleries, Pontiac, MI

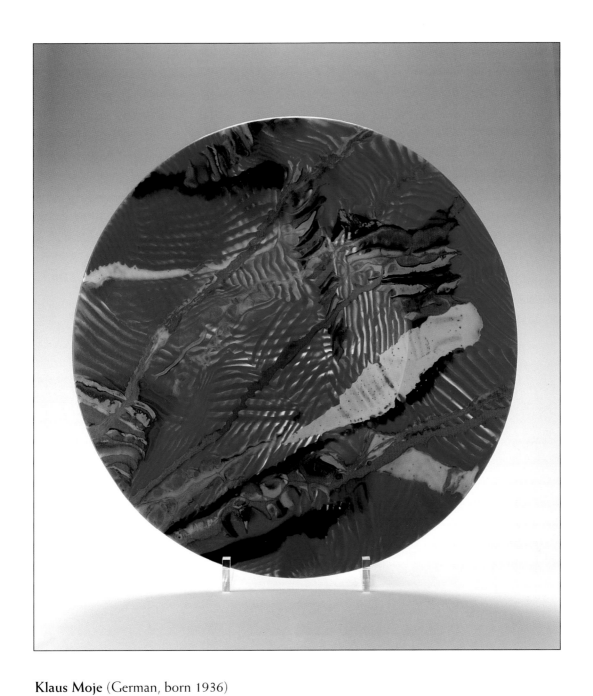

Klaus Moje (German, born 1936)

9-1989 #42

1989

Fused and slumped glass

22″ Diameter

Collection of Jeffrey and Cynthia Manocherian

Photo: Eva Heyd

Etsuko Nishi (Japanese,
 born 1955)
Caged Vessel
1994
Pâte de verre
7″ x 11″ x 11″
Collection of the artist
Courtesy of Heller
 Gallery, New York, NY

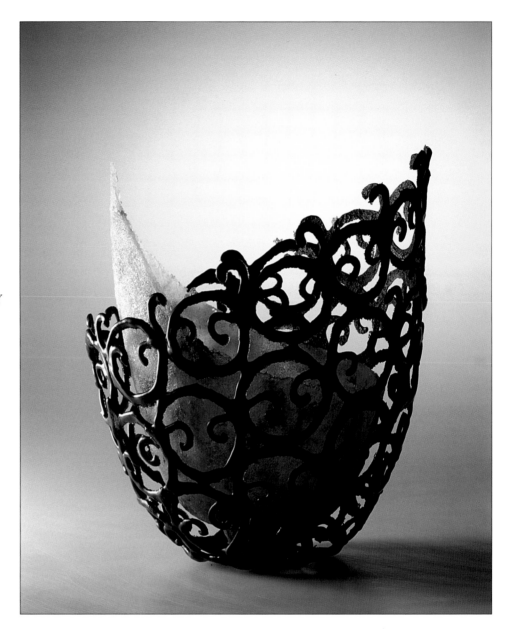

My particular interest has been to focus on the representation of the emotional quality of soft-ness. I was fascinated by the softness of various fabrics, including silk. The first thing to change the direction of my [artistic] inquiry was when one day in autumn I noticed a lace scarf that a woman was wearing around her neck. As it rustled in the breeze, it looked like moving light. It was almost as if the light was stored in the lace and radiated from it. The second thing was a Roman cage cup or *diatretum*, dating from the fourth century. The third event occurred on a visit to the Musée d'Orsay in Paris when I saw a *pâte-de-verre* cup by Albert Dammouse. It is a small cup, some five centimeters in height and ten centimeters in diameter, made from extremely thin and delicate glass and shaped to imitate purple, pale pink, and pale yellow petals. It was titled *Anemone* and looked most beautifully soft and delicate. From the 1980s, I started to incorporate the luminous transparency of the shawl, the double structure of the Roman cup, and the Dammouse bowl into my own making of *pâte de verre*, and very soon began to achieve the technical and aesthetic results I desired.

Etsuko Nishi
London, England
September 1998

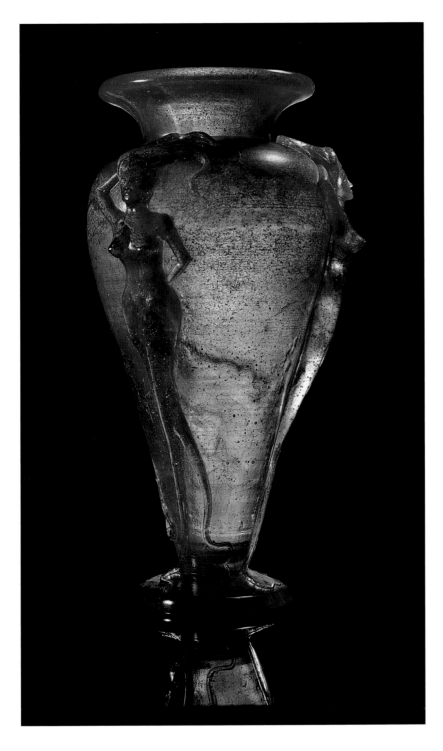

Seth Randal (American, born twentieth century)
Les Femmes Dangereuses
1993
Pâte de cristal
18" x 8" x 8"
Collection of Lorraine and Ron Haave
Photo: Roger Schreiber

My work is steeped in history and memory. My "African Series" was inspired by classic Greek pottery forms from the collection of the Metropolitan Museum of Art. In my "Larger than Life Series," I am attempting to realize and interpret dynamic people from diverse and ancient cultures. Gods, kings, queens, princesses—each one is unique, has its own inner spirit and its own story to tell.

But my work is never literal or definite. It is more a collage of color, style, and motifs that speaks of ancient people, far faraway places, and cultures long gone. I am inspired by age, history, and, above all, the permanence embodied in timeless styles.

Seth Randal
Artist's statement, Holding the Past: Historicism in Northwest Glass Sculpture, *Seattle Art Museum, 1995, n.p.*

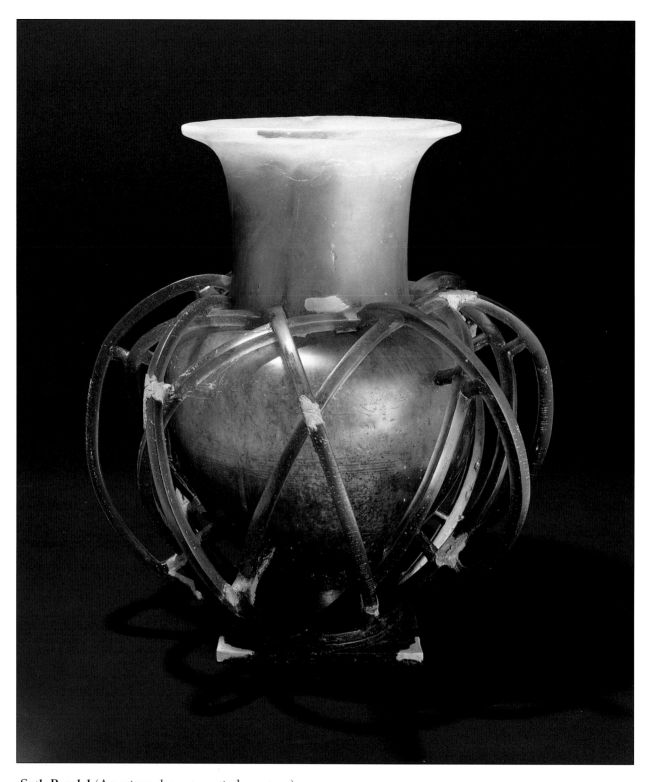

Seth Randal (American, born twentieth century)
Untitled (Double Caged Cup)
1995
Pâte de verre
18″ x 18″ Diameter
Collection of the artist
Courtesy of Leo Kaplan Modern, New York, NY
Photo: Noel Allum

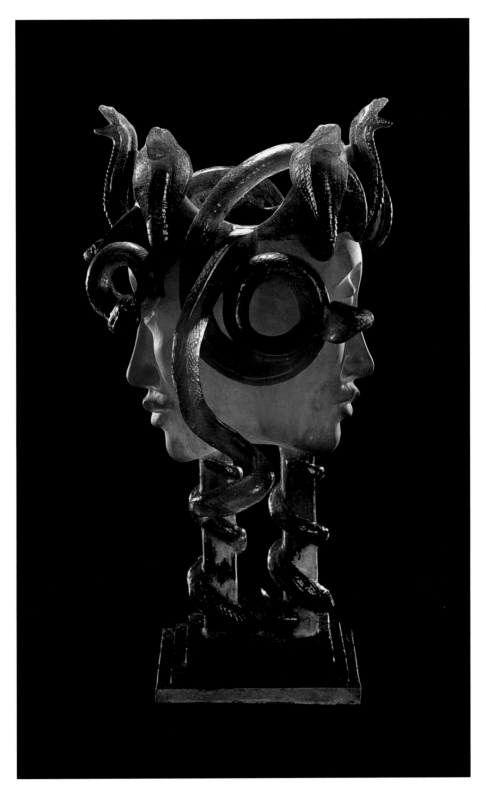

Seth Randal (American, born twentieth century)
A Woman of Substance
1996
Pâte de cristal
22" x 12" x 9"
Collection of Ron and Lisa Brill
Photo: Roger Schreiber

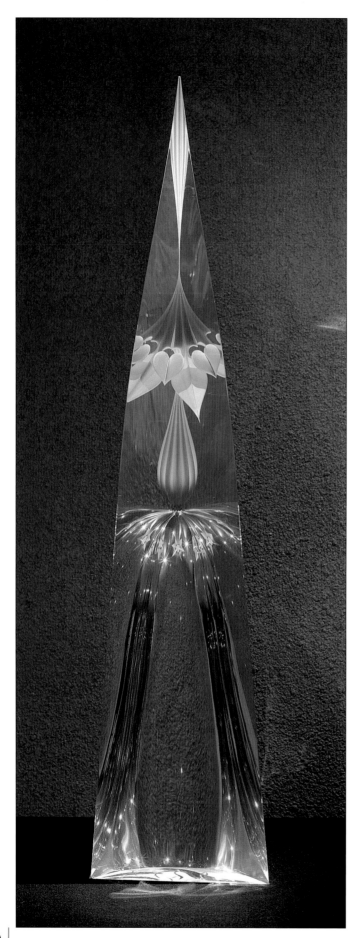

Christopher Ries (American, born 1952)
Desert Flower
1996
Optical glass
38⁵⁄₁₆″ x 15⁵⁄₁₆″ x 8¾″
Collection of Ron and Jackie Carmen
Photo: Jeff Bates

Aesthetically what has held is
that, although I work in three dimensions, I also
have the fourth dimension of optical illusion. I've
seen European glass [sculptures that] are gemlike
pieces, but what I haven't seen are simple, ele-
gant symphonies of light. I've explored every-
thing from figurative sculpture to the sublimely
abstract, and the most satisfying is the sublimely
abstract. This is the quintessential aesthetic of
glass. Its translucency, transparency, refractive
and reflective qualities, when they all coalesce,
it's exciting and unique. It's magic.

Christopher Ries
Duryea, Ohio
Telephone interview by Karen S. Chambers
13 September 1998

80

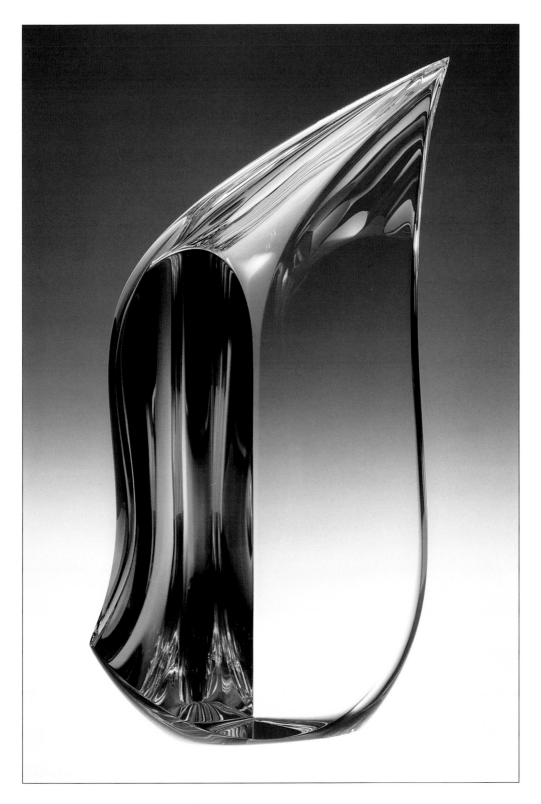

Christopher Ries (American, born 1952)

Embrace

1994

Optical glass

23″ x 14″ x 4″

Collection of the artist

Courtesy of Naples Art Gallery, Naples, FL

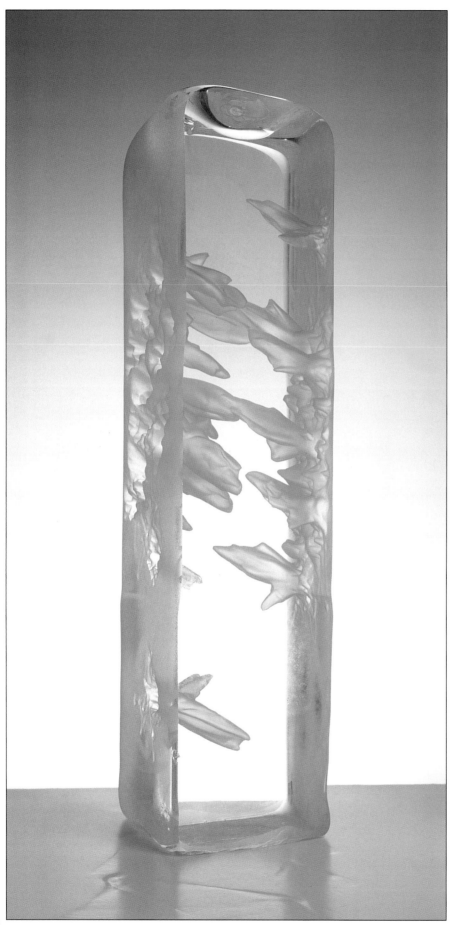

Christopher Ries (American, born 1952)
Coral Garden
1978
Optical glass
27" x 7" x 7"
Museum of Contemporary Art, Lake Worth, FL
Gift of the Lannan Foundation 1978.153
Photo: Barry Kinsella

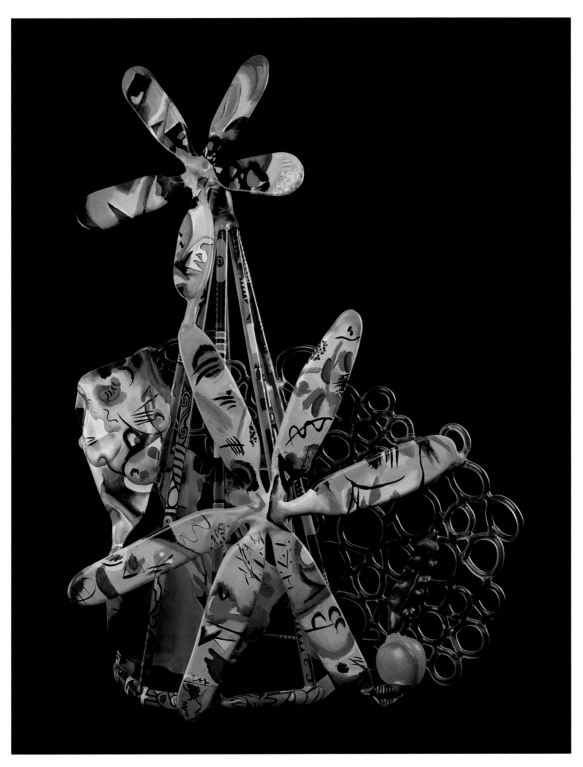

Ginny Ruffner (American, born 1952)
Don Quixote, Eat Your Heart Out!
1994–95
Lampworked and painted glass
28" x 21" x 13"
Collection of Dr. and Mrs. Richard Basch
Photo: Doug Schaible

Being an artist, [I find that] all of art history has been a wonderful seedbed of ideas.

Ginny Ruffner
Seattle, Washington
28 September 1998

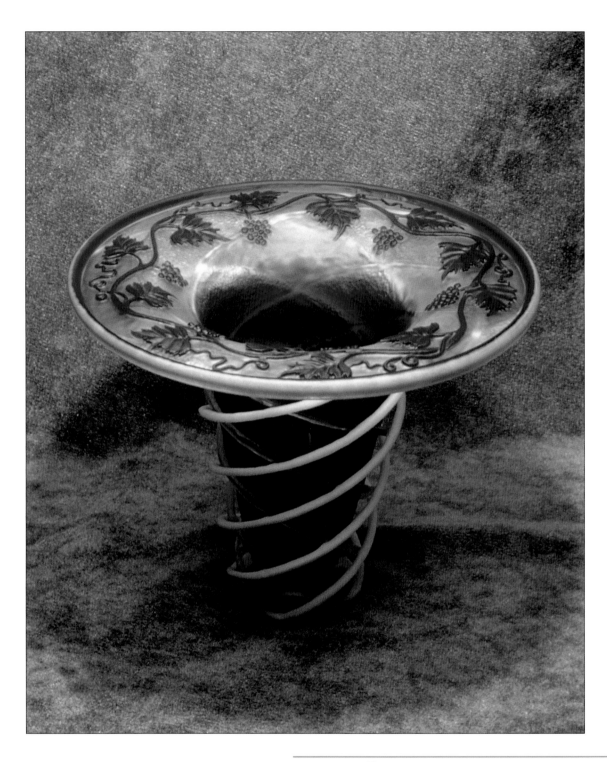

Barry Sautner (American, born 1952)
Cyclone
1993
Sand-carved glass
4¾″ x 6″ x 6″
Collection of the artist

Inspired by both Roman cage cups and later English cameo carvers, I use new techniques and technology to replicate the fine detail created in the past by other means. Glass has always been my canvas and my voice. In my carving I attempt to express my innermost feelings, which are very difficult for me to express in words.

Barry Sautner
Lansdale, Pennsylvania
28 September 1998

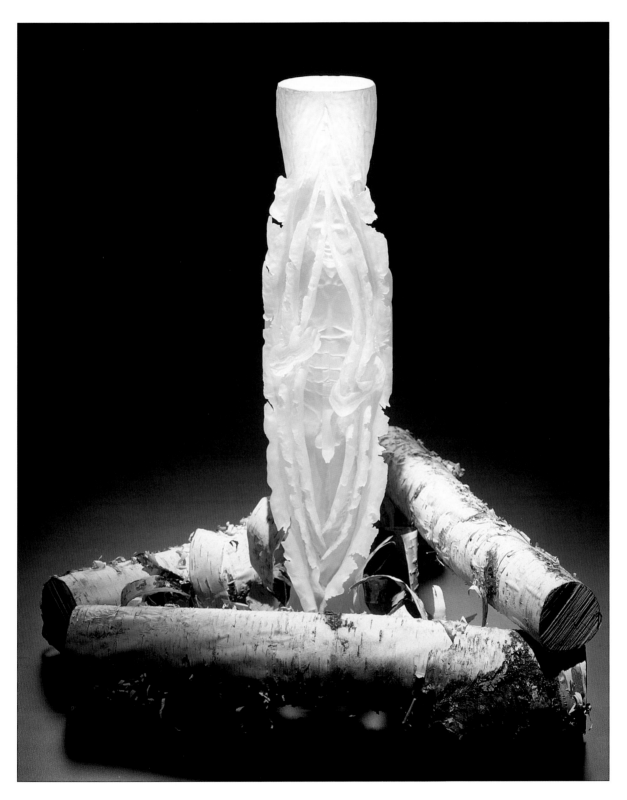

Barry Sautner (American, born 1952)
The Emergence
1996
Sand-carved glass and birch logs
26″ x 14″ x 14″
Collection of the artist
Photo: Doug Schaible

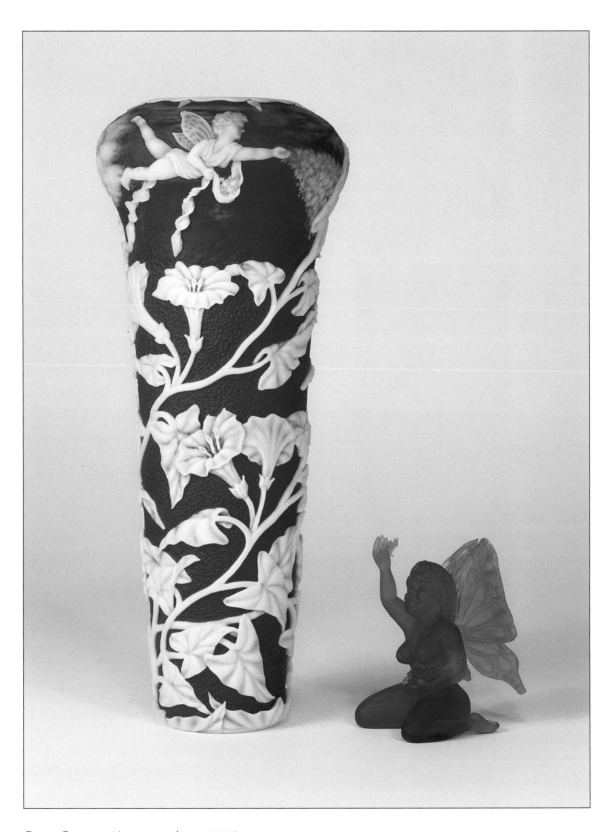

Barry Sautner (American, born 1952)
Stardust: Collecting the Fallen Stars
1997
Sand-carved glass
8½″ x 5½″ x 3½″ (vessel)
Collection of the artist

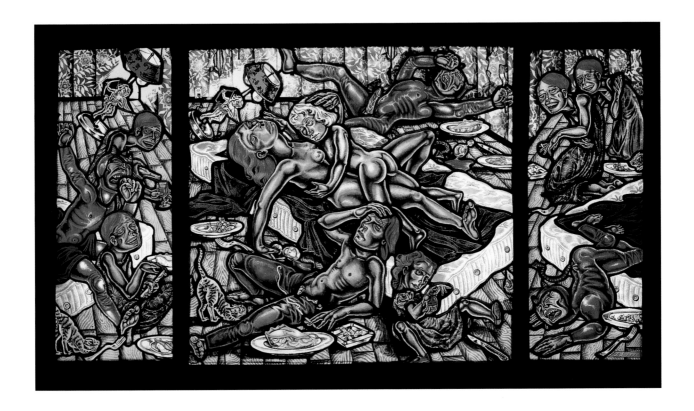

Judith Schaechter (American, born 1961)
Virtue Triumphs (When the Devil Sleeps)
1991
Stained glass
26¼″ x 45½″ W
Collection of Beverly and Sam Kostrinsky
Photo: Courtesy of Snyderman Gallery,
 Philadelphia, PA

The main way that the history of glass has affected me is that, if Dale Chihuly had not started the Rhode Island School of Design glass program, I never would have taken the elective stained-glass class that changed my artwork forever. The German artist Hans Gottfried von Stockhausen originated the idea of stained glass as "autonomous"—separate from architecture—also making my work possible.

I am inspired mostly by fine arts and popular culture, like comic books, and glass itself. The glass that has inspired me includes Gothic stained glass, the work of my teacher Ursula Huth, and very often, my students. I am very inspired by the potential of stained glass and hope to push what the medium can do.

Judith Schaechter
Philadelphia, Pennsylvania
September 1998

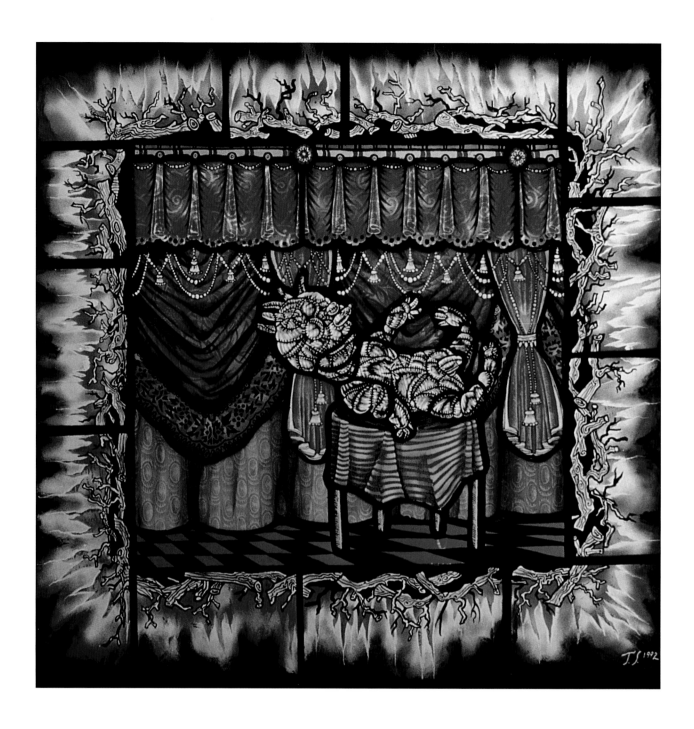

Judith Schaechter (American, born 1961)
Infernal!
1992
Stained glass
18″ x 19″ W
Collection of Joan and Milton Baxt
Photo: Courtesy of Snyderman Gallery, Philadelphia, PA

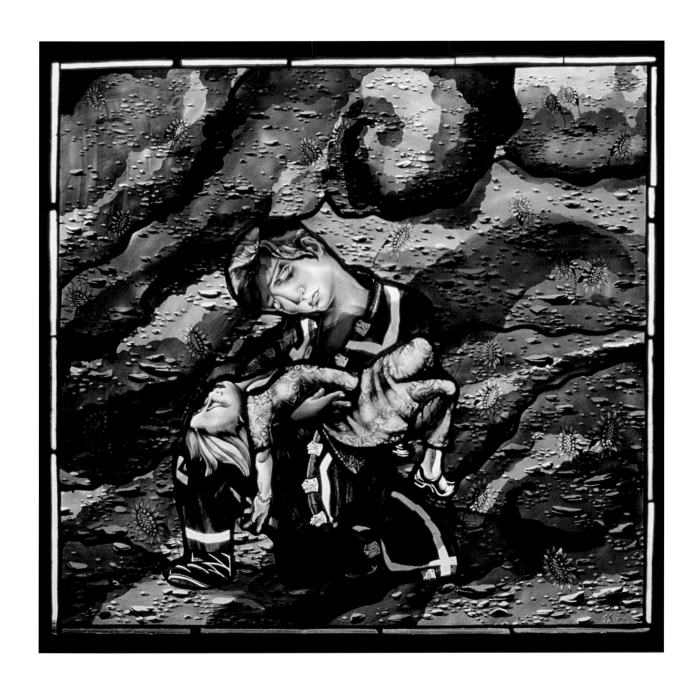

Judith Schaechter (American, born 1961)
Failure and Child
1997
Stained glass
26″ x 28″ W
Collection of Sheldon and Lois Polish
Photo: Courtesy of Snyderman Gallery, Philadelphia, PA

Paul J. Stankard (American, born
 1943)
Goat's Beard Daisy with Spirits from the
 "Cloistered Botanical Series"
1989
Lampworked glass encased in crystal
6¾" x 3¼" x 3"
Collection of Dale & Doug Anderson
Photo: Bill Sanders

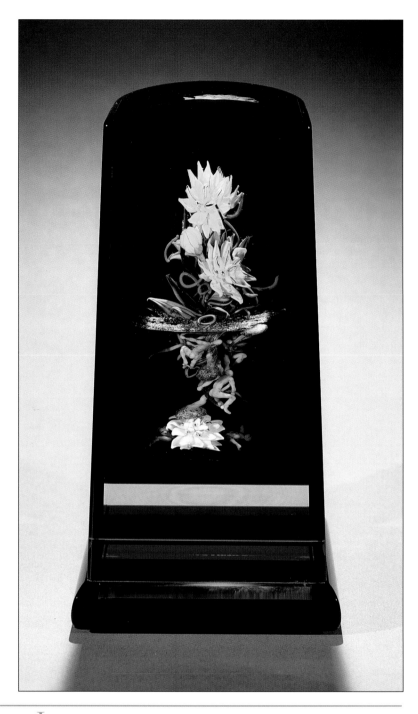

I see my work in the tradition of the French paperweight makers of the 1800s. Mine is a personal aesthetic and true to the material, with more illusion. There is organic credibility, but it's far from real. It's an imaginary world.

Gallé, Tiffany, and the other artists of the Art Nouveau period took the grand view of nature, but I take a microscopic look—the beauty and the mystery of the blossom instead of the field. It records a sentiment and sensitivity that is of our time.

Paul Stankard
Mantua, New Jersey
Telephone interview by Karen S. Chambers
20 September 1998

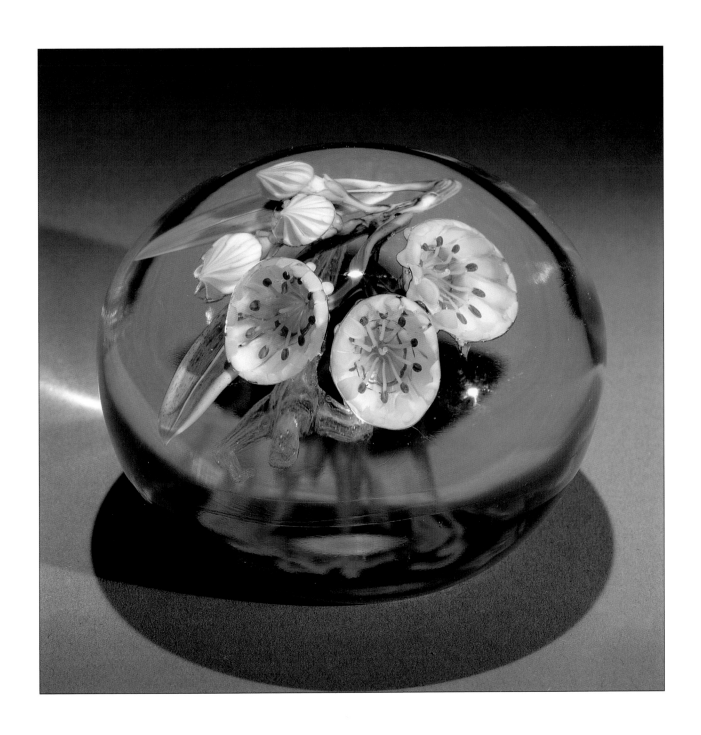

Paul J. Stankard (American, born 1943)
Mountain Laurel Bouquet with Apparition
1991
Lampworked glass encased in crystal
3″ Diameter
Collection of Barrie Feld
Photo: Bill Sanders

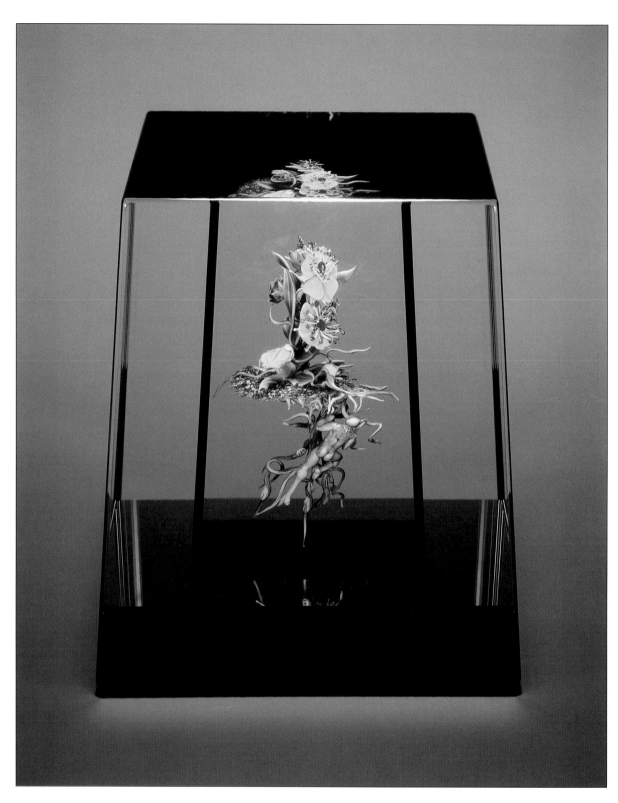

Paul J. Stankard (American, born 1943)
Coronet Botanical Cube
1995
Lampworked glass encased in crystal
5¼″ H
Collection of Mike and Annie Belkin
Photo: John Bigelow Taylor

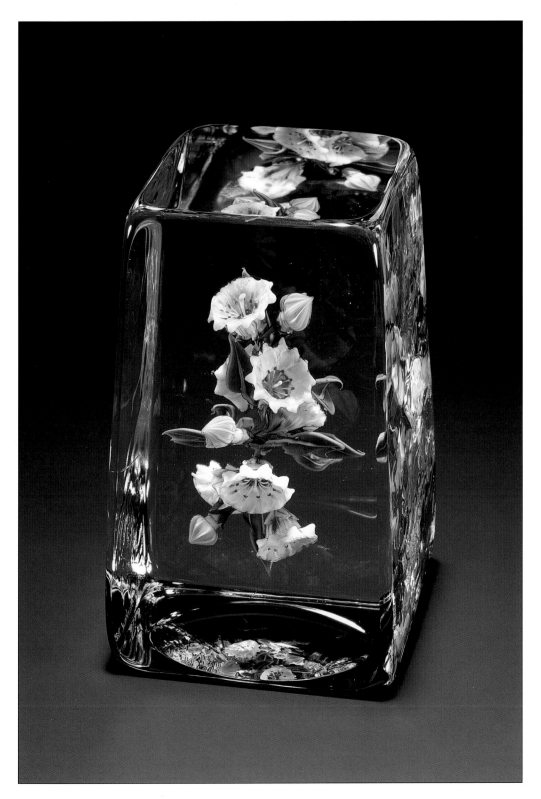

Paul J. Stankard (American, born 1943)

Mountain Laurel Botanical

1994

Lampworked glass encased in crystal

5″ H

Collection of Mike and Annie Belkin

Photo: John Bigelow Taylor

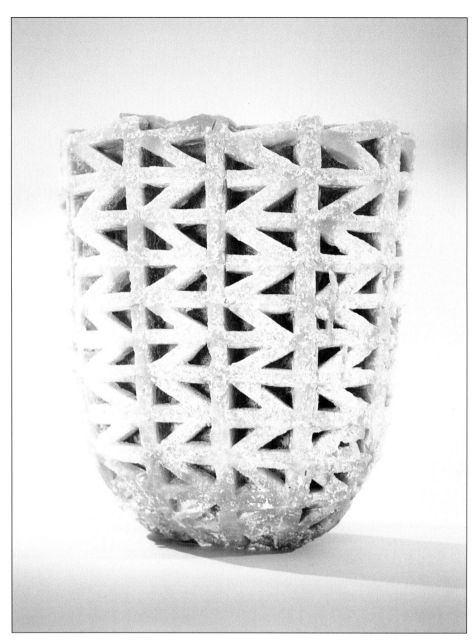

Karla Trinkley (American,
 born 1956)
Pink Bowl
1990
Pâte de verre
15⅞" x 14" x 8¾"
The Toledo Museum of Art,
 Toledo, OH
Gift of Edward Drummond
 Libbey 1991.5

The history of ceramics has had more influence on me than the history of glass. I'd say the history of classical shape and archaic form has been more influential, i.e., the perfect proportions of the human body and/or vessel coupled with visual weight and balance.

Oceanic art, primitive weaponry, personal boundary delineations (fences, grillwork, oil storage tanks), bridges, Eastern architecture, diatoms, skeletal structure of seed pods, archaic gorgets, and bannerstones have inspired me.

I worked with *pâte de verre* because of how I read it described: waxy, translucent, and mystical. It wasn't mainstream when I started working with it in 1979; therefore, it was more challenging visually, conceptually, and scientifically. As far as seeing an actual piece to replicate: no.

Karla Trinkley
Boyertown, Pennsylvania
30 September 1998

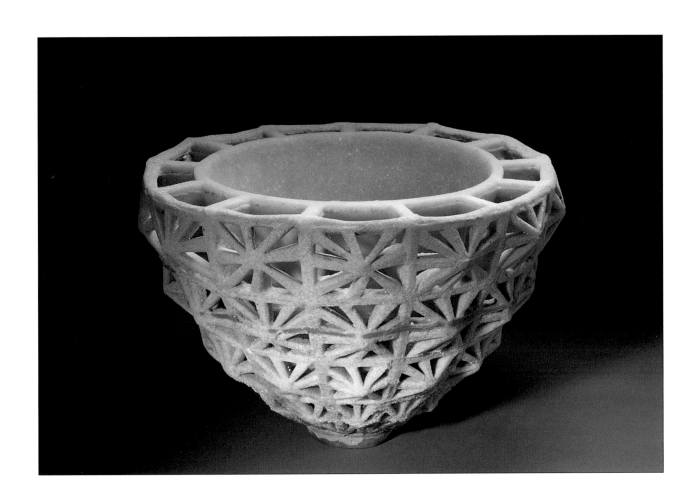

Karla Trinkley (American, born 1956)
Terrapene
1994
Pâte de verre
13" x 21" Diameter
Collection of Ian Friedman
Courtesy of Barry Friedman Ltd., New York, NY

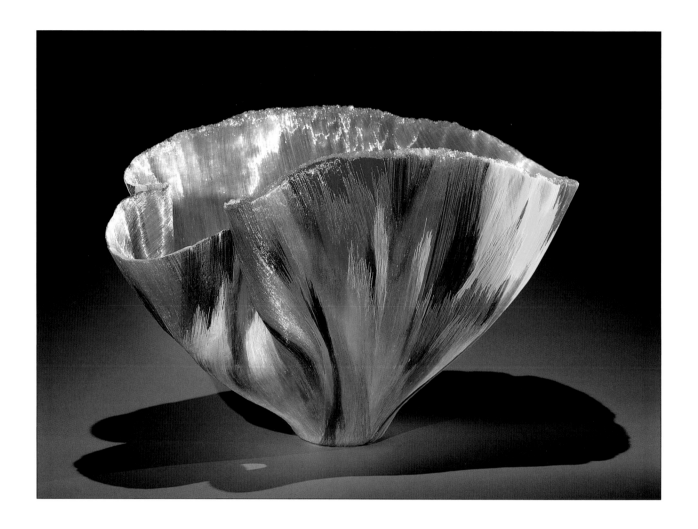

Toots Zynsky (American, born 1951)
Night Street Chaos
1998
Fused glass
7⅛″ x 13″ x 7″
Collection of Dale & Doug Anderson
Photo: Bill Sanders

Many years ago, before I ever had any intention of incorporating color into my primarily sculptural glasswork, I saw at the Corning Museum a "ribbon bowl"—Roman from the first century B.C. or A.D. (it is not known for sure) and made before glassblowing was invented. Although it was many years after that I began to explore the use of color, in retrospect, that piece must have sparked something in my imagination.

In addition to the natural world, more recently Italian paintings from the fourteenth and fifteenth centuries, with their dense palette and fusion of both rich and muted tones, have probably been my most important conscious source of inspiration.

Toots Zynsky
Amsterdam, the Netherlands
28 September 1998

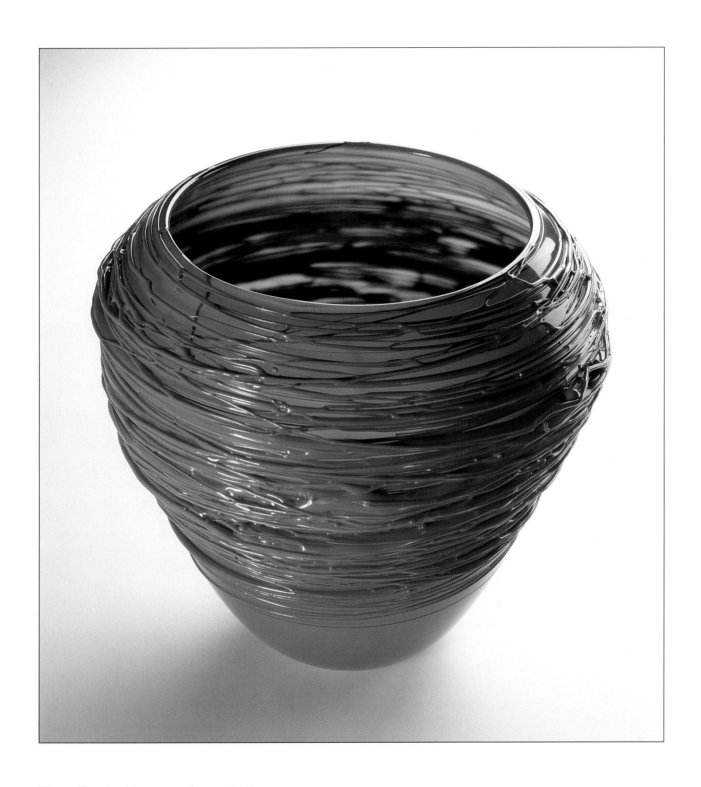

Toots Zynsky (American, born 1951)
Untitled
1982
Fused glass
6″ x 7″ Diameter
Collection of Mr. and Mrs. Carl H. Pforzheimer, III
Photo: Eva Heyd

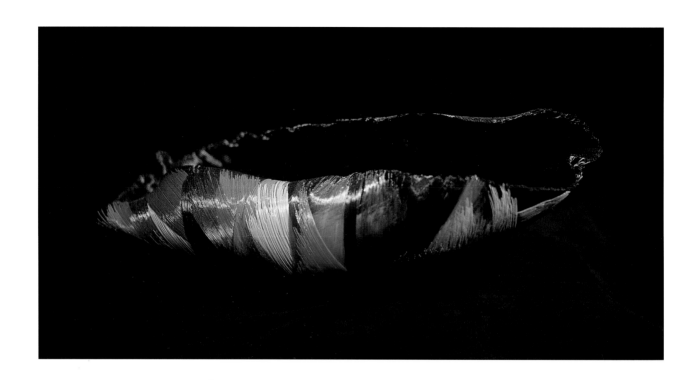

Toots Zynsky (American, born 1951)
Dark Room Chaos
1994
Fused glass
5½" x 17½" x 5½"
Collection of Myrna and Sheldon Palley

HISTORICAL OBJECTS

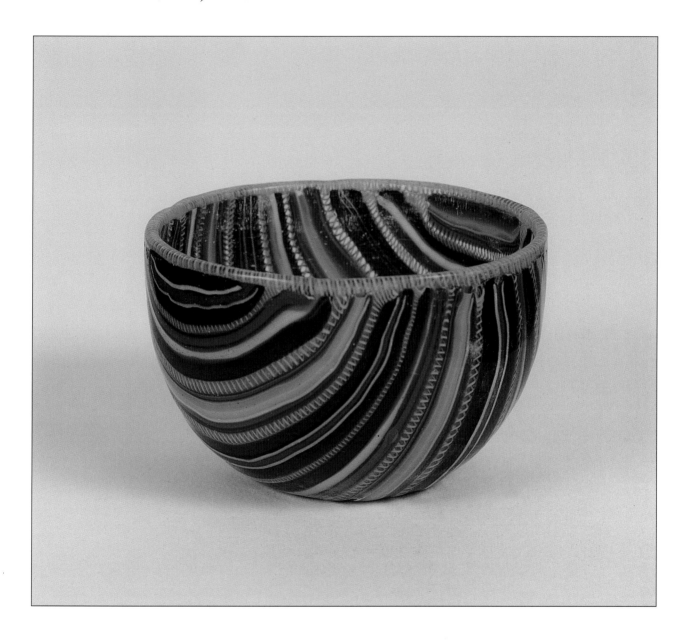

Agate Bowl
Roman (possibly Italy or Alexandria, Egypt)
First century B.C. to first century A.D.
Fused and slumped glass
2¼″ x 3¹¹⁄₁₆″ Diameter
The Toledo Museum of Art, Toledo, OH
Purchased with funds from the Libbey Endowment
Gift of Edward Drummond Libbey 1968.87

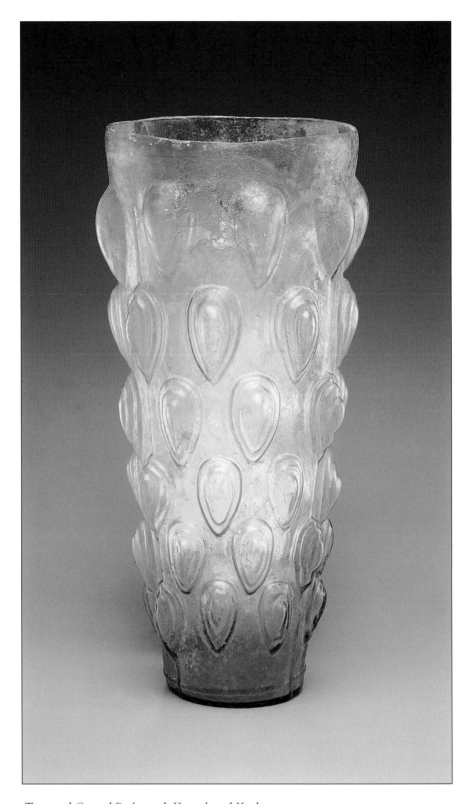

Truncated Conical Beaker with Knot-shaped Knobs
Roman (probably Eastern Mediterranean)
Middle to second half of first century A.D.
Mold-blown glass
8″ H
The Toledo Museum of Art, Toledo, OH
Gift of Edward Drummond Libbey 1923.490

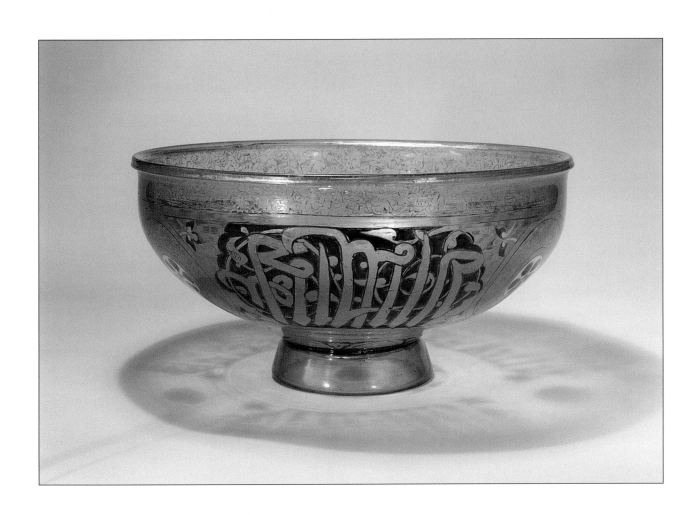

Bowl
Islamic
Mid-fourteenth century
Mold-blown and enameled glass
7" H
The Toledo Museum of Art, Toledo, OH
Purchased with funds from the Libbey Endowment
Gift of Edward Drummond Libbey 1944.33

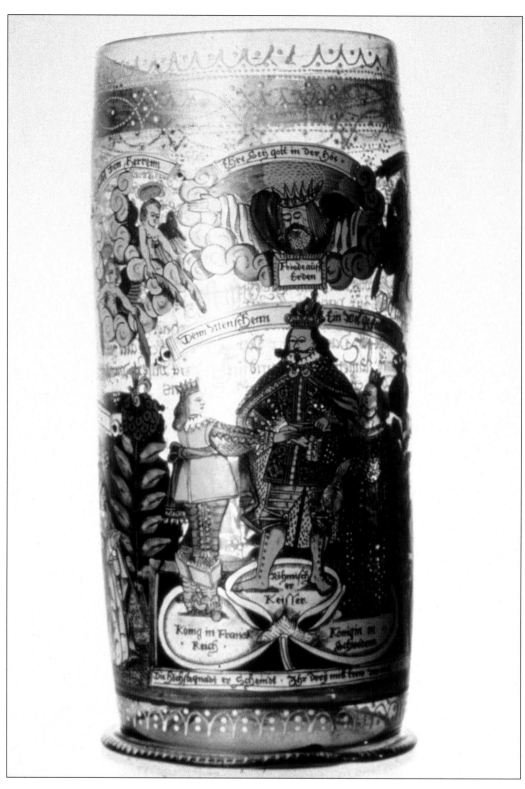

Humpen
German (Franconia)
1651
Enameled glass
10½″ H
The Toledo Museum of Art, Toledo, OH
Gift of Edward Drummond Libbey 1950.29

New England Glass Works (East Cambridge, MA)
Footed Bowl
About 1815–35
Mold-blown glass
5⅜″ x 8¼″ Diameter
The Newark Museum, Newark, NJ
Purchase 1954 Sophronia Anderson Bequest 54.224

Bowl
Italian, Venice, Murano
About 1875
Fused and slumped glass
3⅜″ x 6½″ Diameter
The Metropolitan Museum of Art, New York, NY
Gift of James Jackson Jarves, 1881 (81.8.228)
Photo: © 1998 The Metropolitan Museum of Art

Thomas Webb & Sons (British, nineteenth century)
Sunflower Vase
About 1888–89
Cameo glass
13½″ H
The Toledo Museum of Art, Toledo, OH
Gift of Florence Scott Libbey 1986.10

Tiffany Studios (Corona, NY)
Reticulated Tobacco Jar with Cover
Late nineteenth to early twentieth century
Bronze and blown glass
7¾" H
Chrysler Museum of Art, Norfolk, VA
Gift of Walter P. Chrysler, Jr. 71.2694
Photo: © Chrysler Museum of Art, Norfolk, VA

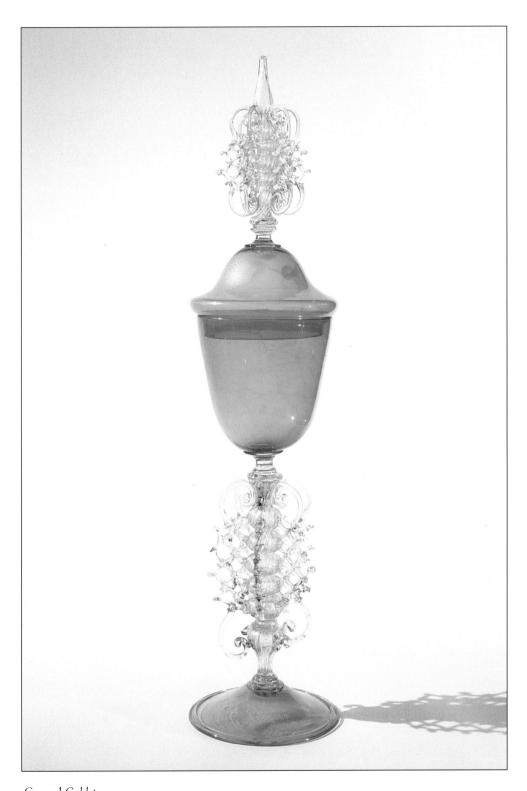

Covered Goblet
Italian, Venice
About 1900–50
Blown glass
32″ H
Chrysler Museum of Art, Norfolk, VA
Gift of Mrs. Marjory S. Strauss 81.44
Photo: © Chrysler Museum of Art, Norfolk, VA

Russian Emperor's Glassworks (St. Petersburg, Russia)
Vase
1903
Cameo glass
20¾" x 8¼" Diameter
Tampa Museum of Art, Tampa, FL
Gift of Sylvia and Samuel Jacobson 89.5
Photo: Hans Kaczmarek, GMP and Son

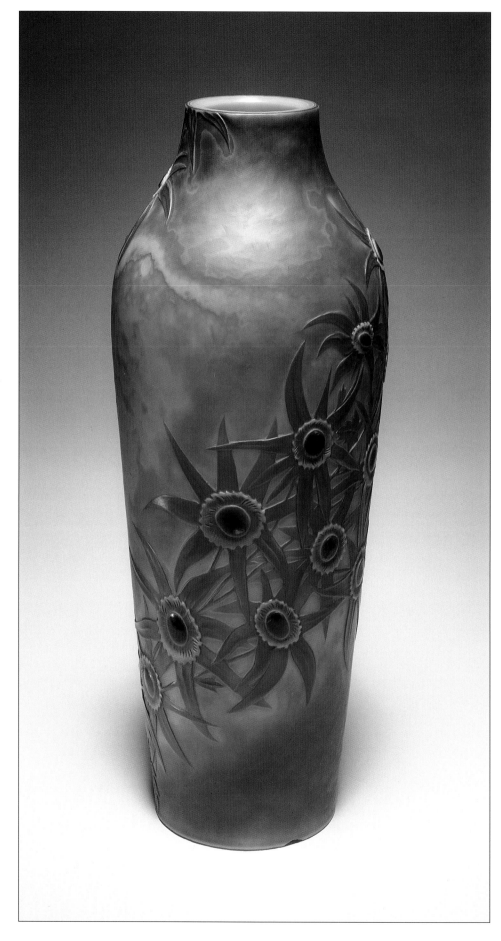

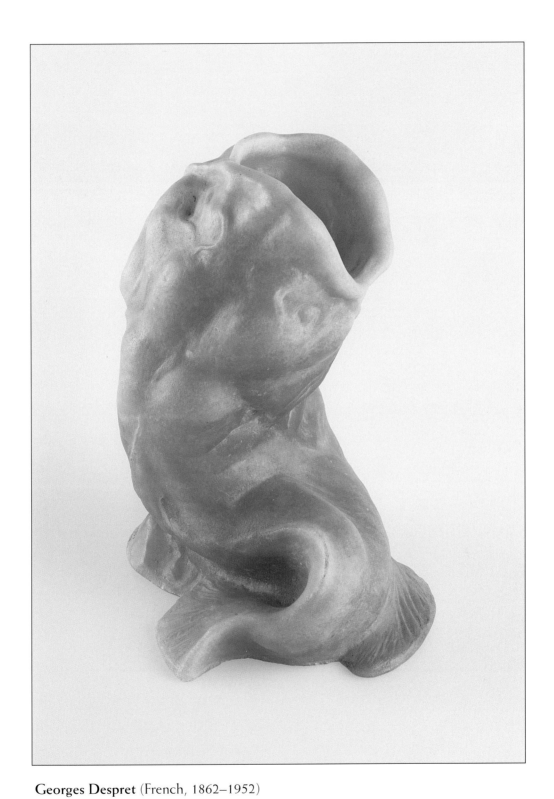

Georges Despret (French, 1862–1952)

Fish

About 1906

Pâte de verre

9⅞" H

Chrysler Museum of Art, Norfolk, VA

Gift of Walter P. Chrysler, Jr. 71.6354

Photo: Scott Wolf, Chrysler Museum of Art

© Chrysler Museum of Art, Norfolk, VA

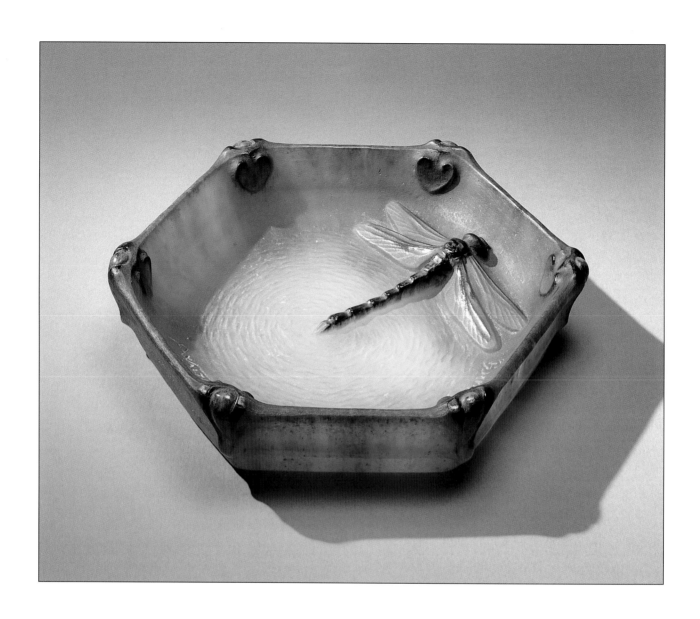

Amalric Walter (French, 1859–1942)
Vide Poche or *Cendrier*
About 1920
Pâte de verre
1⅝" x 7⅞" Diameter
Chrysler Museum of Art, Norfolk, VA
Gift of Walter P. Chrysler, Jr. 71.6668
Photo: © Chrysler Museum of Art, Norfolk, VA

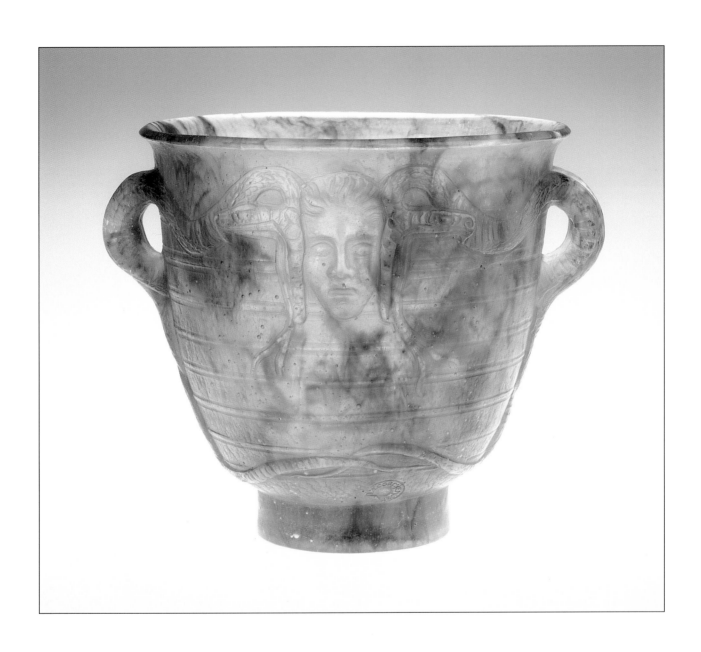

François-Émile Décorchemont (French, 1880–1971)
Bowl
1921–22
Blown glass and *cire-perdue* cast glass
6⅞" H
The Toledo Museum of Art, Toledo, OH
Gift of Hugh J. Smith, Jr., New York 1949.1
Photo: Tim Thayer

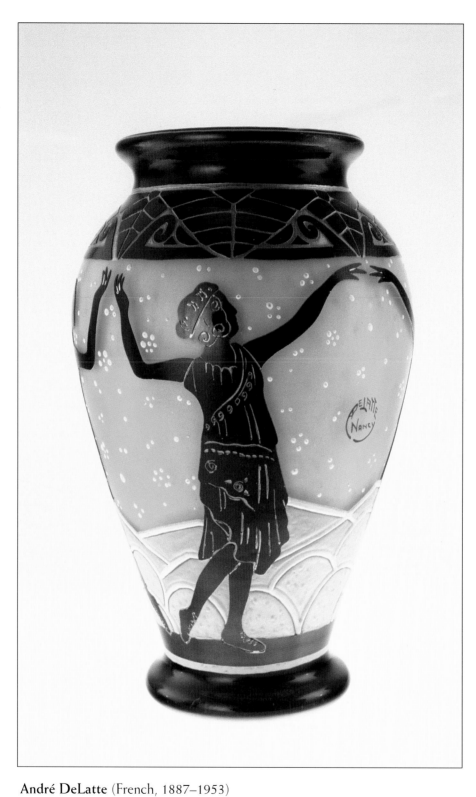

André DeLatte (French, 1887–1953)
Isadora Duncan–Style Vase
About 1922
Glass
12″ H
Chrysler Museum of Art, Norfolk, VA
Gift of Walter P. Chrysler, Jr. 71.6364
Photo: © Chrysler Museum of Art, Norfolk, VA

Daum Frères (Nancy, France)
Footed Bowl
About 1925–30
Blown glass
11⅜″ H
Chrysler Museum of Art, Norfolk, VA
Gift of Walter P. Chrysler, Jr. 71.7176
Photo: © Chrysler Museum of Art, Norfolk, VA

Frederick Carder (American, 1863–1963)
for the Steuben Glass Works, Corning, NY
Rose duBarry and Mirror Black Bath Salts Jar
About 1925
Blown lead glass with applied threading and cut stopper
4″ x 4½″ x 4½″
Rockwell Museum, Corning, NY 78.486.a-b F
Photo: James O. Milmoe

Frederick Carder (American, 1863–1963)
for the Steuben Glass Works, Corning, NY
Millefiori Plate
About 1926
Fumed lead glass
8¾″ Diameter
Private collection on long-term loan to the Rockwell Museum, Corning, NY
Photo: James O. Milmoe

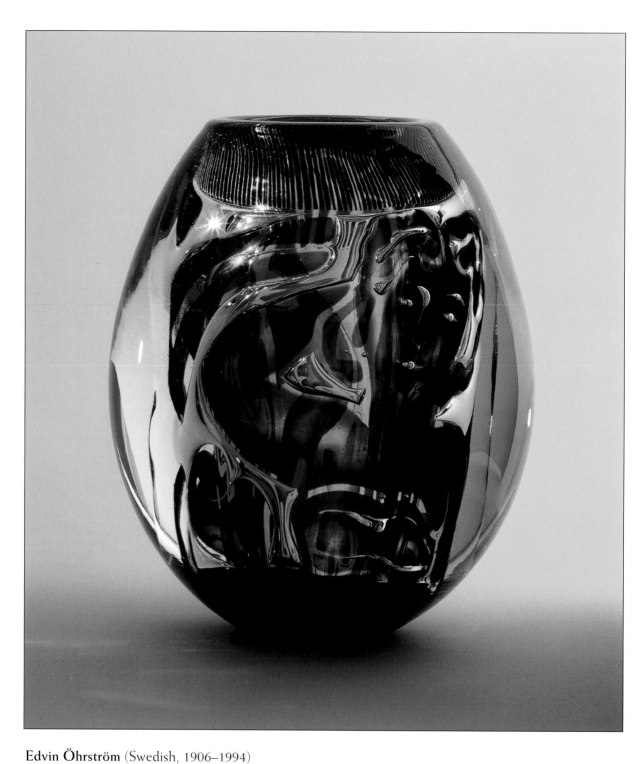

Edvin Öhrström (Swedish, 1906–1994)
for A.B. Orrefors Glasbruk, Orrefors, Sweden
Ariel #104
1939
Blown glass
8⅛″ x 7¼″ Diameter
The Metropolitan Museum of Art, New York, NY
Purchase, Edward C. Moore, Jr., Gift, 1939 (39.154.5)
Photo: Mark Darley
©1989 The Metropolitan Museum of Art

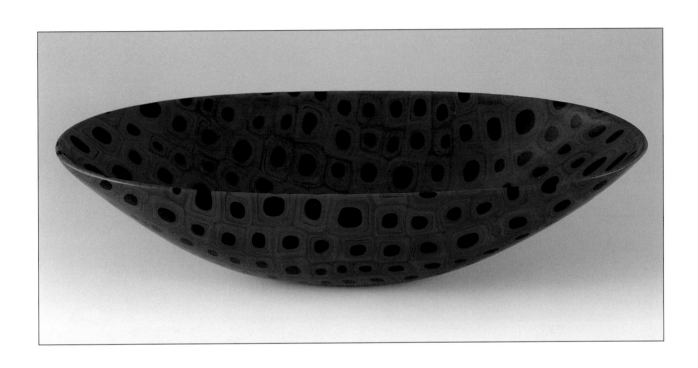

Carlo Scarpa (Italian, 1906-1976)
Murrine Bowl
About 1940
Fused glass
1¾" x 7¾" x 3½"
Courtesy of Barry Friedman Ltd., New York, NY
Photo: Ali Elai, Camerarts, Inc., New York, NY

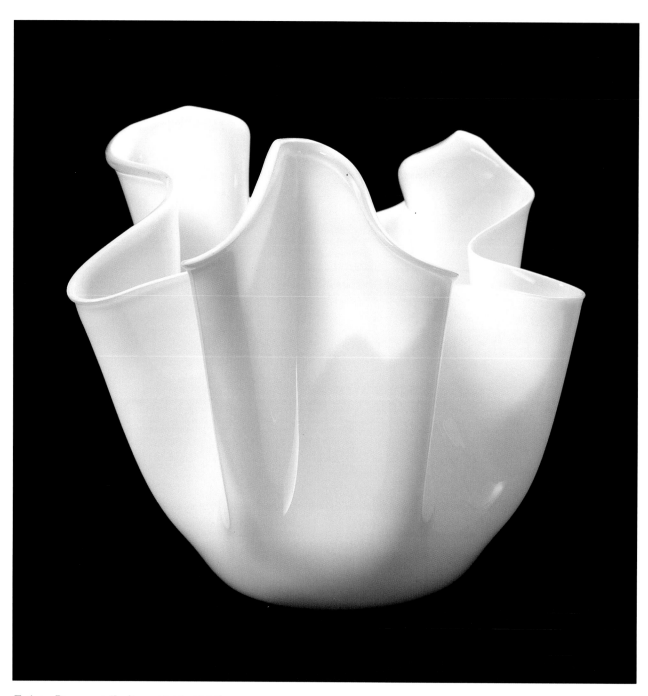

Fulvio Bianconi (Italian, 1915–1996)
Paolo Venini (Italian, 1895-1959)
Designed for Venini & C., Venice, Italy
White Fazzoletto (Handkerchief) Vase
About 1948
Blown glass
10⅜" x 11¼" x 10½"
Courtesy of Charles Cowles Gallery, New York, NY

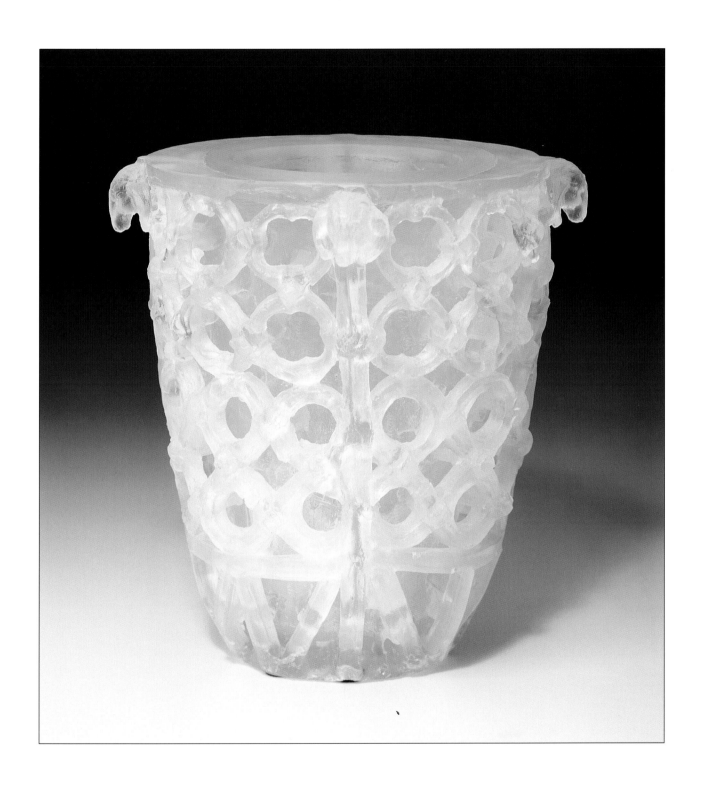

Frederick Carder (American, 1863–1963)

Colorless Diatreta Vase

1951

Cire-perdue cast lead glass

6 11/16″ x 6 7/16″ Diameter

Rockwell Museum, Corning, NY

Bequeathed by Frank and Mary Elizabeth Reifschlager 82.4.85 F

Photo: Chris Ibberson

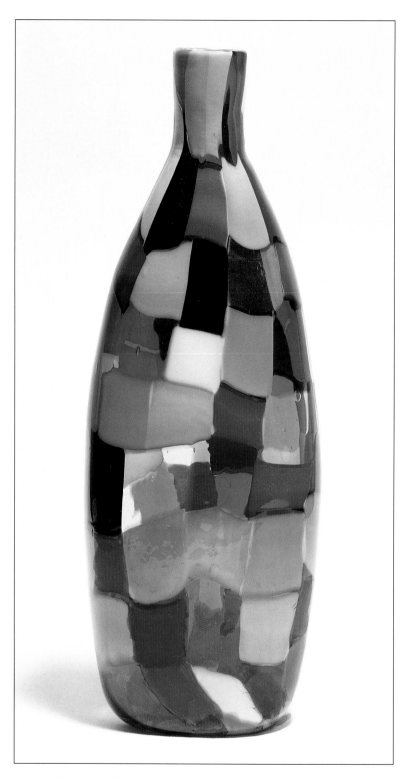

Fulvio Bianconi (Italian, 1915–1996)
Designed for Venini & C., Venice, Italy
Bottle-Shaped Vetro Pezzato Vase
About 1955
Blown glass
14″ x 5″ x 3″
Courtesy of Barry Friedman Ltd., New York, NY
Photo: Ali Elai, Camerarts, Inc., New York, NY

CHECKLIST OF WORKS IN THE EXHIBITION

H x W x D (or Diameter)

Doug Anderson (American, born 1952)
Fish Plate
1985
Pâte de verre
16" Diameter
Collection of Jeffrey and
 Cynthia Manocherian

Star Gazer
1989
Pâte de verre
14¼" x 5" x 10½"
Collection of the artist

Fish
1991
Pâte de verre
3½" x 4" x 3"
Collection of the artist
Courtesy of Heller Gallery,
 New York, NY

Oppressed
1992
Pâte de verre
7½" x 4" Diameter
Collection of the artist

John Brekke (American, born 1955)
Hole in the Levee
1995
Blown and sandblasted glass
28" x 13" x 10"
Collection of the artist
Courtesy of Leo Kaplan Modern,
 New York, NY

Uhoh My Darlings
1995
Blown and sandblasted glass
12" x 12½" x 7½"
Collection of the artist
Courtesy of Leo Kaplan Modern,
 New York, NY

Underground Brooklyn
1997
Blown and sandblasted glass
13" x 11" x 7½"
Collection of the artist
Courtesy of Leo Kaplan Modern,
 New York, NY

Robert Carlson (American, born 1952)
Aeon
1990–96
Blown glass, pigments, and gold,
 aluminum, and copper leaf
30" x 10½" Diameter
The Toledo Museum of Art, Toledo, OH,
Gift in honor of Ashley and Brennan
 Kasperzak 1996.40

Temple of Dreams
1993
Blown glass, enamel paint, and gold leaf
31" x 11" W
Collection of Nancy and Phillip Kotler

Axis Mundi
1996
Blown glass, wood, enamel paint, and
 gold and copper leaf
32" x 16" x 13"
Collection of Sara Jane Kasperzak

Dale Chihuly (American, born 1941)
*Cobalt and Gold Crackle Venetian with Leaves
 and Coils*
1993
Blown glass
24" x 18" x 16"
Collection of the artist

*Titanium White Seaform Set with
 Black Lip Wraps*
1998
Blown glass
22" x 30" x 22"
Collection of the artist

*Rose and Coral Persian Set with
 Black Lip Wraps*
1998
Blown glass
15" x 26" x 31"
Collection of the artist

Dan Dailey (American, born 1947)
Le Vent
1984
Pâte de verre
13" x 23½" x 4"
Collection of Barbara and Kenneth
 Tricebock

Nimble from the "Male/Female Series"
1989
Mold-blown, sandblasted, and
 acid-polished crystal
11" x 8" x 5"
Collection of the artist

Nude with Golden Thorns
1995
Blown glass, fabricated and gold-plated
 bronze, and Vitrolite
31" x 26" x 9"
Collection of the artist
Courtesy of Imago Gallery,
 Palm Desert, CA

Antic Circus Vase
1996
Blown glass and gold-plated bronze
18‴ x 15" Diameter
Courtesy of Riley Hawk Galleries,
 Columbus and Cleveland, OH

Michael Glancy (American, born 1950)
Golden Triskellion
1984
Blown glass and copper
5⅛" x 2½" Diameter
Chrysler Museum of Art, Norfolk, VA
Purchase, Paramount Industrial
 Companies Contemporary Glass Fund
 84.422

Euclidean Eruption
1986
Blown glass and copper
7" x 6" Diameter
Collection of Jeffrey and Cynthia
 Manocherian

Boss Codex
1986
Blown glass and copper
15" x 25" x 10"
Collection of Myrna and Sheldon Palley

Reverberating Nexus
1989
Blown glass, industrial plate glass, copper,
 and silver
11" x 18" x 18"
Collection of the artist

William Gudenrath (American, born
 1950)
Dragon-stemmed Goblet (based on a seven-
 teenth-century Venetian dragon-
 stemmed goblet in the British
 Museum, London, England)
1998
Blown and hot-worked glass
12" H
Collection of the artist

Dragon-stemmed Goblet (based on a seven-
 teenth-century Venetian dragon-
 stemmed goblet in the British
 Museum, London, England)
1998
Blown and hot-worked glass
13" H
Collection of the artist

Writhen-stemmed Footed Bowl with Optic Fluting
 (based on a seventeenth-century
 Venetian dragon-stemmed goblet in
 the British Museum, London, England)
1998
Blown and hot-worked glass and gold leaf
6" x 11" Diameter
Collection of the artist

Wineglass (based on a sixteenth-century
 Venetian wineglass in The Corning
 Museum of Glass, Corning, NY)
1998
Blown glass
8" H
Collection of the artist

Champagne Glass (based on a sixteenth-
 century Venetian wineglass in The
 Corning Museum of Glass,
 Corning, NY)
1998
Blown glass
9½" H
Collection of the artist

Champagne Glass (based on a sixteenth-
 century Venetian wineglass in The
 Corning Museum of Glass,
 Corning, NY)
1998
Blown glass
11" H
Collection of the artist

Dorothy Hafner (American, born 1952)
Quadrant
1997
Blown glass
12" x 12" x 5½"
Collection of the artist
Courtesy of Heller Gallery,
 New York, NY

Mozambique
1997
Blown glass
17½" x 6½" x 5½"
Collection of the artist
Courtesy of Heller Gallery,
 New York, NY

Cranberry Wrap
1997
Blown glass
24" x 7" x 6"
Collection of the artist
Courtesy of Heller Gallery,
 New York, NY

Dante Marioni (American, born 1964)
Goose Beak Trio
1997
Blown glass
34¼" x 8¼" W; 31¾" x 7½" W; 18½" x
 13¼" W
Collection of the artist
Courtesy of Grand Central Gallery,
 Tampa, FL

Red Mosaic Vase
1997
Blown glass
25½" x 5½" x 5½"
Collection of Mr. and Mrs. Thomas
 Schreiber

Dante Marioni (American, born 1964)
Richard Marquis (American, born 1945)
Shard Whopper
1992–95 (Blown by Marioni in 1992,
 decorated by Marquis in 1995)
Blown glass and glass shards
28" x 10¼" Diameter
Collection of Dale & Doug Anderson

Richard Marquis (American, born 1945)
Teapot Goblet #134
About 1989
Blown glass
10" H
Collection of Mr. and Mrs. William Block

Marquiscarpa N-1
1991–92
Blown, fused, slumped, and
 fabricated glass
6½" x 13" x 2½"
Collection of Dale & Doug Anderson

Hightone Red Rocket
1995
Cast and blown glass
22" x 29" x 8½"
Collection of the artist

Klaus Moje (German, born 1936)
Untitled (Bowl or Lifesaver)
1979
Fused glass
3⅞" x 10¹⁄₁₆" Diameter
The Toledo Museum of Art, Toledo, OH
Gift of Dorothy and George Saxe 1993.6

9-1987 #34
1987
Fused glass
1¾" x 12¼" x 12"
Collection of the artist
Courtesy of Habatat Galleries,
 Pontiac, MI

9-1989 #42
1989
Fused and slumped glass
22" Diameter
Collection of Jeffrey and Cynthia
 Manocherian

Etsuko Nishi (Japanese, born 1955)
Lace Cage Bowl
1991
Pâte de verre
6¼" x 10½" x 10½"
Collection of the artist
Courtesy of Heller Gallery,
 New York, NY

Caged Vessel
1994
Pâte de verre
7" x 11" x 11"
Collection of the artist
Courtesy of Heller Gallery,
 New York, NY

Caged Vessel
1994
Pâte de verre
10¼" x 9" x 9"
Collection of the artist
Courtesy of Heller Gallery,
 New York, NY

Seth Randal (American, born twentieth
 century)
Les Femmes Dangereuses
1993
Pâte de cristal
18" x 8" x 8"
Collection of Lorraine and Ron Haave

Untitled (Double Caged Cup)
1995
Pâte de verre
18" x 18" Diameter
Collection of the artist
Courtesy of Leo Kaplan Modern,
 New York, NY

A Woman of Substance
1996
Pâte de cristal
22" x 12" x 9"
Collection of Ron and Lisa Brill

Christopher Ries (American, born 1952)
Coral Garden
1978
Optical glass
27" x 7" x 7"
Museum of Contemporary Art,
 Lake Worth, FL
Gift of the Lannan Foundation 1978.153

Flame of Prometheus
1983
Optical glass
9" x 13¾" x 5"
Collection of Robert and Cheri Discenzo

Embrace
1994
Optical glass
23" x 14" x 4"
Collection of the artist
Courtesy of Naples Art Gallery, Naples, FL

Ice Cave
About 1991
Optical glass
17" x 14" x 9"
Collection of R. C. Friedman

Desert Flower
1996
Optical glass
38⁵⁄₁₆" x 15⁵⁄₁₆" x 8¾"
Collection of Ron and Jackie Carmen

Ginny Ruffner (American, born 1952)
In Case You Wondered, The Glass Is Half Full
1992
Lampworked and painted glass
14" x 30" x 13"
Collection of the artist
Courtesy of Heller Gallery, New York, NY

Still Alive
1993
Lampworked and painted glass
18" x 12" x 6"
Collection of the artist
Courtesy of Heller Gallery, New York, NY

Don Quixote, Eat Your Heart Out!
1994–95
Lampworked and painted glass
28" x 21" x 13"
Collection of Dr. and Mrs. Richard Basch

Barry Sautner (American, born 1952)
Cyclone
1993
Sand-carved glass
4¾" x 6" x 6"
Collection of the artist

The Emergence
1996
Sand-carved glass and birch logs
26" x 14" x 14"
Collection of the artist

Stardust: Collecting the Fallen Stars
1997
Sand-carved glass
8½" x 5½" x 3½" (vessel)
Collection of the artist

Judith Schaechter (American, born 1961)
Virtue Triumphs (When the Devil Sleeps)
1991
Stained glass
26¼" x 45½" W
Collection of Beverly and Sam Kostrinsky

Infernal!
1992
Stained glass
18" x 19" W
Collection of Joan and Milton Baxt

Study for Failure and Child
1997
Pencil on paper
28¼" x 22¼" W (framed)
Collection of Sheldon and Lois Polish

Failure and Child
1997
Stained glass
26" x 28" W
Collection of Sheldon and Lois Polish

Paul J. Stankard (American, born 1943)
Goat's Beard Daisy with Spirits from the
 "Cloistered Botanical Series"
1989
Lampworked glass encased in crystal
6¾" x 3¼" x 3"
Collection of Dale & Doug Anderson

Mountain Laurel Bouquet with Apparition
1991
Lampworked glass encased in crystal
3" Diameter
Collection of Barrie Feld

Mountain Laurel Botanical
1994
Lampworked glass encased in crystal
5" H
Collection of Mike and Annie Belkin

Coronet Botanical Cube
1995
Lampworked glass encased in crystal
5¼" H
Collection of Mike and Annie Belkin

Karla Trinkley (American, born 1956)
Pink Bowl
1990
Pâte de verre
15⅞" x 14" x 8¾"
The Toledo Museum of Art, Toledo, OH
Gift of Edward Drummond Libbey 1991.5

Terrapene
1994
Pâte de verre
13" x 21" Diameter
Collection of Ian Friedman
Courtesy of Barry Friedman Ltd.,
 New York, NY

Toots Zynsky (American, born 1951)
Untitled
1982
Fused glass
6" x 7" Diameter
Collection of Mr. and Mrs. Carl H.
 Pforzheimer, III

Endless Chaos
1994
Fused glass
7⅛" x 13" x 7½"
The Metropolitan Museum of Art,
 New York, NY
Gift of Kate Elliott, in honor of Anne
 Gould Hauberg, 1994 (1994.552)

Dark Room Chaos
1994
Fused glass
5½" x 17½" x 5½"
Collection of Myrna and Sheldon Palley

Night Street Chaos
1998
Fused glass
7⅛" x 13" x 7"
Collection of Dale & Doug Anderson

Historical Objects

In Chronological Order

Agate Bowl
Roman (possibly Italy or
 Alexandria, Egypt)
First century B.C. to first century A.D.
Fused and slumped glass
2¼" x 3¹¹⁄₁₆" Diameter
The Toledo Museum of Art, Toledo, OH
Purchased with funds from the Libbey
 Endowment
Gift of Edward Drummond Libbey
 1968.87

*Truncated Conical Beaker with Knot-shaped
 Knobs*
Roman (probably Eastern Mediterranean)
Middle to second half of first century A.D.
Mold-blown glass
8" H
The Toledo Museum of Art, Toledo, OH
Gift of Edward Drummond Libbey
 1923.490

Flask
Roman, Eastern Mediterranean (Syro-
 Palestinian)
Fourth to fifth century A.D.
Blown glass and applied and tooled
 decoration
7" x 2⅜" W
The Toledo Museum of Art, Toledo, OH
Gift of Edward Drummond Libbey
 1923.1054

Bottle
Post-Sasanian (Persian)
Seventh or eighth century A.D.
Blown, cut, and polished glass
5¹⁵⁄₁₆" x 3¾" Diameter
The Toledo Museum of Art, Toledo, OH
Gift of Edward Drummond Libbey
 1967.7

Bowl
Islamic
Mid-fourteenth century
Mold-blown and enameled glass
7" H
The Toledo Museum of Art, Toledo, OH
Purchased with funds from the Libbey
 Endowment
Gift of Edward Drummond Libbey
 1944.33

Humpen
German (Franconia)
1651
Enameled glass
10½" H
The Toledo Museum of Art, Toledo, OH
Gift of Edward Drummond Libbey
 1950.29

Rosewater Sprinkler
Islamic, Persian
Eighteenth century
Glass
14⅜" H
The Toledo Museum of Art, Toledo, OH
Gift of Edward Drummond Libbey
 1953.108

New England Glass Works (East
 Cambridge, MA)
Footed Bowl
About 1815–35
Mold-blown glass
5⅜" x 8¼" Diameter
The Newark Museum, Newark, NJ
Purchase 1954 Sophronia Anderson
 Bequest 54.224

Bowl
Italian, Venice, Murano
About 1875
Fused and slumped glass
3⅜" x 6½" Diameter
The Metropolitan Museum of Art,
 New York, NY
Gift of James Jackson Jarves, 1881
 (81.8.228)

Thomas Webb & Sons (British, nineteenth century)
Sunflower Vase
About 1888–89
Cameo glass
13½" H
The Toledo Museum of Art, Toledo, OH
Gift of Florence Scott Libbey 1986.10

Tiffany Studios (Corona, NY)
Reticulated Tobacco Jar with Cover
Late nineteenth to early twentieth century
Bronze and blown glass
7¾" H
Chrysler Museum of Art, Norfolk, VA
Gift of Walter P. Chrysler, Jr. 71.2694

Covered Goblet
Italian, Venice
About 1900–50
Blown glass
32" H
Chrysler Museum of Art, Norfolk, VA
Gift of Mrs. Marjory S. Strauss 81.44

Russian Emperor's Glassworks (St. Petersburg, Russia)
Vase
1903
Cameo glass
20¾" x 8¼" Diameter
Tampa Museum of Art, Tampa, FL
Gift of Sylvia and Samuel Jacobson 89.5

Georges Despret (French, 1862–1952)
Fish
About 1906
Pâte de verre
9⅞" H
Chrysler Museum of Art, Norfolk, VA
Gift of Walter P. Chrysler, Jr. 71.6354

Amalric Walter (French, 1859–1942)
Vide Poche or *Cendrier*
About 1920
Pâte de verre
1⅝" x 7⅞" Diameter
Chrysler Museum of Art, Norfolk, VA
Gift of Walter P. Chrysler, Jr. 71.6668

François-Émile Décorchemont (French, 1880–1971)
Bowl
1921–22
Blown glass and *cire-perdue* cast glass
6 7/8" H
The Toledo Museum of Art, Toledo, OH
Gift of Hugh J. Smith, Jr., New York 1949.1

André DeLatté (French, 1887–1953)
Isadora Duncan-style Vase
About 1922
Glass
12" H
Chrysler Museum of Art, Norfolk, VA
Gift of Walter P. Chrysler, Jr. 71.6364

Daum Frères (Nancy, France)
Footed Bowl
About 1925–30
Blown glass
11⅜" H
Chrysler Museum of Art, Norfolk, VA
Gift of Walter P. Chrysler, Jr. 71.7176

Frederick Carder (American, 1863–1963) for the Steuben Glass Works, Corning, NY
Rose duBarry and Mirror Black Bath Salts Jar
About 1925
Blown lead glass with applied threading and cut stopper
4" x 4½" x 4½"
Rockwell Museum, Corning, NY 78.486.a-b F

Millefiori Plate
About 1926
Fumed lead glass
8¾" Diameter
Private collection on long-term loan to the Rockwell Museum, Corning, NY

Edvin Öhrström (Swedish, 1906–1994) for A. B. Orrefors Glasbruk, Orrefors, Sweden
Ariel #104
1939
Blown glass
8⅛" x 7¼" Diameter
The Metropolitan Museum of Art, New York, NY
Purchase, Edward C. Moore, Jr., Gift, 1939 (39.154.5)

Carlo Scarpa (Italian, 1906-1976)
Murrine Bowl
About 1940
Fused glass
1¾" x 7¾" x 3½"
Courtesy of Barry Friedman Ltd., New York, NY

Fulvio Bianconi (Italian, 1915–1996)
Paolo Venini (Italian, 1895–1959)
Designed for Venini & C., Venice, Italy
White Fazzoletto (Handkerchief) Vase
About 1948
Blown glass
10⅜" x 11¼" x 10½"
Courtesy of Charles Cowles Gallery, New York, NY

Frederick Carder (American, 1863–1963)
Colorless Diatreta Vase
1951
Cire-perdue cast lead glass
6¹¹⁄₁₆" x 6⁷⁄₁₆" Diameter
Rockwell Museum, Corning, NY
Bequeathed by Frank and Mary Elizabeth Reifschlager 82.4.85 F

Fulvio Bianconi (Italian, 1915–1996)
Designed for Venini & C., Venice, Italy
Bottle-Shaped Vetro Pezzato Vase
About 1955
Blown glass
14" x 5" x 3"
Courtesy of Barry Friedman Ltd., New York, NY

Artists' Biographical Information

Doug Anderson (born 1952, Erie, PA)

Lives and works in Warsaw, OH

Education:

M.F.A., Rochester Institute of Technology, Rochester, NY, 1980

B.F.A., Columbus College of Art and Design, Columbus, OH, 1975

Selected Awards:

Rakow Commission, Corning Museum of Glass, Corning, NY, 1986

Ohio Arts Council Fellowship, 1986

Selected Public Collections:

American Craft Museum, New York, NY

Chrysler Museum of Art, Norfolk, VA

Huntington Gallery, Huntington, WV

Musée des Arts Décoratifs, Paris, France

Renwick Gallery, National Museum of American Art, Smithsonian Institution, Washington, DC

Selected Bibliography:

Dolez, Albane. *Glass Animals.* New York: Harry N. Abrams, Inc., Publishers, 1988.

Frantz, Susanne K. *Contemporary Glass: A World Survey from the Corning Museum of Glass.* New York: Harry N. Abrams, Inc., Publishers, 1989.

Klein, Dan. *Glass: A Contemporary Art.* New York: Rizzoli International Publications, 1989.

Lucie-Smith, Edward, and Paul Smith. *Craft Today: Poetry of the Physical.* New York: Weidenfeld & Nicolson, 1986.

Yoshimazu, Tsuneo. *Survey of Glass in the World,* vol. 6, *Contemporary Glass.* Tokyo: Kyuryudo Art Publishing Co., 1992.

John Brekke (born 1955, Chicago, IL)

Lives and works in Brooklyn, NY

Education:

B.S., University of Wisconsin, Madison, WI, 1978

Illinois State University, Normal, IL, 1975–76

Art Institute of Chicago, Chicago, IL, 1971–73

Selected Awards:

Fulbright-Hayes Fellowship, Australia, 1998–99

Artist-in-Residence, Canberra School of Art, Canberra, Australia, 1996

Emerging Artist Fellowship, Empire State Craft Alliance, 1993

Fellowship, Creative Glass Center of America, Millville, NJ, 1990

Artist-in-Residence, New York Experimental Glass Workshop, New York, NY, 1985

Selected Public Collections:

American Craft Museum, New York, NY

Carnegie Museum of Art, Pittsburgh, PA

Corning Museum of Glass, Corning, NY

Daichi Museum, Nagoya, Japan

Milwaukee Art Center, Milwaukee, WI

Selected Bibliography:

Chambers, Karen S., *Tell Me a Story: Narrative Art in Clay and Glass.* Manila: United States Information Agency, 1992.

Cotter, Holland, "Leopard and Tiger Return to the Mountain: Art in General." *The New York Times,* 20 February 1998, p. E37.

Erml, George, "Team Work: A Photo Essay." *Glass: UrbanGlass Quarterly,* No. 71, Summer 1998, pp. 38–43.

Milne, Victoria, "In Context." *Glass: UrbanGlass Quarterly,* No. 61, Winter 1995, pp. 46–49.

Perreault, John, "Leopard and Tiger Return to the Mountain." *Glass: UrbanGlass Quarterly,* No. 71, Summer 1998, p. 51.

Robert Carlson (born 1952, Brooklyn, NY)

Lives and works in Bainbridge Island, WA

Education:

Pilchuck Glass School, Stanwood, WA, 1981, 1982

City College of New York, NY, 1970–73

Selected Awards:

Northwest Poets and Artists Calendar, Bainbridge Arts Council, Bainbridge Island, WA, 1992

Visual Artists Residency, Centrum Foundation, Port Townsend, WA, 1992

National Endowment for the Arts Fellowship, 1990

Selected Public Collections:

Corning Museum of Glass, Corning, NY

Glasmuseum, Ebeltoft, Denmark

Glass Museum, Frauenau, Germany

Los Angeles County Museum of Art, Los Angeles, CA

Toledo Museum of Art, Toledo, OH

Selected Bibliography:

Frantz, Susanne K. *Contemporary Glass: A World Survey from the Corning Museum of Glass.* New York: Harry N. Abrams, Inc., Publishers, 1989, p. 216.

Glowen, Ron. "The Symbolism of Alchemy." *American Craft,* October/November 1994, pp. 52–55.

Kangas, Matthew. "Robert Carlson at MIA Gallery." *Glass: UrbanGlass Quarterly,* No. 56, Summer 1994, p. 52.

Miller, Bonnie. *Out of the Fire: Contemporary Glass Artists and Their Work.* San Francisco: Chronicle Books, 1991, pp. 27–29.

Yoshimazu, Tsuneo. *Survey of Glass in the World,* vol. 6, *Contemporary Glass.* Tokyo: Kyuryudo Art Publishing Co., 1992, p. 12.

Dale Chihuly (born 1941, Tacoma, WA)

Lives and works in Seattle, WA

Education:

M.F.A., Rhode Island School of Design, Providence, RI, 1967

M.S., University of Wisconsin, Madison, WI, 1966

B.A., interior design, University of Washington, Seattle, WA, 1965

Selected Awards:

Outstanding Achievement in Glass, UrbanGlass, Brooklyn, NY, 1996

National Living Treasure, United States Governors, 1992

Master Craftsman Apprenticeship award with Kate Elliott, National Endowment for the Arts, 1976

National Endowment for the Arts Fellowship, 1975

Louis Comfort Tiffany Foundation Grant, 1968

Fulbright-Hayes Fellowship, Italy, 1968

Selected Public Collections:

American Craft Museum, New York, NY

Cleveland Museum of Art, Cleveland, OH

Los Angeles County Museum of Art, Los Angeles, CA

Metropolitan Museum of Art, New York, NY

Museum of Contemporary Art, Chicago, IL

Victoria and Albert Museum, London, England

Selected Bibliography:

Bannard, Walter Darby, and Henry Geldzahler. *Chihuly: Form from Fire.* Daytona Beach, FL: Museum of Arts and Sciences; Seattle: University of Washington Press, 1993.

Chambers, Karen S., Dale Chihuly, Henry Geldzahler, and Michael W. Monroe. *Chihuly: Color, Glass and Form.* Tokyo, New York, and San Francisco: Kodansha International, 1986.

Earle, Sylvia, and Joan S. Robinson. *Chihuly Seaforms.* Seattle: Portland Press, 1994.

Glowen, Ron. *Venetians: Dale Chihuly.* Altadena, CA: Twin Palms Publishers, 1989.

Kuspit, Donald B. *Chihuly.* New York: Harry N. Abrams, Inc., Publishers, 1997.

Oldknow, Tina. *Chihuly Persians.* Seattle: Portland Press, 1996.

Dan Dailey (born 1947, Philadelphia, PA)

Lives and works in Kensington, NH

Education:

M.F.A., Rhode Island School of Design, Providence, RI, 1972

B.F.A., Philadelphia College of Art, Philadelphia, PA, 1969

Selected Awards:

Outstanding Achievement in Glass, UrbanGlass, Brooklyn, NY, 1998

Honorary Lifetime Membership, Glass Art Society, 1998

Masters Fellowship, Creative Glass Center of America, Millville, NJ, 1989

National Endowment for the Arts Fellowship, 1979

Fulbright-Hayes Fellowship, Italy, 1972–73

Selected Public Collections:

American Craft Museum, New York, NY

Corning Museum of Glass, Corning, NY

Detroit Institute of Arts, Detroit, MI

Metropolitan Museum of Art, New York, NY

Philadelphia Museum of Art, Philadelphia, PA

Toledo Museum of Art, Toledo, OH

Selected Bibliography:

Chambers, Karen S. "The Uncontradictable Dan Dailey." *The World & I,* January 1992, pp. 288–293.

Cocordas, Eleni, Henry Geldzahler, and William Warmus. *Dan Dailey: Simple Complexities in Drawing and Glass.* Philadelphia: Philadelphia Colleges of the Arts; Washington, DC: Renwick Gallery, National Museum of American Art, Smithsonian Institution, 1997.

Gardner, Paul V. "Imaginative, Original, Humorous—Glass Creations by Dan Dailey." *Neues Glas,* No. 4 (1983), pp. 182–189.

Lewis, Albert. "Dan Dailey—Captured Phenomenon." *New Work,* October/November 1979, pp. 6–11.

Matano, Koji. "Dan Dailey." *Glasswork,* No. 6, August 1990, pp. 12–19.

Michael Glancy (born 1950, Detroit, MI)

Lives and works in Rehoboth, MA

Education:

M.F.A., Rhode Island School of Design, Providence, RI, 1980

B.F.A., Rhode Island School of Design, Providence, RI, 1977

B.A., University of Denver, Denver, CO, 1973

Selected Awards:

Fellowship Grant, Centre International d'Art Contemporain, Château Beychevelle, Bordeaux and Paris, France, 1990

Massachusetts Council on the Arts, 1987

National Endowment for the Arts Fellowship, 1986

Selected Public Collections:

Chrysler Museum of Art, Norfolk, VA

Detroit Institute of Arts, Detroit, MI

Los Angeles County Museum of Art, Los Angeles, CA

Metropolitan Museum of Art, New York, NY

Renwick Gallery, National Museum of American Art, Smithsonian Institution, Washington, DC

Victoria and Albert Museum, London, England

Selected Bibliography:

Duncan, Alistair. *Beyond Vessels: Recent Glass Works by Michael Glancy.* New York: Barry Friedman Ltd., 1997.

Hampson, Ferdinand. *Glass: State of the Art.* Detroit: Elliot Johnston Publishers, 1984, p. 33.

Klein, Dan. *Michael Glancy—Interaction 1991.* Basel, Switzerland: Édition von Bartha, 1991.

McTwigan, Michael. "Balancing Order and Chaos." *Glass,* No. 42 (1990), pp. 20–29.

von Bartha, Miklos, Dale Chihuly, Erik Gottschalk, and Dan Klein. *Constellations—an Alternative Galaxy: Glass by Michael Glancy.* Basel, Switzerland: Édition von Bartha, 1995.

William Gudenrath (born 1950, Houston, TX)
Lives and works in Corning, NY
Education:
M.M., harpsichord, Juilliard School of Music, New York, NY, 1978
B.M., organ, North Texas State University, Denton, TX, 1974
Selected Awards:
Corning Museum of Glass, Corning, NY, Fellow, 1988
Selected Bibliography:
Chronicle: The Portland Vase. Videotape. BBC-TV and Arts & Entertainment, 1989.
Journey through Glass: A Tour of the Corning Museum Collection. Videotape. Corning, NY: Corning Museum of Glass, 1992.
The Story of Glass. CD-ROM. London: Victoria and Albert Museum, 1994.
Tait, Hugh, ed. *Glass: 5,000 Years.* New York: Harry N. Abrams, Inc., Publishers, 1991.
Verre Is Beautiful. Videotape. Conseil Général du Val d'Oise, 1993.

Dorothy Hafner (born 1952, Woodbridge, CT)
Lives and works in New York, NY
Education:
B.S., Skidmore College, Saratoga Springs, NY, 1974
Selected Awards:
Fellissimo Design Award, New York Foundation for the Arts, 1997
New York Foundation for the Arts Fellowship, 1986
Artist-in-Residence, Fabric Workshop, Philadelphia, PA, 1984
Artist-in-Residence, Artpark, Lewiston, NY, 1977, 1978
Selected Public Collections:
American Craft Museum, New York, NY
Brooklyn Museum, Brooklyn, NY
Corning Museum of Glass, Corning, NY
Norton Museum of Art, West Palm Beach, FL
Victoria and Albert Museum, London, England

Selected Bibliography:
Ancient Inspiration/Contemporary Interpretations. Binghamton, NY: Roberson Museum and Science Center, 1982.
Clark, Garth. *American Ceramics, 1876 to the Present.* New York: Abbeville Press, 1987.
Herman, Lloyd. *Art that Works.* Seattle: University of Washington Press, 1990.
Koplos, Janet. "Hafner's Synchromist Sculpture." *Glass: UrbanGlass Quarterly,* No. 70, Spring 1998, pp. 36–42.
Levin, Elaine. *The History of American Ceramics.* New York: Watson-Guptill, 1984.

Dante Marioni (born 1964, Mill Valley, CA)
Lives and works in Seattle, WA
Education:
Pilchuck Glass School, Stanwood, WA, 1984, 1985
Colorado Mountain College, Vail, CO, 1983
Penland School of Craft, Penland, NC, 1983
Selected Awards:
Outstanding Achievement in Glass, UrbanGlass, Brooklyn, NY, 1997
Louis Comfort Tiffany Foundation Award, 1987
Glass Eye Scholarship, 1985
Selected Public Collections:
Carnegie Museum of Art, Pittsburgh, PA
Hunter Museum of American Art, Chattanooga, TN
Los Angeles County Museum of Art, Los Angeles, CA
National Gallery of Victoria, Melbourne, Australia
Renwick Gallery, National Museum of American Art, Smithsonian Institution, Washington, DC
Selected Bibliography:
Herman, Lloyd. *Clearly Art: Pilchuck's Glass Legacy.* Bellingham, WA: Whatcom Museum of History, 1992, p. 46.
Kangas, Matthew. "Dante Marioni: Apprentice to Tradition." *American Craft,* February/March 1994, pp. 34–37.
Miller, Bonnie. *Out of the Fire: Contemporary Glass Artists and Their Work.* San Francisco: Chronicle Books, 1991, pp. 60–63.
Monroe, Michael. *The White House Collection of American Crafts.* New York: Harry N. Abrams, Inc., Publishers, 1995, p. 44.
Sims, Patterson. *Holding the Past: Historicism in Northwest Glass Sculpture.* Seattle: Seattle Art Museum, 1995.
Waggoner, Shawn. "Dante Marioni: Upholding the Vessel Tradition." *Glass Art,* Winter 1994, pp. 4–8.

Richard Marquis (born 1945, Bumblee, AZ)
Lives and works in Whidbey Island, WA
Education:
M.A., University of California, Berkeley, CA, 1972
B.A., University of California, Berkeley, CA, 1970
Selected Awards:
College of Fellows, American Craft Council, 1995
National Endowment for the Arts Fellowship, 1990, 1981, 1978, 1974
Fulbright-Hayes Grant (Senior), New Zealand, 1988, 1982
Fulbright-Hayes Fellowship, Italy, 1969
Selected Public Collections:
American Craft Museum, New York, NY
Australian National Gallery, Canberra, Australia
Metropolitan Museum of Art, New York, NY
Renwick Gallery, National Museum of American Art, Smithsonian Institution, Washington, DC
Royal Ontario Museum, Toronto, Canada
Selected Bibliography:
Frantz, Susanne K. *Contemporary Glass: A World Survey from the Corning Museum of Glass.* New York: Harry N. Abrams, Inc., Publishers, 1989, pp. 69, 110–111.

Glowen, Ron. "Glass Funk: Richard Marquis." *American Craft*, December 1982/January 1983, pp. 34–37.

Miller, Bonnie. "The Irreverent Mr. Marquis." *Neues Glas*, No. 2 (1988), pp. 78–84.

Oldknow, Tina. *Richard Marquis Objects.* Seattle: Seattle Art Museum, 1997.

Porges, Maria, "Richard Marquis: Material Culture." *American Craft*, December 1995/January 1996, pp. 36–40.

Klaus Moje (born 1936, Hamburg, Germany)

Lives and works in Canberra, Australia

Education:

Rheinbach and Hademar glass schools, 1957–59

Selected Awards:

Innovation in Glassworking, UrbanGlass, Brooklyn, NY, 1997

Honorary Life Member of the Arbeitsgemeinschaft Kunsthandwerk, 1996

Australian Creative Fellowship, 1995–97

Selected Public Collections:

Australian National Gallery, Canberra, Australia

Hokkaido Museum of Modern Art, Sapporo, Japan

Kunstgewerbemuseum, Berlin, Germany

Metropolitan Museum of Art, New York, NY

Toledo Museum of Art, Toledo, OH

Victoria and Albert Museum, London, England

Selected Bibliography:

Cochrane, Grace. *The Crafts Movement in Australia: A History.* Sydney, Australia: New South Wales University Press, 1992.

Edwards, Geoffrey. *Klaus Moje: Glass/Glas.* Melbourne, Australia: National Gallery of Victoria, 1995.

Hollister, Paul. "Klaus Moje." *American Craft*, December 1984/January 1985, pp. 18–22.

Lundstrom, Boyce, and Dan Schwoerer. *Kiln Firing Glass: Glass Fusing, Book One.* Portland, OR: Vitreous Group Publications, 1983.

Ricke, Helmut. *Dale Chihuly–Klaus Moje.* Ebeltoft, Denmark: Glasmuseum, 1991.

Taragin, Davira S. *Contemporary Crafts and the Saxe Collection.* Toledo, OH: Toledo Museum of Art, 1993.

Etsuko Nishi (born 1955, Kobe, Japan)

Lives and works in London, England

Education:

Ph.D. program, Royal College of Art, London, England, 1994–present

Postgraduate Diploma, Canberra School of Art, Canberra, Australia, 1990

Pilchuck Glass School, Stanwood, WA, 1983, 1985, 1987

Pratt Fine Arts Center, Seattle, WA, 1981–83

B.A., Mukagawa University, Kobe, Japan, 1978

Selected Public Collections:

Australian National University, Canberra, Australia

Corning Museum of Glass, Corning, NY

Glasmuseum, Ebeltoft, Denmark

Glass Museum, Hiroshima, Japan

Hokkaido Museum of Modern Art, Sapporo, Japan

Satsuma Glass Museum, Kagoshima, Japan

Selected Bibliography:

"Artist's Profile." *Fujin no Tomo*, March 1989, pp. 111–113; March 1992, pp. 1–5.

Chambers, Karen S. "New York Letter." *Glasswork*, No. 14, February 1993, p. 37.

Changing Techniques in Glass. Canberra, Australia: Australian National University, 1989.

New Glass Review. Corning, NY: Corning Museum of Glass, vol. 10 (1988), vol. 11 (1989), vol. 16 (1995), vol. 17 (1996).

"Profile." *Asahi Newspaper.* 18 July 1988, p. 15.

Seth Randal (born twentieth century, New York, NY)

Lives and works in Los Angeles, CA

Education:

Pilchuck Glass School, Stanwood, WA, 1990

Massachusetts College of Art, Boston, MA, 1988–89

A.A.S., glass, Parsons School of Design, New York, NY, 1988

Royal College of Art, London, England, 1976–77

Sir John Cass Academy of Art, London, England, 1974–75

Selected Public Collections:

Corning Museum of Glass, Corning, NY

Glasmuseum, Ebeltoft, Denmark

Los Angeles County Museum of Art, Los Angeles, CA

Museum of American Glass, Millville, NJ

Seattle Art Museum, Seattle, WA

Tacoma Art Museum, Tacoma, WA

Selected Bibliography:

Carducci, Vincent. "Season of Glass." *American Craft*, August/September 1992, pp. 69–70.

Lynn, Martha Drexler. *Seth Randal.* New York: Leo Kaplan Modern, 1993.

"Portfolio." *American Craft*, February/March 1991, pp. 56–57.

Sims, Patterson. *Holding the Past: Historicism in Northwest Glass Sculpture.* Seattle: Seattle Art Museum, 1995.

Christopher Ries (born 1952, Columbus, OH)

Lives and works in Tunkhannock, PA

Education:

M.F.A., glass, University of Wisconsin, Madison, WI, 1977

B.F.A., ceramics and glass, Ohio State University, Columbus, OH, 1975

Selected Awards:

Ohioana Citation for Distinguished Service to Ohio in the Field of Art, 1990

Ohio Arts Council Aid to Individual Artists Fellowship, 1978–79

Leo Yassenoff Scholarship, 1974–75

Selected Public Collections:

Carnegie Museum of Art,
Pittsburgh, PA

Cincinnati Art Museum,
Cincinnati, OH

Columbus Museum of Art,
Columbus, OH

Indianapolis Museum of Art,
Indianapolis, IN

Museum of Contemporary Art,
Lake Worth, FL

Toledo Museum of Art, Toledo, OH

Selected Bibliography:

Cusik, Daniel L. "A Clear Look at
Christopher Ries." *ArtToday* 3 (1990),
pp. 6–11.

Ellis, Anita J. *Illusions in Glass: The Art of
Christopher Ries.* Cincinnati: Cincinnati
Art Museum, 1988.

Hollister, Paul. "Glass as Different as
Can Be." *Collector Editions Quarterly,*
Spring 1979.

Waggoner, Shawn. "The Fourth
Dimension: The Art Glass of
Christopher Ries." *Glass Art* 12, No. 1,
November/December 1996, pp. 4–7.
"Windows to a View." Thirty-minute
video documentary. Scranton, PA:
WVIA, first broadcast November
1993.

Ginny Ruffner (born 1952, Atlanta,
GA)

Lives and works in Seattle, WA

Education:

M.F.A., University of Georgia,
Athens, GA, 1975

B.F.A., University of Georgia,
Athens, GA, 1974

Selected Awards:

Glass Eye Scholarship, 1993

National Endowment for the Arts
Fellowship, 1985, 1986

Selected Public Collections:

Cooper-Hewitt National Design
Museum, Smithsonian Institution,
New York, NY

Corning Museum of Glass,
Corning, NY

Hokkaido Museum of Modern Art,
Sapporo, Japan

Kunstmuseum, Düsseldorf, Germany

Renwick Gallery, National Museum of
American Art, Smithsonian Institution,
Washington, DC

Selected Bibliography:

Frantz, Susanne K. *Glass: A World
Survey from the Corning Museum of Glass.*
New York: Harry N. Abrams, Inc.,
Publishers, 1989.

Layton, Peter. *Glass Art.* Seattle and
London: University of Washington
Press, 1996.

Mayer, Barbara. *Contemporary American
Craft: A Collector's Guide.* Salt Lake City:
Gibbs M. Smith, Inc., 1988, pp. 74,
176.

Miller, Bonnie. *Why Not? The Art of
Ginny Ruffner.* Seattle and London:
Tacoma Art Museum in association
with University of Washington Press,
1995.

Pall, Ellen. "Starting from Scratch."
New York Times Magazine, 24 September
1995, pp. 39–43.

Barry Sautner (born 1952, Philadelphia,
PA)

Lives and works in Lansdale, PA

Selected Public Collections:

Bergstom-Mahler Museum,
Neenah, WI

Houston Museum of Fine Arts,
Houston, TX

Museum of Fine Arts, St.
Petersburg, FL

Newark Museum, Newark, NJ

Selected Bibliography:

Chambers, Karen S. "Barry Sautner:
Carved in Glass." *Glass Craftsman,*
October/November 1996,
pp. 14–17, 29.

Goldstein, Sidney M., Leonard S.
Rakow, and Juliette K. Rakow, *Cameo
Glass: Masterpieces from 2000 Years of
Glassmaking.* Corning, NY: Corning
Museum of Glass, 1982, pp. 56–57.

Rakow, Juliette K., and Leonard S.
Rakow. "American Cameo Glass." *Glass
Art Society Journal* (1983–1984),
pp. 24–31.

Rakow, Leonard S., and Juliette K.
Rakow. "Barry Sautner: Glass
Sculptor." *New Work,* Summer 1987,
pp. 10–11.

Tanguy, Sarah. "Barry Sautner."
American Craft, August/September 1997,
p. 74.

Yoshimizu, Tsuneo. *Survey of Glass in the
World,* vol. 6, *Contemporary Glass.*
Tokyo: Kyuryudo Art Publishing Co.,
1992. p. 25.

Judith Schaechter (born 1961,
Gainesville, FL)

Lives and works in Philadelphia, PA

Education:

B.F.A., Rhode Island School of Design,
Providence, RI, 1983

Selected Awards:

Joan Mitchell Award, 1995

Pew Foundation in the Arts, 1992

Pennsylvania Council on the Arts
Fellowship, 1990, 1985

Louis Comfort Tiffany Foundation
Award, 1989

National Endowment for the Arts
Fellowship, 1988, 1986

Selected Public Collections:

Corning Museum of Glass,
Corning, NY

Metropolitan Museum of Art,
New York, NY

Philadelphia Museum of Art,
Philadelphia, PA

Renwick Gallery, National Museum of
American Art, Smithsonian Institution,
Washington, DC

Selected Bibliography:

Frantz, Susanne K. *Contemporary Glass:
A World Survey from the Corning Museum of
Glass.* New York: Harry N. Abrams,
Inc., Publishers, 1989. p. 142.

Douglas, Mary. "Judith Schaechter:
Modern Martyrs." *American Craft,*
August/September 1995,
pp. 46–49, 64.

Kehlmann, Robert. *Twentieth-Century
Stained Glass: A New Definition.* Kyoto:
Shoin, 1992, pp. 164–165.

Moody, Rick, Maria Porges, and
Judith Tannenbaum. *Heart Attacks—
Judith Schaechter.* Philadelphia: Institute
of Contemporary Art, 1994.

Steinke, Darcey. *Judith Schaechter:
Parables in Glass.* Philadelphia:
Pennsylvania Academy of the Fine
Arts, 1998.

Paul J. Stankard (born 1943, Attleboro, MA)
Lives and works in Mantua, NJ
Education:
Diploma, scientific glassblowing, Salem County Vocational Technical Institute, Pensgrove, NJ, 1963
Selected Awards:
Innovation in Glassworking Technique, UrbanGlass, Brooklyn, NY, 1998
Excellence Award, New Jersey Council of County Colleges, 1993
Corning Museum of Glass, Corning, NY, Fellow, 1991
New Jersey State Council on the Arts Award for Excellence, 1989, 1986
Selected Public Collections:
American Craft Museum, New York, NY
Art Institute of Chicago, Chicago, IL
Hokkaido Museum of Modern Art, Sapporo, Japan
Metropolitan Museum of Art, New York, NY
Museum of Fine Arts, Boston, MA
Victoria and Albert Museum, London, England
Selected Bibliography:
Dietz, Ulysses Grant. *Paul J. Stankard: Homage to Nature.* New York: Harry N. Abrams, Inc., Publishers, 1996.
Hollister, Paul. "Natural Wonders: The Lampwork of Paul J. Stankard." *American Craft,* February/March 1987, pp. 36–43.
Klein, Dan. *Glass: A Contemporary Art.* New York: Rizzoli International Publications, 1989.
Spillman, Jane Shadel, and Susanne K. Frantz. *Masterpieces of American Glass.* New York: Crown Publishers, 1990.
Yoshimizu, Tsuneo. *Survey of Glass in the World,* vol. 6, *Contemporary Glass.* Tokyo: Kyuryudo Art Publishing Co., 1992.

Karla Trinkley (born 1956, Trenton, NJ)
Lives and works in Boyertown, PA

Education:
M.F.A., Rhode Island School of Design, Providence, RI, 1981
B.F.A., Tyler School of Art, Elkins Park, PA, 1979
Bucks County Community College, Newtown, PA, 1974–76
Selected Awards:
Shimonoseki City Art Museum Prize, World Glass Now, Hokkaido Museum of Art, Sapporo, Japan, 1994
Pennsylvania Council of the Arts Fellowship, 1990, 1984
National Endowment for the Arts Fellowship, 1986
Asahi Shimbun Award, Hokkaido Museum of Art, Sapporo, Japan, 1985
Selected Public Collections:
Corning Museum of Glass, Corning, NY
Hokkaido Museum of Modern Art, Sapporo, Japan
Los Angeles County Museum of Art, Los Angeles, CA
Metropolitan Museum of Art, New York, NY
Philadelphia Museum of Art, Philadelphia, PA
Toledo Museum of Art, Toledo, OH
Selected Bibliography:
Lynn, Martha Drexler and Barry Shifman. *Masters of Contemporary Glass: Selections from the Glick Collection.* Indianapolis: Indianapolis Museum of Art in cooperation with Indiana University Press, 1997, pp. 132–133, 158.
Miller, Bonnie J. "Karla Trinkley: Silent Spaces." *New Work,* No. 31, Fall 1987, pp. 24–25.
Reynolds, Rebecca Ann Gay. "Karla Trinkley." *Glass Today by American Studio Artists.* Boston: Museum of Fine Arts, 1997, pp. 64–65.

Toots Zynsky (born 1951, Boston, MA)
Lives and works in Providence, RI
Education:
Rhode Island School of Design, Providence, RI, 1973, 1979
Pilchuck Glass School, Stanwood, WA, 1971, 1973

Haystack Mountain School of Crafts, Deer Isle, ME, 1970
Selected Awards:
Rakow Commission, Corning Museum of Art, Corning, NY, 1988
National Endowment for the Arts Fellowship, 1986, 1982
Stichting Klanscap, Amsterdam, the Netherlands, Research Grant, 1984
Pilchuck Glass School Artist-in-Residence, Stanwood, WA, 1982
New York State Council on the Arts Grant, 1982
Selected Public Collections:
Hokkaido Museum of Modern Art, Sapporo, Japan
Metropolitan Museum of Art, New York, NY
Musée des Arts Décoratifs, Paris, France
Museum Bellerive, Zürich, Switzerland
Museum of Modern Art, New York, NY
Stedelijk Museum, Amsterdam, the Netherlands
Selected Bibliography:
Bester, Jean-Claude. Interview. *Revue de la Céramique et du Verre,* January/February 1995, pp. 2–7.
Charleston, Robert. *Masterpieces of Glass: A World History from the Corning Museum of Glass.* New York: Harry N. Abrams, Inc., Publishers, 1990, pp. 228, 236.
Lynn, Martha Drexler and Barry Shifman. *Masters of Contemporary Glass: Selections from the Glick Collection.* Indianapolis: Indianapolis Museum of Art in cooperation with Indiana University Press, 1997, pp. 23, 142–143.
Mentasi, Rosa Barovier. *Vetro Veneziano, 1890–1990.* Venice: Arsenale Editrice, 1992, p. 177.
Toots Zynsky: Tierra del Fuego Series. Amsterdam: Stedelijk Museum, 1989.

Glossary

Acid etching: a process of applying an acid-resistant mask of wax, varnish, or oil to the glass surface, scratching a design through the mask, and applying a solution of hydrofluoric acid, potassium fluoride, and water to corrode or etch the exposed areas.

Annealing: the controlled cooling of glass in an oven or lehr to remove the stress that would be caused by rapid or uneven cooling of thicker and thinner areas and that could cause fracturing.

Ariel: a technique devised in 1936 by Orrefors Glasbruk designers Edvin Öhrström and Vicke Lindstrand in cooperation with master blower Gustaf Bergkvist. The technique is related to Graal. A thick cased blank is deeply carved and then reheated to allow another layer of clear glass to be gathered over it, thus trapping air within the walls. Its name is taken from the airy spirit of Shakespeare's play *The Tempest.*

Blank: any glass form intended for later decoration using cold techniques such as sandblasting, acid etching, or painting.

Blown glass: glass formed by inflating a gob of soft glass gathered on the end of a blowpipe.

Blowpipe: a hollow metal tube used for gathering and blowing glass.

Bubble: the air- or gas-filled cavity in a glass piece on a blowpipe.

Cane: a solid rod of glass used in various types of surface decoration on the primary glass form. Cane designs are made by grouping thicker rods together, heating them, and then pulling the fused bundle to make a thinner rod, which may be sliced into buttons or used whole.

Cased glass: glassware made of two or more layers of glass of different colors.

Cast glass: molten glass poured into a mold, or chunks of glass placed in a mold, then in a kiln, and heated until the glass slumps into the mold (slump casting).

Cold work: a general term for glassworking processes that do not involve heat or the molten state, including stained glass, engraving, etching, cutting, grinding, drilling, sandblasting, polishing, and laminating.

Crystal: glass made with at least 24 percent lead oxide (half-lead crystal). Full-lead crystal contains at least 30 percent. Lead gives glass better light-dispersing qualities and makes it more suitable for cutting and engraving.

Cut glass: glass decorated using rotating wheels made of iron, copper, stone, or diamond to cut facets in its wall.

Diatreta: a glass vessel surrounded by a cage of glass attached to the body by struts.

Dichroic glass: glass that changes color depending on the angle of the light falling on it, and whether it is reflected or transmitted.

Enamel: finely powdered colored glass suspended in a liquid medium and painted on a cold glass surface. It requires firing for permanence.

Engrave: to scratch or mark the glass surface with a diamond point, metal needle, or rotating stone, diamond, or metal wheel.

Filigrana: Italian; a traditional decorative technique using canes embedded with white or colored threads of glass. The canes are heated on a plate, picked up on a hot bubble of glass, and melted into the bubble's surface.

Flamework: see Lampwork.

Free-blown glass: glass blown on a blowpipe and shaped by hand tools; also known as off-hand glass.

Furnace: a gas-fired or electric heat source for melting glass. It must reach and maintain temperatures of at least 2200 degrees Fahrenheit.

Fuse: to bond two or more pieces of glass together by heating them in a kiln.

Gaffer: the head of the glassblowing team. A gaffer is assisted by other glassblowers, each performing a specific task, including preparing the bubble, blowing as the gaffer shapes the bubble, or carrying the finished piece to the annealing oven.

Gather: to take molten glass, with a twisting motion, from the furnace onto the blowpipe or gathering iron. The gathered material is called a blob, gob, or paraison of glass.

Glass: an amorphous, artificial, noncrystalline substance, usually transparent but sometimes translucent or opaque, made by fusing silica and alkali.

Glassblowing: the process of shaping gathered glass by blowing air through a blowpipe

Graal: a decorative technique developed at Orrefors Glasbruk in 1916 by master glassblower Knut Bergqvist. A surface design is etched, cut, or engraved on a cooled cased-glass cylinder. Then the blank is reheated, covered with an additional layer of clear glass, and blown out to its final shape.

Grind: to remove glass using an abrasive wheel or belt.

Hot-work: a general term for glassworking processes involving molten glass.

Kiln: a small oven capable of reaching temperatures between 1800 and 2300 degrees Fahrenheit.

Lampwork: to heat and soften glass rods over a small open flame and then manipulate them to form objects or vessels; also known as flameworking or scientific glassblowing.

Latticino or latticinio: Italian; opaque white glass embedded in clear glass canes; a traditional Venetian decorative technique.

Lehr: an annealing oven.

Lost wax: *cire perdue* in French; a casting process in which a wax model is encased in a mold material and the wax melted out, leaving a negative mold.

Millefiori: Italian; literally, a thousand flowers; colored glass canes arranged into a pattern resembling a flower and then fused into a single rod or cane, which can be sliced and embedded in a clear glass matrix.

Mold-blown glass: pieces of molten glass blown into a mold.

Mosaic: glass *tesserae* fused together to form a sheet that can be slumped or picked up on a hot glass bubble.

Murano: the Venetian island where glassblowers were confined in 1291 because of the danger of fires.

Murrine: Italian; a technique using different colors of glass fused together in bundles to form a design and then heated and drawn out to reduce the size of the cane. Slices of this cane are used to decorate or form objects in the mosaic technique.

Occhi: Italian; literally, glass with eyes; an ornamental glass developed at the Venini glassworks. It consists of a mosaic pattern arranged in rows.

Paraison: the bubble of hot glass at the end of the blowpipe; also called a blob, gob, or parison.

Pâte-de-verre: French; literally, glass paste; a technique in which ground glass mixed with a flux is placed in a mold and fused at high temperature in a kiln.

Prunts: hot blobs of glass added as decoration to a glass surface during the blowing process.

Sandblasting: a cold-work process used to decorate, carve, or cut glass. Areas not to be affected are masked with tape or resist. Then the piece is bombarded with fine grains of sand or carborundum. The effects range from a frosted, matte surface to actual cuts.

Scientific glassblowing: see Lampwork.

Slump: to heat glass over or in a mold to the point at which it softens and sags to conform to the mold shape.

Studio Glass: glass designed and made by an artist/craftsperson rather than a factory glassmaker. Such pieces are usually signed.

Studio Glass movement: the term given to the development of small, artist-run studios for the production of art glass. The movement was precipitated in 1962 by technological advances by Dominick Labino and promoted by Harvey Littleton.

Trail: to apply thin threads of glass from a larger blob of hot glass on the surface of a paraison as it is rotated.

Tesserae: small, thin pieces of glass.

Vasa diatreta: see *Diatreta*.

Vetro pezzato: Italian; an ornamental glass developed by Venini & C., about 1951. It consists of squares of colored glass fused into a patchwork mosaic sheet that is then picked up on the hot bubble during the blowing process.

For additional and more complete definitions, see Harold Newman, *An Illustrated Dictionary of Glass* (London: Thames and Hudson, 1977).

REFERENCES

Babylon, Venice, Damascus, Prague: Travels through the Past of Glass

Barovier-Mentasti, Rosa. Introduction to *L'Arte Vetraria*, by Antonio Neri. Florence, 1612. Reprint, Milan: Edizioni Il Polifilo, 1980.

Bowman, Leslie Greene. *American Arts and Crafts: Virtue in Design*. Los Angeles: Los Angeles County Museum of Art, 1990.

Cirlot, J. E. *A Dictionary of Symbols*. New York: Philosophical Society, 1962.

Dorigato, Attilia. *Murano Glass Museum*. Milan: Electa, 1986.

Dubin, Lois Sherr. *The History of Beads*. New York: Harry N. Abrams, Inc., Publishers, 1987.

Hess, Catherine, and Timothy Husband. *European Glass in the J. Paul Getty Museum*. Los Angeles: J. Paul Getty Museum, 1997.

Honey, W. B. *Glass*. London: Victoria and Albert Museum, 1946.

Jacoby, David. "Raw Materials for the Glass Industries of Venice and the Terraferma, 1370–1460." *Journal of Glass Studies* 35 (1993), pp. 65–89.

Klein, Dan, and Ward Lloyd, eds. *The History of Glass*. London: Orbis, 1984.

Newton, Roy, and Sandra Davidson. *Conservation of Glass*. London: Butterworth, 1989.

Oppenheim, A. Leo, Robert H. Brill, Dan Barug, and Axel von Saldern. *Glass and Glassmaking in Ancient Mesopotamia*. Corning Museum of Glass Monographs, vol. 3. New York: Corning Museum of Glass, 1970.

Perrot, Paul N. *Three Great Centuries of Venetian Glass*. New York: Corning Museum of Glass, 1958.

Polak, Ada. *Glass: Its Traditions and Its Makers*. New York: Putnam, 1975.

Roberts, Gareth. *The Mirror of Alchemy*. London: British Library, 1994.

Spillman, Jane Shadel, and Susanne K. Frantz. *Masterpieces of American Glass*. New York: Crown, 1990.

Stern, E. Marianne, and Birgit Schlick-Nolte. *Early Glass of the Ancient World: Ernesto Wolf Collection*. Ostfildern, Germany: Verlag Gerd Hatje, 1994.

Tait, Hugh. *The Golden Age of Venetian Glass*. London: British Museum, 1979.

von Saldern, Axel. *German Enameled Glass*. Corning Museum of Glass Monographs, vol. 2. New York: Corning Museum of Glass, 1965.

Warmus, William. *Émile Gallé: Dreams into Glass*. Corning, NY: Corning Museum of Glass, 1984.

Zecchin, Luigi. *Vetro e Vetrai di Murano*, vols. 1–3. Venice: Arsenale Editrice, 1987, 1989, 1990.

Clearly Inspired: Contemporary Glass and Its Origins

Arnason, H. H. *History of Modern Art*. Englewood Cliffs, NJ: Prentice-Hall; New York: Harry N. Abrams, Inc., Publishers, 1968.

Bannard, Walter Darby, and Henry Geldzahler. *Chihuly: Form from Fire*. Daytona Beach, FL: Museum of Arts and Sciences; Seattle: University of Washington Press, 1993.

Byrd, Joan Falconer. *Harvey K. Littleton: A Retrospective Exhibition*. Atlanta: High Museum of Art, 1984.

Edwards, Geoffrey. "Klaus Moje: Three Decades of Glass." In *Klaus Moje: Glass/Glas*. Melbourne, Australia: National Gallery of Victoria, 1995.

Frantz, Susanne K. *Contemporary Glass: A World Survey from the Corning Museum of Glass*. New York: Harry N. Abrams, Inc., Publishers, 1989.

Harden, Donald B., Hansgerd Hellenkemper, Kenneth Painter, and David Whitehouse. *Glass of the Caesars*. Milan: Olivetti, 1987.

Lynn, Martha Drexler and Barry Shifman. *Masters of Contemporary Glass: Selections from the Glick Collection*. Indianapolis: Indianapolis Museum of Art in cooperation with Indiana University Press, 1997.

Lynn, Martha Drexler. *Seth Randal*. New York: Leo Kaplan Modern, 1993.

Manhart, Marcia, and Tom Manhart, eds. *The Eloquent Object: The Evolution of American Art in Craft Media since 1945*. Tulsa, OK: Philbrook Museum of Art, 1987.

Newman, Harold. *An Illustrated Dictionary of Glass*. London: Thames and Hudson, 1977.

Nickson, Graham. "Why Transcribe." In *New York Studio School of Drawing, Painting and Sculpture Catalogue*. New York, 1997.

Oldknow, Tina. *Richard Marquis Objects*. Seattle: Seattle Art Museum, 1997.

Polak, Ada. *Modern Glass*. London: Faber and Faber, 1962.

Rose, Bernice. "Sol LeWitt and Drawing." In *Sol LeWitt*. New York: Museum of Modern Art, 1978.

Sims, Patterson. *Holding the Past: Historicism in Northwest Glass Sculpture*. Seattle: Seattle Art Museum, 1995.

Sweeney, Joey. "Through a Glass Darkly." *Philadelphia Weekly*, 4 June 1997, p. 30.

Tait, Hugh, ed. *Glass: 5,000 Years*. New York: Harry N. Abrams, Inc., Publishers, 1991.

Widman, Dag. "Pioneers, Breakthrough, Triumph." In *Orrefors: A Century of Swedish Glassmaking*. Stockholm: Byggförlaget-Kultur, 1998.